PHOTOGRAPHING CHILDREN PHOTO WORKSHOP

Ginny Felch with Allison Tyler Jones

Photographing Children Photo Workshop

Published by Wiley Publishing, Inc. 10475 Crosspoint Blvd. Indianapolis, IN 46256 www.wiley.com

Copyright © 2008 by Wiley Publishing, Inc., Indianapolis, Indiana

Cover image © 2008 Ginny Felch

Published simultaneously in Canada

ISBN 978-0-470-11432-2

Manufactured in the United States of America

1098765432

No part of this publication may be reproduced, stored in a retrieval system or transmitted in any form or by any means, electronic, mechanical, photocopying, recording, scanning or otherwise, except as permitted under Sections 107 or 108 of the 1976 United States Copyright Act, without either the prior written permission of the Publisher, or authorization through payment of the appropriate per-copy fee to the Copyright Clearance Center, 222 Rosewood Drive, Danvers, MA 01923, (978) 750-8400, fax (978) 750-4744. Requests to the Publisher for permission should be addressed to the Legal Department, Wiley Publishing, Inc., 10475 Crosspoint Blvd., Indianapolis, IN 46256, (317) 572-3447, fax (317) 572-4355, or online at http://www.wiley.com/go/permissions.

LIMIT OF LIABILITY/DISCLAIMER OF WARRANTY: THE PUBLISHER AND THE AUTHOR MAKE NO REPRESENTATIONS OR WARRANTIES WITH RESPECT TO THE ACCURACY OR COMPLETENESS OF THE CONTENTS OF THIS WORK AND SPECIFICALLY DISCLAIM ALL WARRANTIES, INCLUDING WITHOUT LIMITATION WARRANTIES OF FITNESS FOR A PARTICULAR PURPOSE. NO WARRANTY MAY BE CREATED OR EXTENDED BY SALES OR PROMOTIONAL MATERIALS. THE ADVICE AND STRATEGIES CONTAINED HEREIN MAY NOT BE SUITABLE FOR EVERY SITUATION. THIS WORK IS SOLD WITH THE UNDERSTANDING THAT THE PUBLISHER IS NOT ENGAGED IN RENDERING LEGAL, ACCOUNTING, OR OTHER PROFESSIONAL SERVICES. IF PROFESSIONAL ASSISTANCE IS REQUIRED, THE SERVICES OF A COMPETENT PROFESSIONAL PERSON SHOULD BE SOUGHT. NEITHER THE PUBLISHER NOR THE AUTHOR SHALL BE LIABLE FOR DAMAGES ARISING HEREFROM. THE FACT THAT AN ORGANIZATION OR WEB SITE IS REFERRED TO IN THIS WORK AS A CITATION AND/OR A POTENTIAL SOURCE OF FURTHER INFORMATION DOES NOT MEAN THAT THE AUTHOR OR THE PUBLISHER ENDORSES THE INFORMATION THE ORGANIZATION OR WEB SITE MAY PROVIDE OR RECOMMENDATIONS IT MAY MAKE. FURTHER, READERS SHOULD BE AWARE THAT INTERNET WEB SITES LISTED IN THIS WORK MAY HAVE CHANGED OR DISAPPEARED BETWEEN WHEN THIS WORK WAS WRITTEN AND WHEN IT IS READ.

For general information on our other products and services or to obtain technical support, please contact our Customer Care Department within the U.S. at (800) 762-2974, outside the U.S. at (317) 572-3993 or fax (317) 572-4002.

Wiley also publishes its books in a variety of electronic formats. Some content that appears in print may not be available in electronic books.

Library of Congress Control Number: 2007926009

Trademarks: Wiley and the Wiley Publishing logo are trademarks or registered trademarks of John Wiley and Sons, Inc. and/or its affiliates. All other trademarks are the property of their respective owners. Wiley Publishing, Inc. is not associated with any product or vendor mentioned in this book.

About the Authors

Ginny Felch, as a child of the '50s, was given a Brownie camera by her father. She was encouraged by his kind compliments about her sensitivity and composition. The beauty and nostalgia of New England as well as Ginny's mother's eclectic eye for beauty and her appreciation of art and design were gifts that contributed to her developing eye. Ginny was trained as a wedding photographer after years of studying black-and-white photography. Later, her love for children, spurred by devotion to her son, Zachary, led to an inspired career creating children's portraits.

Under the name of Virginia Clayton, she exhibited and lectured her way to becoming a Master of Photography through Professional Photographers of

America and has been coached by some great photographers, including Marie Cosindas, Morley Baer, Ruth Bernhard, Robert Farber, Sara Moon, and Josef Karsh. Ginny has had speaking engagements across the country and in Europe. In 1990, she visited the Soviet Union while documenting the Heart to Heart Children's Medical Alliance as part of a group of volunteer doctors and nurses from Oakland Children's Hospital.

Shortly after returning home from working with parents facing the possibility of losing their children, Ginny endured the tragedy of losing her own 15-year-old son in an automobile accident. Soon thereafter, her home and all belongings were destroyed in the Oakland Firestorm of 1991. This was the beginning of a challenging and courageous journey of healing and discovery. Her survival and reclaimed zest for life were due in no small part to her relationship with her husband, Will, and his family.

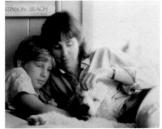

When Ginny finally did return to her life as a children's photographer, she found it all the more poignant and meaningful to be a part of the joy and appreciation of children and life. Ginny is motivated deeply by the moody and sculptural effect of natural light on a myriad of subjects, creating a sense of place and feeling of timelessness. Her children's portraits are known for those qualities as well as her warmth and ability to connect with and relate to children.

Her philosophy about photography is that the equipment and technology take a back seat to vision, creativity, and passion. Above all, Ginny seeks beauty. Here is one of her favorite quotations:

"Beauty has a dignity and poise that takes us beyond our smallness and negativity; beauty brings us in to remembrance. Beauty is the bridge between the real and the ideal. Not everything is beautiful; yet when we develop a graceful and gracious eye, we can find beauty in the most unexpected places." —John O'Donohue

Allison Tyler Jones is a professional photographer located in Mesa, Arizona. Allison photographed her high school yearbook and has held photography as a passion for most of her life. Married, with 2 children and 5 step-children (yep, that's 7!), she is the former co-owner of the beloved Memory Lane Photo and Paper Arts store in Arizona and co-author of the photography books Designing with Photos and Expressions: Taking Extraordinary Photos for Your Scrapbook and Memory Art. Allison has also compiled a bestselling book of quotes titled Quote, Unquote Vol. 1. After retiring from her retail store in 2005, Allison launched her photography studio, Allison Tyler Jones Photography, Inc., where she specializes in children and family relationship portraiture.

Allison lectures nationally and internationally on photography. Her inspiration is the personalities of her subjects and their relationships with one another.

Credits

Acquisitions Editor Ryan Spence

Senior Project Editor Cricket Krengel

Project Editor Kelly Maish

Development Editor Kelly Dobbs Henthorne

Technical Editors Ellen Jackson Stacy Wasmuth

Editorial Manager Robyn Siesky

Vice President & Group Executive Publisher Richard Swadley

Vice President & Publisher Barry Pruett

Business Manager Amy Knies

Senior Marketing Manager Sandy Smith Book Designers LeAndra Hosier Tina Hovanessian

Project Coordinator Kristie Rees

Graphics and Production Specialists Andrea Hornberger Shane Johnson Jennifer Mayberry Erin Zeltner

Quality Control Technician Todd Lothery

Cover Design Daniella Richardson Larry Vigon

Proofreading and Indexing Melissa D. Buddendeck Sherry Massey For Will: You have taught me most of what I know about the strength and fragility of the human spirit. I am deeply grateful for your love, appreciation, and undying support in our life journey.

For Zach: My son and angel guide, my soul inspiration. Without you, my little zachabuddha, there would be no book.

~ Ginny Felch

Acknowledgments

First of all, I would like to express my gratitude to Robert Farber for inviting me to write an inspirational book on photographing children. All along the way, he has encouraged me to stick with my intention to place more emphasis on the creative than the technical. I wholeheartedly believe that he shares my passion for photography and understands the emphasis on creativity.

Judith Farber, my friend and neighbor, has been a soul-mate throughout the process of putting this book together. I have called her during times when I wasn't sure I could pull it off, and she commiserated so beautifully that I found myself getting right back to the drawing board.

I am certain that this book would not have come about without the support and friendship of my editor, Kim Spilker. As acquisitions editor, she went way beyond her job description, I'm sure, to hold my hand, encourage me, and help me all along the way.

Soon after I started working on the book, I realized that I didn't actually have a lot of the photographs from before 1991, when my house burned down. Because of that and the fact that I wanted to show different styles and points of view besides my own, I invited other photographers, known and unknown to me, to submit photographs. I was thrilled at the responses and have been very inspired by the images. My eyes have been opened once again! Thank you, Deidre Lingenfelter, Linda Murray Lapp, Joyce Wilson, Lizbeth Guerrina, Marybeth McCormack, Amy Melious, Pat Stroud, Gail Nogle, Marianne Drenthe, Matt Reoch, Patrisha McLean, Melanie Sikma, Scarlett, Rick Chapman, Wendi Hiller, Tina Wilson, Sherman Hines, Theresa Smerud, Karma Wilson, Heather Jacks, and Amanda Keys. You all went beyond the imaginable to get files to me in short order. I have met some wonderful new friends and peers along the way.

I am so grateful to all of my clients, past and present, who have generously allowed me to work with their children. I have been so enriched by many of the friendships that developed henceforth. Rediscovering old clients from my past life has made this quest a full circle experience and has been a very important part of my healing. Revisiting photographs from 30 years ago has been like rediscovering lost treasures.

My patient husband, Will, has exhibited an inordinate amount of patience and tolerance through the past six months. I promise on this public page that I won't ever whine quite as loudly as I have in the past when he works too hard. Thanks to my family and to my treasured friends for your support and affirmation that "You can do it!" You left me alone when I needed space and encouraged me all along the way, which I needed more than you know. Your feedback to my chapters has helped me immeasurably.

Jake Elwell, of Harold Ober Associates, my nephew and very close friend, I thank you for giving me the confidence to look at a book contract and not wither away. Your experience in the publishing business and your understanding of my nature helped me to trust your advice implicitly.

ACKNOWLEDGMENTS

Have I mentioned my dog, Gracie? How patient she has been as she plumped up because of missing beach walks and ball fetching. When I thought I would explode with angst, just holding her tightly brought my blood pressure down measurably!

Deidre Lingenfelter, you have encouraged me to write a book ever since I can remember. Your love and support have carried me a long, long way. My friend Linda Lapp Murray was my first mentor, and we have remained dear friends and partners in creative crime.

Marty London's wise words of wisdom are always in the back of my mind as I face life's joy and challenges. Gail Graham's enthusiastic feedback and encouragement to exercise along the way was an everyday incentive (and I will start exercising tomorrow!). Ginny Otis and my sister, Barbara Steele, gave me helpful hints and feedback.

It truly did take a village for this book to happen, and I thank you all from the depths of my heart.

~ Ginny Felch

Contents

CHAPTER 1	The Art of Photographing Children	3
Advice for the A	Aspiring Professional	4
Be Inspired		6
Resources for In	nspiration	10
The Importance	e of Play	12

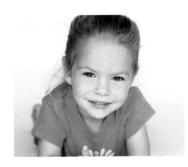

CHAPTER 2 The Look of a Photograph	17
You Don't Need to Know Everything	19
Going Beyond Automatic: Exposure Basics	19
Shutter Speed Movement Rule of thumb: Shutter speed selection Freezing movement Blurring movement	20 21 22 22 23
Aperture	23
ISO	24
Depth of Field	24
Using Program Modes Portrait mode Sports mode Landscape mode Close-up or Macro mode	28 28 29 29 29

Aperture Priority mode Shutter Priority mode	29 30
What Do You Want?	31

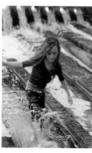

CHAPTER 3	Seeing the Light	35
Learning to S	See Light	36
Available Lig	ht	40
The Sweet L	ight: Dawn and Twilight	42
Using Reflec Reflection Shadows	tions and Shadows s	44 44 48
Photographi Foggy days Overcast s		50 51 53
Finding Cont	couring Light	53
Using Soft Window Light		56
Knowing Wh	en to Compromise	EO

CHAPTER 4 Manipulating the Light	63
Indirect Light Porches or overhangs Open shade	64 64 65
Direct Light Direct sun Creating a halo: Using rim or backlighting	66 66 67
To Flash or Not to Flash Concept of main light and fill Bounce it Diffuse it	68 68 69
Direction of Light Flatter: Using flat or front lighting Contour: Using Rembrandt or 3-D lighting	70 70 70
Light Modifiers Reflectors Diffusers Gobos or subtractive lighting	72 72 75 75
Color Temperature or White Balance	75
Basic Studio Lighting One-light setup Metering The final result	78 80 80 81

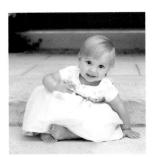

CHAPTER	5	Composing Photographs	85
Snapsho	ts ver	sus Portraits	86
Focus on	Feeli	na	87

CONTENTS

Keeping It Simple Watch your backgrounds Using negative space	87 88 91
Framing the Image General framing guidelines Frames within the frame	92 93 94
Parents as Props	95
The Rule of Thirds	96
Using Lines Parallel lines Diagonal lines Converging lines S and C curves	99 99 101 102 102
Breaking the Rules	104

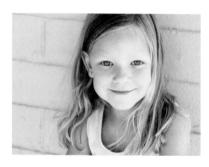

CHAPTER 6 What's Your Style?	111
Classic and Romantic	112
In the studio	112
On location	113
Clothing	114
Capturing the mood	118
Contemporary	119
In the studio	119
On location	123
Photojournalistic Style	125
On location	128
Mood	130

Preparing Parents for Their Child's Portrait	132
Outlining expectations	133
On the shoot with parents	133
Keep shooting	135
Portrait Planning	135

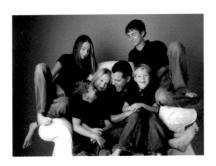

CHAPTER 7	Evoking Expression and Emotion	139
Observing Er	notions and Moods	141
Visualization		142
Revealing the	e Eyes: Gateway to the Soul	143
Involving You	r Subjects with Nature	148
Studying Boo	ly Language, Gestures, and Movement	152
Telling a Stor	y with Your Photographs	154
The Psychological	gy of Photographing Children	156

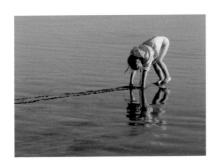

CHAPTER 8	Ages, Stages, and Groups	161
Newborns		162
Challenges		162
Rewards		164

Babies Three to six months Six to twelve months	165 166 167
Toddlers	167
Preschoolers	171
School-age Children	174
Tweens and Teens Teen boys Teen girls	174 179 179
Grouping Families Parent and child Siblings Families	180 180 184 187

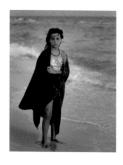

CHAPTER 9 Equipment for the Children's Photographer	193
Considering a Camera Upgrade	194
Using Interchangeable Lenses	195
Lens speed	195
Lens focal lengths	196
Prime lenses	196
Zoom lenses	197
Looking Inside Your Camera Bag	100

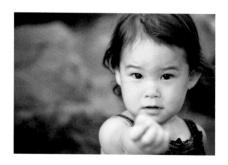

CHAPTER 10	Post-Production and Presentation	203
Establishing Your Workflow		204
Getting Started with Image Editing		205
Image-Editing Workflow		206
Eye and teeth	mishes and smoothing skin	207 207 207 208 210
Changing Colors for Impact Black and white conversions Actions and plug-ins		210 211 211
Cropping Tips		212
Presentation Ga Storyboards Gallery-wrapp Coffee table d	ed canvas prints	217 217 217 217 218

Glossary 223 Index 229

Introduction

In 1987, Josef Karsh wrote the following to me:

"I have just returned to find your enchanting portfolio. I find the collection sensitive and exquisitely executed. You have also managed to capture the tentative quality of adolescence, an especially difficult thing to do. It was interesting for me to read how you psychologically prepare parents and children for their session with you. I would most certainly encourage you to do a book on children's photography."

The sheer miracle of childhood is something few can deny. The intrinsic innocence, honesty, spontaneity, and whimsy of children have been the subject of prose, poetry, and paintings throughout the history of man. Since the introduction of the art and craft of photography, the depiction of children has been a popular and passionate quest.

What a thrill it is to have such a long and fun-filled career as a photographer of children. It has always been my desire to share the passion and the craft with those who feel the same stirrings of attraction to this field. I know that many are put off or discouraged by the threat of the supposed technical challenge of photography and equipment.

It truly makes me sad to think of the unexpressed vision of those who hold back due to that fear or intimidation. I believe this threat or challenge is manufactured; the flames of fear continue to be fanned by some manufacturers of camera equipment, authors of books, and teachers of photography.

Don't get me wrong; there is a place for understanding how to better execute fine photographs, but your vision, passion, and personal tastes have a deeply profound effect on what you produce. It excites me to think that I can be any part of encouraging you to follow your bliss, your heart, and your passion for photographing children. That has always been my point of view whether teaching, mentoring, or producing children's photographs.

Even when I worked in the darkroom, I was interested in keeping the process more of a mystery and a magical experience. To see an image rise up out of the paper submerged in water is still a miracle to me! I continue to feel that magic when I peer through a lens and even when I work on an image in Photoshop. I want to know less about why things happen and more about making my images sing.

Those who are looking for scientific definitions and formulae for sharp and perfect images might look elsewhere. Books abound with such information. I hope that in this book you find inspiration and encouragement to follow any urges you have had to make photographs that capture the spirit of a child.

WHO SHOULD PHOTOGRAPH CHILDREN

Everyone who enjoys and appreciates children and who wants to learn to capture their energies should photograph children. I would guess that a large majority of cameras are purchased when parents see their firstborn child.

With the advances of digital technology, anyone can take an acceptable image of a child — in that the exposure is good. That is almost guaranteed. The issue here is how to take an exceptional photograph of a child, one that holds your attention for years.

I believe that parents have the potential to be excellent photographers of their children. The motivation is great, in creating a history of the life of a child, as well as to surround yourself with images that bring you back to that day. The opportunity is there, as parents usually spend an inordinate amount of time watching, playing with, and tending to their children in all manner of activities. Most importantly, parents have the heart connection built right in! That is the key that opens the door to the potential for creating beautiful images of children.

Certainly, other people cherish children and love to observe and photograph them. The ingredients needed are passion and an interest in learning to see! Right there, you have most of what you need, even with a simple point-and-shoot camera.

Wonderful photographs of children have so many uses these days. You can create brilliant scrapbooks, slideshows, and even customized books. Wouldn't you just love to improve your photography by leaps and bounds just by learning to see and understanding a few photography basics? I think your time has come!

WHAT I'VE LEARNED FROM COACHING PHOTOGRAPHY

Most people contact me for two reasons. Either they have been photographing children for years and want to learn to go beyond their existing work, or they are just starting out and have been put off or intimidated by the technical elements of the camera and computer. The second group is my favorite.

Dispelling fear is a beautiful thing. When you are fearful, your mind tends to shut down, and things make less sense. You get discouraged, and you give up. Fear is the enemy of creativity, and creativity is what you need to nurture the most if you want to improve your photographs. On the other hand, entering into the zone of creativity can allay bigger fears and can open you up to new experiences and joys.

Heritage Illustrated Dictionary's definition of creativity, "to cause to exist, bring into being, originate," makes me think of giving birth. No baby is alike (identical twins, the exception), and each one is uniquely created from two unlike parents. A new being comes forth, with new possibilities, much like the creation of an idea, or an image.

Shouldn't that give us all hope? The potential for new ideas is within ourselves, and we are all potential creators or artists. You can look outside of yourself for inspiration, but your point of view, your sense of timing, and your personal interpretations are all the resources you need to spring forth with more extraordinary imagery.

WHAT IS AHEAD

I really hope that this process of learning about improving your photographs of children will be fun, inspiring, and relaxing and that you will learn to trust yourself above all. Not just trust yourself, but *value* and *honor* your true nature and your unique vision. You have something unique to contribute to the volumes of photographs that have been created over the years. I really believe that.

Through exercises about seeing and appreciating light and composition, you will expose yourself to a beauty you might never have appreciated. Learning to see the light has enhanced my life immeasurably, let alone my photographs of children. What used to be mundane, ordinary moments will be brightened by a more acute observation of your surroundings. A simple walk on the beach, in the park, and down the street will become a more enchanting engagement with life. That is what I truly hope for you.

Choosing children as your subjects can bring you so much insight into your own life. Children really are our teachers. They have all the wisdom that we come into the world with, and we can learn a great deal from them. They are honest, spontaneous, and often carefree little beings, to say nothing of their graceful gestures and penchant for playfulness.

In your interaction with children, in your deep observation of them in order to create lasting images, and in your exploration of their nature, you will be entertained and inspired. Hopefully that inspiration will come through in your photographs.

You are embarking upon, or continuing on, a very fruitful and rewarding path. Let's celebrate and begin!

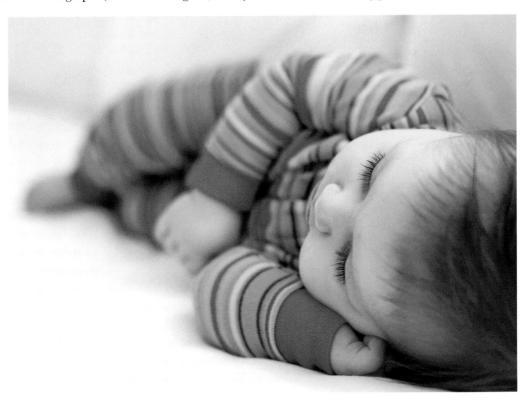

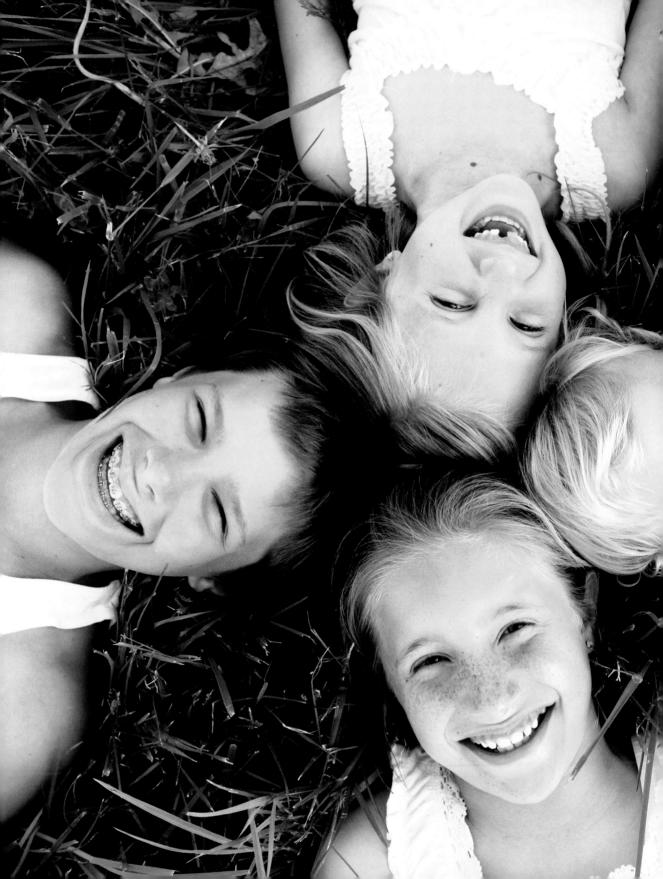

Advice for the Aspiring Professional Be Inspired Resources for Inspiration The Importance of Play

© Jeff Woods / www.jwportraitlife.com.

Photographing children is not for the faint of heart. Just ask any child photographer and you will hear enough stories about fussy newborns and stubborn toddlers that it might make you think twice about this genre of photography. Certainly, a bowl of fruit is much more cooperative than an 18-month-old. You can take your subject, set up the light just right, and spend all afternoon working the angles for the perfect shot of fruit. Not so with children.

Subject to every whim of the children they photograph, the children's photographer must be part Pied Piper, part parent, part psychologist, and, oh yes, part photographer. Making images of children can tax you in every possible way. Chasing them is a physical workout, while trying to coax a 2-year-old (or a 14-year-old, for that matter) to see things your way takes every psychological skill in your arsenal. Add to all this the technical challenges of learning photography in general and *your* camera in particular, and you might feel like giving up before you even start.

While photographing children may not be the easiest hobby or way to make a living, it might turn out to be one of the most rewarding adventures you ever pursue. Children simply are the most fascinating subjects. For example, young children haven't learned to be guarded and self-conscious; every thought and mood is right on their faces, which makes for images with great expression. Sometimes, you lift your camera at just the right moment, the planets align, and you get a shot of something so amazing that all the

rest of it falls away and you realize that you are in love with photographing children.

Parent or professional, being successful at children's portraiture requires you to get seriously in touch with your inner child, and to reach deep and find out what really inspires you both visually and emotionally. This chapter explores what you should know when beginning the journey into photographing children and offers a starting point for inspiration.

ADVICE FORTHE ASPIRING PROFESSIONAL

Judging by the popularity of digital cameras these days, it's apparent that photography has become an international pastime, if not a downright obsession. Prices and availability have made cameras more affordable than ever, and technology continues to enable point-and-shoot technology that results in amazingly good exposures. Even the camera in your phone can turn out a decent image. What is it, then, that pushes one over the edge to want to become a professional photographer, to make images that are better than the rest, good enough to be called, dare we say it...art? Has being a photographer been a lifetime dream? Or have the improving photographs of your own children caused friends and neighbors to ask if you'll photograph their kids? Do you have a true love for and patience with children? Are you willing to put up with a shy child who

note Perha

Perhaps you only have a point-andshoot camera — this is fine; this is

enough. Don't be intimidated by all of the latest advances and technology. The advent of digital photography will allow you to be more successful, more quickly than ever before. You will know when you need to advance, but to start all you need is a camera and a kid.

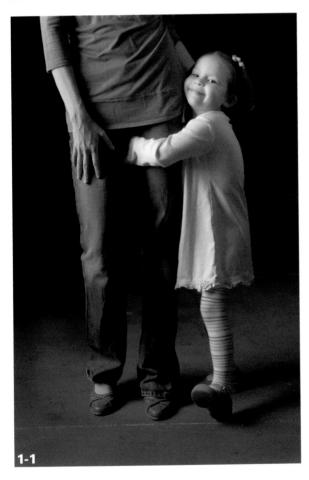

ABOUT THIS PHOTO Children can be among the most challenging and rewarding of photographic subjects. 1/250 second, f/3.5 at ISO 100. ©Allison Tyler Jones / www.atjphoto.com

doesn't want to leave their mother's side as in 1-1 or do you have the patience to wait for a newborn to fall asleep in her father's arms?

Before you dive head-first into the *business* of photography, think about what draws you in and what your aspirations are as a photographer. Taking time to evaluate your goals and motivations will inform every decision, whether it's the type of equipment you need or the kind of business you want to have.

Ask yourself questions such as

- Are you happy simply recording your immediate and extended family history and your friends' lives?
- Do you love to find the beauty and complexity in things around you?
- Who are you and where are you now as a photographer?
- Do you have enough technical skill to feel confident charging for your services or do you have a passion to photograph children but it's still more of a hobby at this point?

If you are considering photographing children as your career and don't feel a draw or some sense of enchantment toward little ones, you would be much better off finding another subject or specialty.

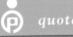

"A photographer's work is given shape and style by his personal

vision. It is not simply technique, but the way he looks at life and the world around him." ~Pete Turner, More Joy of Photography by Eastman A NOTE TO PARENTS A large percentage of photographers who decide to photograph children, either as a hobby or a vocation, do so when they become parents. Suddenly nothing is more profound than nurturing and observing your perfect and beautiful creation. Watching his or her every move and expression, the softness of the cheeks, and the miraculous achievements made each day is awe-inspiring. Using the downtime with a baby or young child and taking advantage of the miraculous moments helps you begin to really see this child. Morning light through the window, sleepy eyes, and grateful smiles suddenly become your favorite subject. Maybe you are a new parent now reading this book for ideas on ways to better capture your own child. Relax and enjoy the pleasure of making simple and spontaneous images of your child.

Who has a better potential to photograph your child than you? If you've ever taken your child to a mass-merchant photo studio to have his or her picture taken you know that those photographers aren't exactly tuned in to the individual child. As a parent, you have the inside track on your child's expressions, moods, and quirks. You have access to your child 24 hours a day allowing you to document the full range of activities, interests, and expressions.

But don't forget, your child also has the inside track on *you*. Somehow, kids just know how to push their parents' buttons, and a friendly photo shoot can go from, "Come on over here sweetie and let's take your picture" to "Stop touching your brother! Do you want a timeout?" Before you know it, you're ready to send them all to their rooms all because you wanted a nice photo for you to remember how much you love your kids.

And so, a caution to all parents out there. Remember why you're taking these photos in the first place. Be patient with those little ones (even when they aren't so little anymore). When you're first learning about photography you can be so worried about "getting the shot" that you forget to be in the moment with your child. Maybe you could photograph the neighbor's kids and she could photograph yours one time. You know you'll be nicer to her kids than you are to your own.

BE INSPIRED

Whether photographing children for fun or profit, paying attention to your creative journey, past and present, helps you develop your own individual style or signature. That signature enables you to create more captivating, inspiring, and authentic photographs.

If you ask ten people to photograph the same child in the same environment, you will see ten

different approaches and styles, because the eyes of the photographer are inevitably filtered by their past experiences and their personal vision (whether they know it or not). So why not hone in on this tendency and begin to develop your own vision and style? A good place to start is by studying the masters of the art of photography. Absorbing the work of other photographers can help you see what you do and don't like, which is

the very beginning of identifying your own style. Nothing is wrong with learning the way of the masters as you amble along your path. But as you do this, honor yourself, as you have embedded in your soul your own style and vision, which is waiting fervently to be noticed and tapped into.

Along the way, go ahead and learn the skills and approaches of others, but eventually your very own style starts to surface and resound. Yes, traces of this mentor or that mentor might show up in your images, but your own vision shines through as in 1-2. In fact, you can't hide it if you wanted to.

ABOUT THIS PHOTO This little boy wasn't about to sit still for his photo, so the photographer started telling jokes and snorting like a pig, which the boy thought was very funny. 1/250 second, f/3.5 at ISO 100. @Allison Tyler Jones / www.atjphoto.com

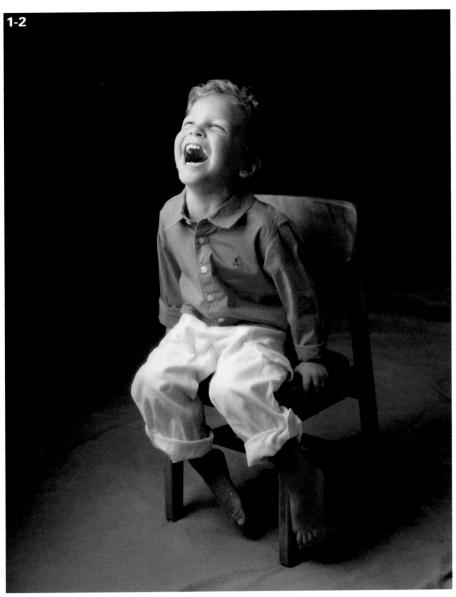

The photo in 1-3 is a new take on an old subject, the family portrait. Taking the best of classic portraiture and combining new elements of more photojournalistic style, this photo of a young family says something fresh and interesting about their lives together.

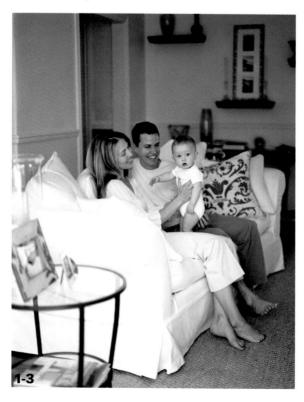

ABOUT THIS PHOTO A new take on the family portrait. Combining a more candid casual feel, this photographer has put her own spin on a timeless photographic tradition. 1/125 second, f/2.8 at ISO 400. ©Laura Cottrill / www.lauracphotography.com

As you discover different styles of portraiture, you might wonder how

different effects are achieved. Chapter 6 explores the most common types of children's portraiture from classic studio work to the emerging popularity of environmental portraits.

Do you ever take the time to think about what inspires you deeply? Do you love the mountains, the beach, or midtown Manhattan? Are you a dreamer or an athlete? Are you an avid reader or art aficionado? Do you love movies, bicycle rides, or traveling to Indonesia? All of your tastes, your passions, and your fascinations are what make you unique and who you are. Never take this for granted; in fact, refining, developing, and acknowledging your tastes and passions contribute greatly to your creativity.

Looking around your home might give you some clues as to what inspires you and what you love. Do you have a style? Is there a consistency to what is around you; for example, a theme such as nature or the arts? Are you surrounded by colors that you enjoy? Maybe you haven't seen that as a choice, and things are dictated by what was free, inherited, or chosen by others. Do you realize how much you are influenced by your surroundings? They feed into you, either negatively or positively, on a daily basis. Would you choose to photograph your surroundings, or do you have to go to another location or country to be inspired? Would you photograph a child in your home?

Many people believe that they don't have the choice to affect their physical environments for a myriad of reasons. However, your surroundings are a very important part of your creativity, so take steps every day to pay attention to what you create around you. This pays off when you design your photographs.

Another source for the roots of your creativity might be to remember what inspired you as a child. What did you have around you, in your bedroom, for example? Did you have collections? Can you see a theme running through any of your knickknacks? Did you have a favorite toy or a favorite place? In a whimsical portrait of a little girl in 1-4, the photographer used her childhood love of swings as inspiration.

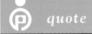

"Art is not so much a matter of methods and processes as it is an

affair of temperament, of taste, and of sentiment...in the hands of the artist, the photograph becomes a work of art...in a word, photography is what the photographer makes it - an art or a trade." ~William Howe Downs

ABOUT THIS PHOTO Take advantage of inspiration from your own environment. The chain on a porch swing acts a frame for this spunky little girl's cute face. 1/125 second, f/2.8 at ISO 200. ©Allison Tyler Jones / www.atiphoto.com

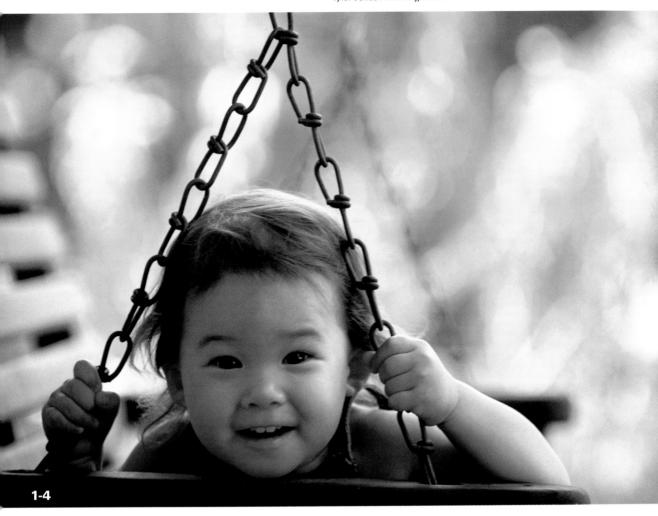

RESOURCES FOR INSPIRATION

Living an enriched life, living as fully as possible, and drawing from your intuition for guidance significantly affect what you reflect back into your photographic images. As a photographer of children, these things can affect your attitude, your taste, and your inspiration for creating more artistic and meaningful portraits. Here are some ideas that you might consider for further exploration.

■ Attending workshops. Nothing is more inspiring than spending days or a week with a group of fellow photographers as in 1-5. The atmosphere of sharing and cooperation in moving your photography forward is very motivating. Getting away from the demands of family and work holds you in a very special and protected place. Maine Photographic Workshops and Santa Fe Workshops come highly recommended for hobbyists and professionals alike. Professional trade organizations such as Professional Photographers of

America and its local affiliates hold lectures and workshops throughout the year, many of them focused on the business of photography. See its Web site at www.ppa.com.

- Working with mentors. Many accomplished photographers are willing to mentor photographers that are newer to the craft. Mentoring is more hands on and longer term than just taking a workshop.
- Reading books. Literature can call you into a sense of place with words alone, tickling your visual imagination. Books by other photographers can be provocative for aspiring photographers. Books of great artists and their lives speak to you from a valuable point of view and move you with their creations.
- Reading magazines. Magazines, by their very nature, can keep you current on styles of clothing and imagery. Whether it's the GAP kids ad or an editorial about child rearing, every page can give you new ideas on photographing children. Check out the new parenting magazines

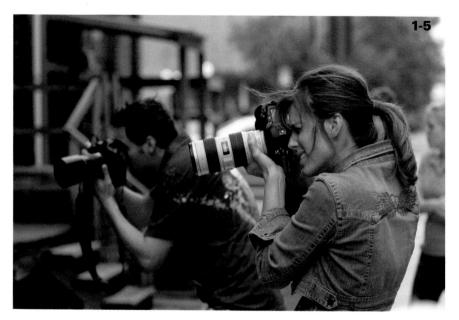

ABOUT THIS PHOTO Photography workshops are a great place to get some hands-on practice. 1/125 second, f/2.8 at ISO 200. © Allison Tyler Jones / www.atjphoto.com

Cookie and Wonder Time. These resources can give you insight into contemporary styles that might influence your work if you let them. Clip out your favorite photos and start an idea file to inspire you when motivation is running low.

- Visiting museums and galleries. In Julia Cameron's *The Artist's Way*, she encourages all artists to have "artist's dates" frequently. It is one thing to visit a museum and quite another to go with the intention of keeping your eyes wide open for inspiration. Taking another artist friend along can make it a fun adventure and inform your work in new ways such as use of color, composition, and light.
- Exploring culture. The performing arts of theatre, ballet, and opera can open your eyes and lead you to new ways of thinking and seeing. With a photographer's eye, watch the delicate and sophisticated lighting used to dramatize dance and theatre. Notice the gestures, movement, costumes, and fabrics. These observations might move you to experiment more with visual materials. Cultural experiences may influence you to seek out more dramatic lighting situations for your portraits of children.
- Traveling. An olive tree in your front yard doesn't hold a candle to one in Tuscany it just doesn't! Moving outside of your everyday environment makes you not only appreciate the styles and light of other cultures, but your own environment as well. New colors, new faces, styles, architecture, food, and foliage open up your own vision at every turn. Observe children of other cultures, their clothing and their activities. When you arrive

p tip

When watching a movie, view bonus features on the DVD you are

watching. Look for lighting setups in the movie scenes to give you great ideas on how to light your own work. Or just pay close attention to the lighting in the next movie you attend. Which direction is it coming from? Notice how each frame is composed just so. Movies directed by Martin Scorsese and Akira Kurosawa, among others, are known for their masterful lighting.

back home, you are forever changed, and you won't be able to help seeing your environment differently. These are the treats that enter your cells and change you forever, feeding your spirit and your vision.

- Checking out the Internet. Bookmarking your favorite photographer's Web sites or blogs is the virtual way to keep an idea file. Join an online forum to share your work in a cooperative spirit with other photographers from around the world. The critique and encouragement from these forums can help you improve very quickly. The Internet is so of-the-moment, giving you access to the latest trends in child photography, such as the contemporary-style portrait in 1-6.
- Doing creativity exercises. You don't have to take a class to do creative exercises. Make up your own using all the inspiration you've gathered from the previous suggestions. Choose your own subjects, but narrow it down, be specific, and work within a time-frame. Work your way through the assignments at the end of each chapter in this book and you might be surprised at how you start examining and appreciating what you see every day and how that influences your work.

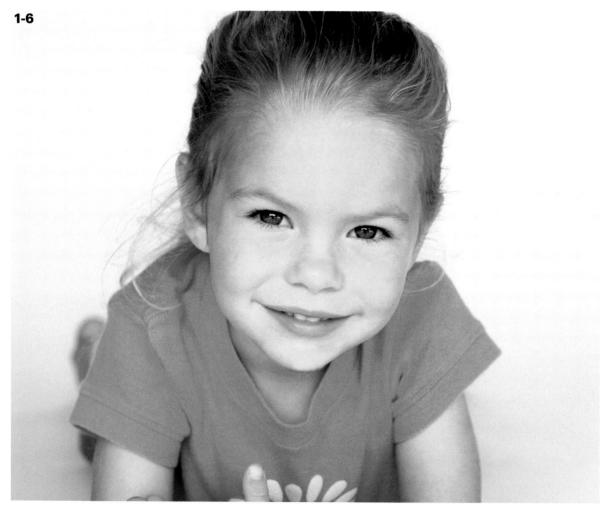

THE IMPORTANCE OF PLAY

Can you remember how important pretending was when you were a child? Pretending was a necessary part of playing, whether it was about cowboys, *Star Wars*, or dolls. Almost everyone eventually learned that pretending was for children and sacrificed this behavior for the sake of growing up.

Your ability to play is an essential skill when photographing children. As you get down on your hands and feet, at their level as in 1-7, seeing life from their perspective and entering into their world of pretend, how can your photography not be influenced?

ABOUT THIS PHOTO Take a photo by lying down on the floor at eye level with the baby. 1/640 second, f/2.8, ISO 400. ©Stacy Wasmuth / www.bluecandyphotography.com

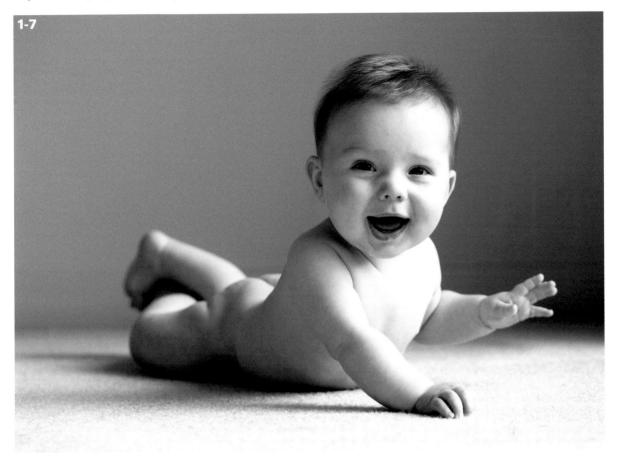

Try this creative exercise: Make 20 photographs out of the following subjects: an egg, texture, harsh light, color, junk as art, window, a face, black, white, shadow, reflection, round, smooth, and partnership. Include a child in each photograph.

Children, as a whole, are very good judges of character and they can smell a phony a mile away. If you really aren't interested in them, they know it. Take the time to sit with them and let them get used to you. Ask them to show you their room, as in 1-8 or their favorite toys. Children are no different from adults in this aspect; they

"Pretending is a great way to exercise our imagination. Pretending

takes us back to our kidhood... it unleashes our creativity." ~Kevin Eikenberry

ABOUT THIS PHOTO After being given a tour of this young boy's bedroom, the photographer noticed how proud he was of his plane collection and took advantage of an unusual angle to get the shot. 1/250 second, f/2.8, ISO 400. ©AllisonTyler Jones / www.atiphoto.com

ABOUT THIS PHOTO Let kids sit with their parents for a bit and take this time to capture a few tender moments of parent time before you put the kids through their paces. 1/250 second, f/2.8, ISO 100. ©AllisonTyler Jones / www.atjphoto.com

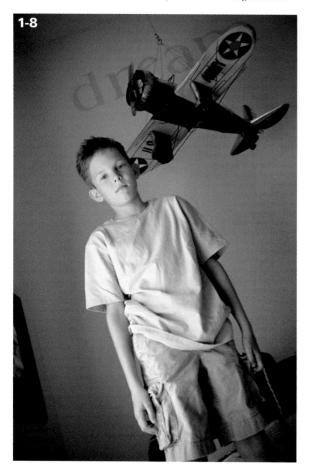

1-9

like people who are genuinely interested in them. Ask them about school, their teachers, friends and interests. Let them look over your camera and show them a few shots throughout the shoot so they feel a part of what is going on. If you are working with a particularly timid child, allow them to first get comfortable by letting them sit with mom or dad for a bit as in 1-9, before they are expected to perform for you.

Taking time to play a little and see the world from the perspective of the child you are photographing can only help you expand your vision in capturing real, candid images. Spending a little time on the floor can also change your viewpoint by not only getting on the child's level but by allowing you to explore new angles and approaches to your subject. Take the chance! You might like it down there!

p quote

"...you don't have to travel to SEE.
One of my favorite assignments is

to shoot a roll of film within 20 feet of your bed." ~Ruth Bernhard

Assignment

Mirror, Mirror on the Wall

You should understand that who you are and what has inspired you shine through in the portraits you create. After reading this chapter, you have perhaps given some thought to what influences you, what your tastes are, and what your passions are. Now that you are more aware, create a children's portrait that reflects some of who *you* are and your style. This can be shown by your choice of colors and tones, by clothing, background environment, or general attitude. Use your imagination and try to come up with something really unique, something that separates you from the crowd.

This photograph of Nate was taken at his family home. The photographer ran around with him and his sister for the better part of an afternoon photographing them in their natural habitat. When the photographer spied the lineup of dinos on the windowsill, she asked the boy if he would like a photo with his "friends." As she lifted her camera, the photographer noticed part of Nate's dad in the reflection in the window behind the boy, which gives the image added depth and meaning 1/640 second at f/2.8, ISO 400.

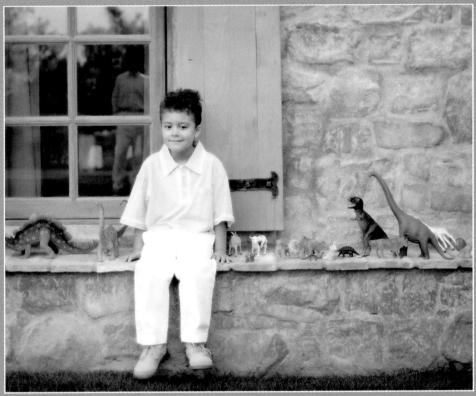

©Allison Tyler Jones

Remember to visit www.pwassignments.com after you complete this assignment and share your favorite photo! It's a community of enthusiastic photographers and a great place to view what other readers have created. You can also post comments, and read other encouraging suggestions and feedback.

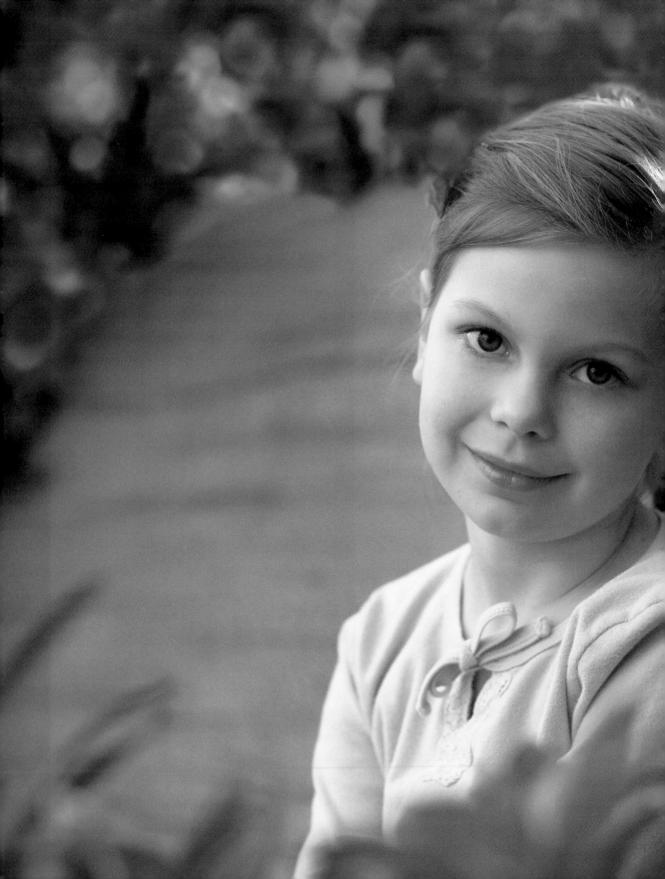

You Don't Need to Know Everything
Going Beyond Automatic: Exposure Basics
Shutter Speed
Aperture
ISO
Depth of Field
Using Program Modes

©Ginny Felch / www.silverliningimages.com

WHAT DO YOU WANT?

While intimidating at first, learning the more technical aspects of photography and how to use your camera will, in the end, give you more tools to create with. These tools help you repeat those lucky shots you get from time to time and, later on, to realize your creative vision for photographing children.

If you are a beginner, try working through the assignments at the end of each chapter using your camera's automatic mode and auto focus. Then, when you feel the need to stretch a bit, you can decide whether you want to proceed and make

more choices by placing your camera into specific program modes or possibly even working in manual mode. If you have a point-and-shoot camera that limits your choices, you can still apply much of the information in this book. As you read through the book, notice that under each photograph there is a description of the image as well as technical information provided that gives you a clue as to how the photographer got that shot, as in 2-1. This chapter helps you understand what those numbers mean and how they can affect the look of every photograph you take.

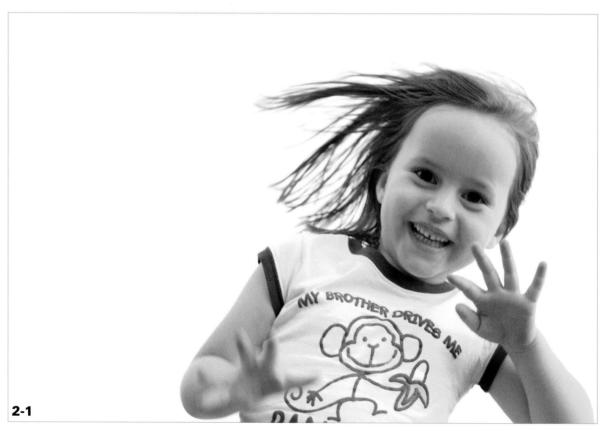

ABOUT THIS PHOTO This little girl was caught, midair, on a trampoline. The shutter speed was not quite fast enough to completely freeze the action but the blur in her hand and hair gives a sense of movement to the image. The camera was in full Auto mode. 1/200 second at f/2.8, ISO 250. ©AllisonTyler Jones / www.ajtphoto.com

auote

"Only a fraction of the camera's possibilities interests me — the

marvelous mixture of emotion and geometry, together in a single instant." ~Henri Cartier-Bresson, Aperture 129, Fall 1992

YOU DON'T NEEDTO KNOW EVERYTHING

You don't have to know everything about the mechanics of your camera to make huge improvements in your photography. Just learning to see light better and working on your composition will yield amazing results in your work. However, if you plan to pursue photography as a more serious hobby or are considering making photography of children a sideline or full-time career, you must learn the more in-depth workings of your camera. Learning camera technique allows you to get the photo you envision and prevent circumstances that result in bad photos.

Beginning photographers are consistently befuddled about the issues of exposure, depth of field, and settings on their cameras, and while new technology makes it easier than ever to make a proper exposure, the bells and whistles that come on today's cameras can further compound the problem.

Q quote

"When asked what camera he used: 'You don't ask an artist what

paints and brushes he uses. You don't ask a writer what typewriter he uses — anyway, I regard the camera as an aid'" ~Man Ray

Even when cameras had a single metering device, exposure and depth of field were still baffling. Often intimidated by such terms as f/5.6, 1/60 second, and depth of field, some would-be photographers gave up before they even started. Just knowing that this part is confusing to just about everyone should help you feel a little better. Unfortunately, there is no substitute for practice

and the more you practice with your camera settings, the quicker you learn to use your camera. If you have already advanced to other modes (besides Auto) on your camera, the following information should help you to better understand what you are doing and why.

GOING BEYOND AUTOMATIC: EXPOSURE BASICS

If you are using Auto mode, you have probably discovered that it most often results in a pretty decent photograph. The key words here are *most often* — but not always. When Auto isn't giving you the results you're looking for, you may need to change the settings on your camera to capture your subject differently.

Cameras come from their manufacturers with set defaults that allow them to create a good image in most situations. That, by definition, means that there are times that you need to do something more specific to the settings in your camera to accommodate the situations you are shooting in. For example, maybe you want to capture your child dancing in a rain puddle and freeze every single drop of water in the splashes she's making. Or, maybe you want to get a shot of your boys running through a meadow of grass with the golden light in their hair but still capture light in their faces. Both of these settings would present some problems for the typical camera in Auto mode.

If you are using Auto mode, you may have also discovered that it often results in a photograph with everything in focus — foreground and background — which is the default choice made by the computer elements in your camera. What if you want to make an image more like many of the images in this book where just a little bit of the photo is in focus and the background is blurred? All of these situations can be achieved by learning more about exposure.

Exposure is what happens when the shutter on your lens opens and lets light into your camera, exposing the film or digital sensor to create an image.

There are three key elements to exposure: *shutter speed*, *aperture*, and *ISO*. Each of these elements, set correctly, creates a properly exposed image. Understanding these elements so you can use them in creative ways can change the look of a photograph dramatically.

SHUTTER SPEED

Shutter speed is relatively easy to understand. It is, essentially, time — the amount of time that your shutter is open to light to record an image on your camera's digital sensor. It is measured in fractions of a second, such as 1/30, 1/60, 1/125, and 1/500.

How long the shutter is open determines whether the image will be tack sharp or soft and blurry. A

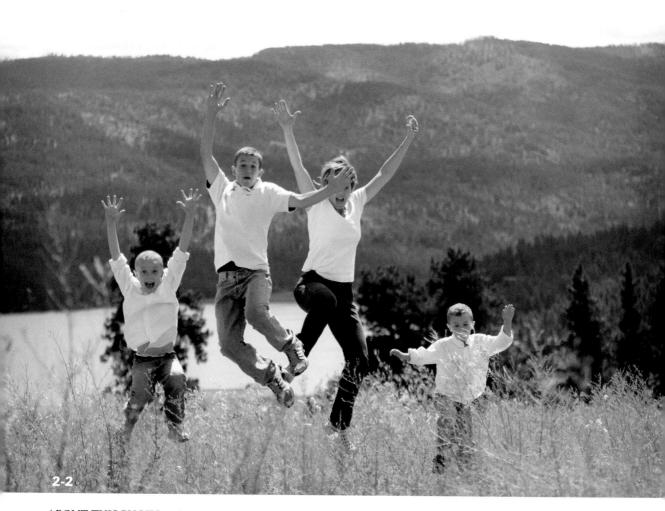

ABOUT THIS PHOTO The shutter speed of 1/800 second was plenty fast enough to freeze these boys and their mom in midair. 1/800 second at f/2.8, ISO 100. ©Allison Tyler Jones www.atjphoto.com

fast shutter speed, such as 1/1000 second, freezes movement; whereas a slow shutter speed, such as 1/50 second, blurs movement. So, the longer the shutter is open, the more likely it is that movement will be recorded. And, the faster the shutter speed, the more likely it is that any movement will be frozen. In most situations, you want your subject to be sharp and in focus so your shutter speed needs to be fast enough to make that happen. For example, if you want to freeze your son at the peak of his jump off the diving board, a fast shutter speed is called for. If, instead, you'd like to show the swish of a little girl twirling in her tutu, you might want to try a slower shutter speed. A fast shutter speed of 1/800 second was used to capture the family in figure 2-2 in mid-leap.

MOVEMENT

Choosing your shutter speed then, is based on movement. Is your subject a wiggly preschooler or a more mature adolescent? With the older child, you can get away with a slower shutter speed and still get the shot. But, remember, your subject isn't the only person who's moving. If you are holding the camera in your hands (also known as shooting handheld) you have to take your own movement into consideration. Many shots have been ruined due to camera shake, which is when the photographer moves causing the camera to shake resulting in a blurry photo. However, sometimes (as in 2-3), a slow shutter speed with a little blur can have a pleasing effect.

If you examine the blurry photo carefully, it's usually easy to tell when it's camera shake versus a moving subject because camera shake blurs the whole photo, whereas in a photo where the subject was blurry because they were moving, everything except the subject is usually in focus.

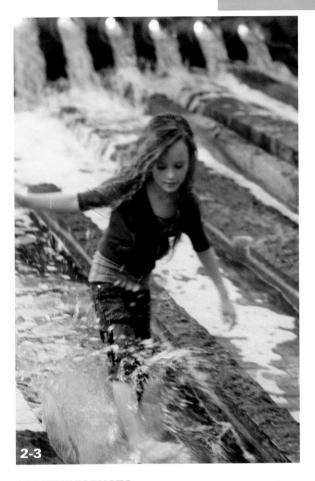

ABOUT THIS PHOTO The shutter speed of 1/60 of a second was too slow to freeze the droplets of water that the little girl was kicking up and camera shake caused the rest of the photo to be out of focus. 1/60 second at f/2.8, ISO 100. ©AllisonTyler Jones / www.atjphoto.com

Most people cannot hold a camera steady with a shutter speed of less than 1/60 of a second and if you move around a lot while you are shooting, you might be better off using 1/100 of a second or faster. In other words, if your camera (in an Auto mode) chooses 1/60 or 1/200 or faster, you should be able to hold your camera steady without a tripod, which is explained in more detail in the next section. If your camera selects a shutter speed below 1/60 and you don't have a tripod, try the following tricks to steady your camera:

ABOUT THIS PHOTO This flying girl was frozen in midair using a fast shutter speed. The photographer stood right behind the girl's father as he tossed her into the air. 1/500 second at f/2.8, ISO 100. ©Allison Tyler Jones / www.atiphoto.com

- Take a deep breath, let it go, and as you exhale, press the shutter.
- Rest or lean the camera against a conveniently located still surface such as a fence post or wall.
- Hold your arms very tightly against your body and widen your stance, making your body into a kind of tripod.

Because this is a book about photographing children, it is assumed that, for the most part, you will be hand-holding your camera, as working with tripods and chasing toddlers don't often mix.

RULE OFTHUMB: SHUTTER SPEED SELECTION

A good rule of thumb for choosing a shutter speed that assures your subject is in focus is to select a shutter speed that is at least the reciprocal of the lens' focal length. On the front of your lens you will find numbers such as 18-70mm or 50mm. For example, if you are shooting with a 50mm lens and you want your subject in focus, you don't want to shoot with a shutter speed any slower than 1/60 second; you can always set a faster shutter speed, you just don't want to go slower because there is more chance of blurring the image. If you have an 18-70mm zoom lens you should be shooting with a shutter speed of no less than 1/100 or 1/125; either of these is fine. So, determine the focal length of your lens, such as 50mm, and set your shutter speed accordingly. If you aren't sure what the focal length of your lens is, you can find it printed on the barrel of your lens.

Table 2-1 offers some shutter speed settings that are a good starting point to achieve non-blurry photos in a variety of child photography situations.

FREEZING MOVEMENT

If you are photographing fast-moving subjects such as children swinging, running, riding, and so

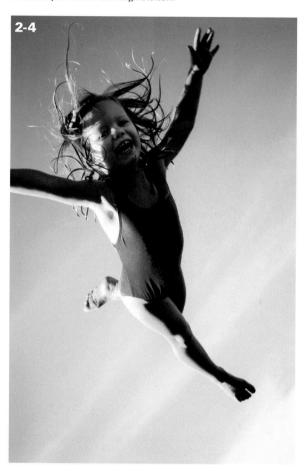

on, you might need an even faster shutter speed to freeze the movement. Shutter speeds of 1/250, 1/500, 1/1000, and faster stop almost any action. The movement in the photo shown in 2-4 of a little girl being tossed into the air by her dad was frozen by a shutter speed of 1/500 second.

Table 2-1

Common Shutter Speed Settings

_	
Situation/Subject	Shutter Speed
Sleeping Baby	1/60 to 1/125
Roaming Toddler	1/125 to 1/250
Kids Running	1/250 to 1/500
Child on Swing	1/500 to 1/1000

SHUTTER SPEED TIPS Here are some shutter speed tips for when you are hand-holding your camera:

- •Too slow: 1/4, 1/8, 1/15, 1/30
- 1/60 second is borderline if you don't have steady hands.
- Fast enough: 1/125, 1/250, 1/500, 1/1000, 1/1500

To freeze movement, use these shutter speeds as a good starting point:

- •Too slow: 1/4, 1/8, 1/15, 1/30, 1/60
- 1/125 is borderline when the action is very fast.
- Fast enough: 1/250, 1/500, 1/1000, 1/1500

BLURRING MOVEMENT

If you're feeling a bit more adventurous, you might want to try blurring the movement of your subject on purpose for a creative effect. Kids on a playground or a little girl jumping on her bed as in 2-5 are all good subjects for trying your hand at blurring movement in your photos. Choose a slower shutter speed but not too slow; you want the moving subject to blur but everything else to be in focus.

APERTURE

Aperture in photography refers to the opening in the lens of your camera. When the shutter is released and light is allowed to come through the lens into your camera, the aperture determines how much light is allowed in. Aperture is measured in *f-stops* such as f/2.8, f/5.6, f/8, f/11, f/16, and so on. The smaller the number, the larger the opening in the lens — f/2.8 is much larger opening than f/16.

ABOUT THIS PHOTO This little girl had pulled on her tutu and was having a great time jumping on her bed. Working with a slow shutter speed allowed the action to blur giving a sense of movement to the photo. 1/40 second at f/2.0, ISO 400. ©AllisonTyler Jones / www.atjphoto.com

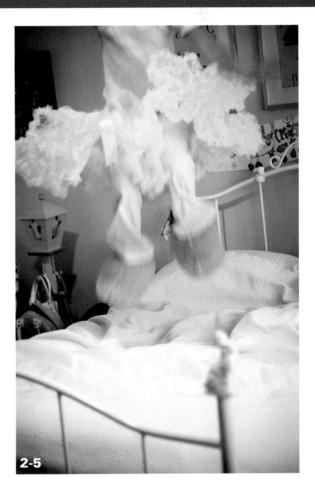

Thinking about shutter speed and aperture together is easier when you think of your eyes. Your eyelid is the shutter of your eye: It is either open or closed. Your pupil is the aperture of your eye. When it's bright outside, your pupil contracts (or closes down) to let less light into your eye. When light is low, your pupil dilates (opens up) letting in the maximum possible light so you can see. What do most people do when they can't see something very well? They squint! They are closing down the aperture of their eye to allow more of what they are looking at to be in focus. This is an easy way to remember how aperture works when the numbers get confusing.

The aperture affects the look of your photo more than any other element of exposure because the aperture controls the depth of field, which is explained later in the chapter.

ISO

On most digital cameras there is a button or menu setting that enables you to choose the ISO setting. ISO, which stands for International Organization for Standardization, refers to the light sensitivity of your camera. ISO ratings originally applied to film speeds, such as 200, 400, and so on. Just like film, the higher the number rating, the more sensitive the sensor on your digital camera is to light. For example, if you need your camera to be very sensitive to light, such as when shooting in low light, then you'd want to choose an ISO of 800 or higher.

The ISO setting is often the easiest variable to manipulate when you need a specific aperture and shutter speed combination.

An easy way to remember which way f-stops go is to think of f-stop

numbers as fractions — where f/2.8 becomes 1/2.8 and f/11 becomes 1/11 — then it makes better sense for the smaller numbers to be a larger opening.

Generally speaking, in order to keep your photographs crisp, you should use a lower ISO. On most cameras, ISO 100 is the lowest setting. When you use higher ISO settings — generally 800 and up — you begin to see *noise* in your images, which is a grainy appearance.

Check out Table 2-2 as a starting point for choosing ISO settings in different situations. Most cameras can deliver excellent, noise-free results when using ISO settings of 100, 200, and 400. The settings in the table are only a starting point for various situations you may find yourself in and are designed to allow for high-enough shutter speeds to allow you to hand-hold your camera.

Table 2-2

Common ISO Settings

Situation	ISO Setting
Sunny Day	100
Porch Light	200
Overcast Day	200 to 400
Window Light	400
Indoor w/o Flash	800 and up
Stage Performances w/o Flash	1600
Indoor Sporting Events w/o Flash	1600

DEPTH OF FIELD

The aperture or f-stop you choose determines the depth of field in your photograph. Depth of field is the field or area in the photograph that is in focus. A photograph with everything in focus from front to back had a long (or deep) depth of field as in the photo of a family at the beach in 2-6. A photograph where just the family is in focus but everything else, foreground and background, is out of focus would have a short (or shallow) depth of field, as in 2-7. Have you noticed that many of the

ABOUT THESE PHOTOS In 2-6 you can see a photo of a young family photographed at the beach using an aperture of f/22 at 1/50 second, giving sharpness to the entire image. In 2-7, the same family was photographed using an aperture f/2.8 at 1/3200 second, causing blurring of the background and all else but the subject, ©Ginny Felch / www.silverliningimages.com

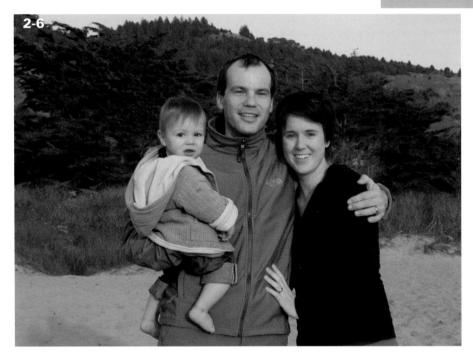

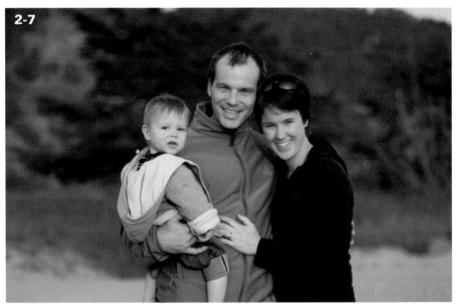

note

The higher you set your ISO, the greater chance of introducing digi-

tal noise into your image. Digital noise may be used for artistic effect, but if you are starting out, try to keep your ISO as low as possible.

portraits that grab your eye are not sharp throughout? Usually, most of the subjects are in focus, but the foreground and background are out of focus. This is how your eyes perceive things as well. If you are looking at someone, the foreground and the background are not sharp.

In 2-8, you see a simplified diagram of how the numbers of the f-stops relate to the depth of field.

Here are few more important items to know regarding depth of field:

Long depth of field. Apertures of f/8 and smaller (f/11, f/16, f/22) all produce a photo with a reasonably long depth of field. These settings are perfect for shots where you want to include the environment as part of the image, as in photographing a child in his or her bedroom where you want to include the detail of all the toys. A longer depth of field is also good when shooting groups of people, as in a family group, so that everyone in the photograph is in focus from the front row to the back. When you see images of children at a distance or portraits in which all things in the image are in focus, the photographer is often using smaller apertures of f/11 to f/16 or smaller, which results in a long depth of field. This technique is often referred to as shooting closed down, meaning the aperture of the lens is smaller and more closed down.

A short depth of field is most often preferred by portrait photographers.

Porthole (foggy)

Aperture is open wide
What you focus on is sharp; all else is not
Good for portraits; selective focus

Pinhole (sharp)

Aperture is small All in view is in focus Good for landscapes

2-8

ABOUT THIS FIGURE If you can picture in your mind the lens opening at small apertures versus the lens opening at larger apertures as in this figure, it will be easier for you to understand how to set your camera.

p tip

When you are photographing a child, it is helpful to know that

focusing on the nose generally ensures that you have the entire face in focus

■ Short depth of field. Apertures of f/2.8, f/2.0, and even f/1.4 or f/1.2 are not uncommon in short depth of field photos. These settings work well for isolating your subject from the background or for highlighting the bits and pieces of a baby or child, as in 2-9. The f-stops used on most of the photographs in this book were anywhere from f/1.4 to f/5.6. That isn't much of a range, considering that there are so many other possibilities (f/8, f/11, f/16, f/22, f/32, and some stops in between). Throughout the book, you can see many portraits of children where you can clearly see their faces yet the background is blurred; in these instances, the photographer was using larger apertures, such as f/3.5 to f/2.8 or larger. The larger apertures create a short depth of field. This technique is often called shooting wide open,

meaning the aperture is as wide open as it can be. The photo in 2-10 was shot wide open with an aperture of f/3.5. The foliage and the entire background are out of focus, leaving just the children to catch your eye.

ABOUT THIS PHOTO A short depth of field highlights the sassy glasses of this fashion-forward preteen girl. 1/200 second at f/2.8, ISO 100. ©Allison Tyler Jones / www.atiphoto.com

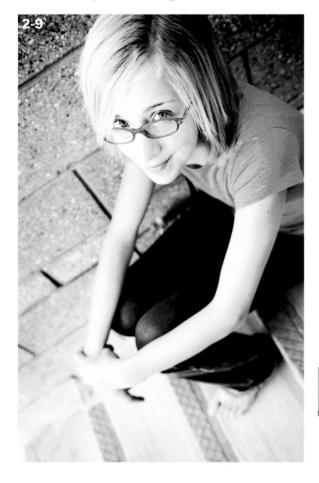

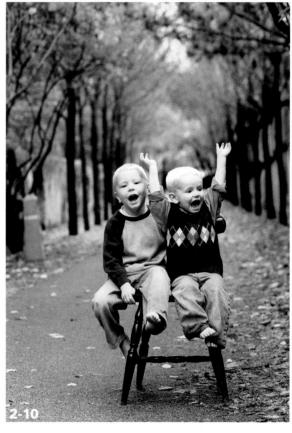

ABOUT THIS PHOTO These silly brothers were photographed with a short depth of field allowing the background to blur out of focus, keeping your attention on the kids. 1/320 second at f/3.5, ISO 250.

©Stacy Wasmuth / www.bluecandyphotography.com

"Photographs are not made by cameras, which are only tools. We make images with our hearts and minds. What must be brought to photography is an ever-open and seeking mind." ~Arnold Newman

USING PROGRAM MODES

The previous discussions of shutter speed, aperture, and ISO are to give you an idea of how your camera works so you can manipulate it for your own ends. Nobody is expecting you to jump in with both feet and only shoot in Manual mode from now on. You can move beyond just plain Auto mode without having to go completely manual. Many cameras have program modes that move beyond the general Auto mode and give you more control over your final image. These program modes allow you to make some decisions about the type of subject matter you want to photograph and match your camera's program mode to the subject you are photographing. Table 2-3 is a list of some common program modes your camera might offer.

Your camera is a precision instrument that has been designed to successfully capture your image.

Let it do some of the work for you when you are learning. The program modes go beyond the allencompassing Auto mode and increase your chances of success for specific shooting situations.

PORTRAIT MODE

Choosing Portrait mode tells your camera that you want your subject in focus but everything else can be out of focus. Portrait mode favors a short depth of field where possible. If you make the same image twice, using Auto and then using Portrait mode, you should see a difference in what is in focus. Portrait mode is a precursor to using Aperture Priority, which gives you more control, allowing you to choose the exact aperture you require and letting the camera set the shutter speed.

Table 2-3

Common Camera Program Modes

Program Mode	Indicated by	Results
Fully Auto mode	A or P	Your camera makes all the decisions.
Portrait mode	1	Camera favors a short depth of field to blur background.
Sports mode	R	Camera favors a fast shutter speed to freeze action.
Landscape mode		Camera favors long depth of field (everything in focus).
Macro mode		Camera favors a short depth of field and macro lens settings for very close-up shots.
Shutter Priority mode	SorTv	You choose the shutter speed, the camera sets the aperture.
Aperture Priority mode	A or Av	You choose the aperture, the camera sets the shutter speed.
Manual mode	M	Total control: You set everything, shutter speed, aperture, and ISO.

SPORTS MODE

Sports mode defaults to a fast shutter speed to allow you to capture fast-moving children or the action in sporting events. This program mode is a precursor to using Shutter Priority, which allows you to set the exact shutter speed required and letting the camera take care of the aperture.

LANDSCAPE MODE

Landscape mode favors long depth of field settings to allow everything — foreground and background — to be in focus. This mode is not used a great deal in child photography but might come in handy when photographing children in an outdoor setting where you want to include the detail in the background or when capturing a large group photo of a family so that everyone is in focus.

CLOSE-UP OR MACRO MODE

Macro mode is great for isolating the bee that just landed on a flower but more applicable for the children's photographer is using this setting to get in close on baby toes, eyelashes, ears, and fingers.

APERTURE PRIORITY MODE

Many digital cameras have a mode called Aperture Priority mode, often abbreviated as A or Av. This mode enables the photographer to decide the aperture or f-stop, and the camera correspondingly chooses the correct shutter speed to give you a proper exposure. Aperture Priority is a better choice than Portrait mode because it gives you more control over your image. You are able to set the exact aperture you need and let the

camera do the rest. Far from being a gimmicky Auto mode, Aperture Priority is used by many professional portrait and wedding photographers all over the world.

This mode is a great choice for general use but particularly for children's portraits. It simplifies the process, allowing you to be spontaneous while ensuring an accurate exposure. You already have enough on your mind when working with children without having to concentrate on camera function! All you need to decide is what should be in focus (short versus long depth of field).

Choose which aperture/f-stop you want to use. You can see that the larger f-stops (smaller numbers) — that is, f/4 and f/5.6 —

larger f-stops (smaller numbers) — that is, f/4 and f/5.6 — give you a pleasing depth of field for portraits. Your best way of deciding which one to use is through experimentation.

Many photographers are now stylizing their portraits using an even larger f-stop, such as f/1.5 or even f/1.2. This creates a more selective focus and really throws all else out of focus except for what you choose as your main subject. It can be the face; it can be the foot. Ah, creative liberty! Just remember that when you are shooting this wide open, your margin for error is very slim; it's easy to get everything out of focus so practice, practice, practice!

Manipulate your depth of field by playing with your aperture settings.

Shoot the same subject in the same setting and only change your aperture for each shot. This gives you an instant library of how the aperture of your lens affects your images.

ABOUT THIS PHOTO Depth of field in this photo is so short that the right eye is in focus while the left eye is out of focus. 1/250 second at f/2.0, ISO 100. ©AllisonTyler Jones / www.atjphoto.com

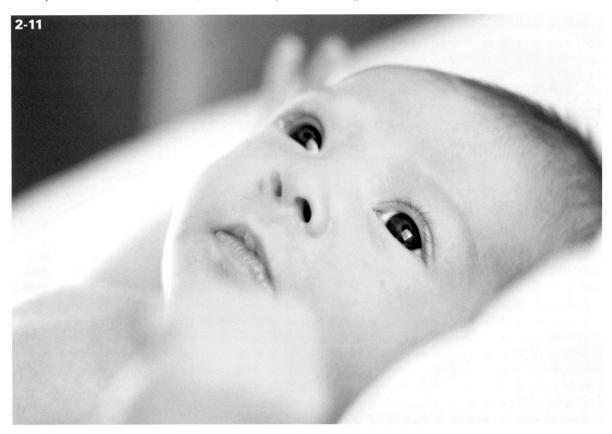

When shooting portraits up close with a very short or shallow depth of field, it's a good idea to focus on the eye closest to the camera, as in 2-11, which captures your attention immediately on the subject's eye and then allows your attention to drift into the rest of the photo. If you look closely, you'll see that the baby's right eye (closest to the camera) is in focus, while her left eye is slightly out of focus.

SHUTTER PRIORITY MODE

Shutter Priority mode allows you to determine the best shutter speed for your subject and the camera does the rest. So, if you are shooting your daughter's softball game and you want to freeze the big run for home as in 2-12, set your camera on Shutter Priority mode, dial in a fast shutter speed, and let the camera take care of the rest.

x-ref

If you find that your creativity is limited by the choices on your cam-

era (if it is a point-and-shoot with Automatic only), it might be time for you to consider a more advanced camera. Check out Chapter 9 for recommendations on cameras and lenses.

ABOUT THIS PHOTO

The split second of sliding for home is captured by a fast shutter speed. 1/800 second at f/5.0, ISO 100. ©AllisonTyler Jones / www.atjphoto.com

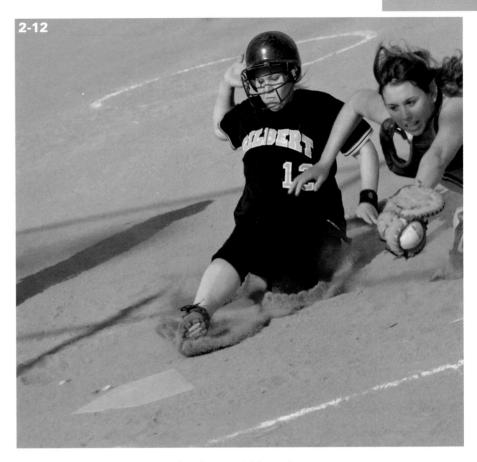

WHAT DOYOU WANT?

If you've made it this far in the chapter, give yourself a pat on the back. That is a lot of technical information to wade through, but your patience will pay off if you learn to practice even one or two of the techniques discussed. The important thing to remember is that every one of these topics is just a tool in your image-making arsenal. Before you shoot your next photo, ask yourself this question, "What do I want?" Do you want a gorgeous close-up of your toddler with the

background blurred so you can concentrate on her face? Perhaps you'd like to freeze your 12-year-old jumping his skateboard off the neighborhood ramp. Rather than just letting your camera do its thing, why not take control and start making some informed decisions about the images you are making? Set your aperture with your subject in mind rather than just to let enough light in to get the shot. When you start to choose your camera settings on purpose and with your subject in mind, you will be amazed at how fast your photography improves.

Assignment

Depth of Field and Selective Focus

This assignment is about learning to make a photograph with depth of field. For this assignment, try to get a beautiful photo with *selective focus*, meaning your subject should be sharp and all else falls out of focus. Photograph a child or children setting your camera on either Portrait mode, if you have it, or Aperture Priority. If you use Aperture Priority, select an aperture (f-stop) that is a small number, such as f/4.0 or lower. If you focus on your subject, that f-stop ensures a shorter depth of field. You will see the difference in a portrait taken with these settings compared with auto focus, where everything tends to be sharp.

Here you can see a photograph of a young girl that is all about color, but the depth of field really sets her apart from the golden background. Notice that the background is out of focus, offsetting her in sharp focus. It is a great way to hone in on your subject and separate it from the background, as you can see here. The lack of focus on the background also gives the portrait a more painterly look.

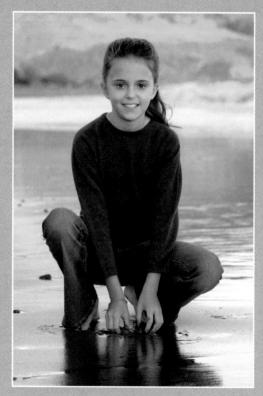

©Ginny Felch / www.silverliningimages.com

Remember to visit www.pwassignments.com after you complete this assignment and share your favorite photo! It's a community of enthusiastic photographers and a great place to view what other readers have created. You can also post comments, and read other encouraging suggestions and feedback.

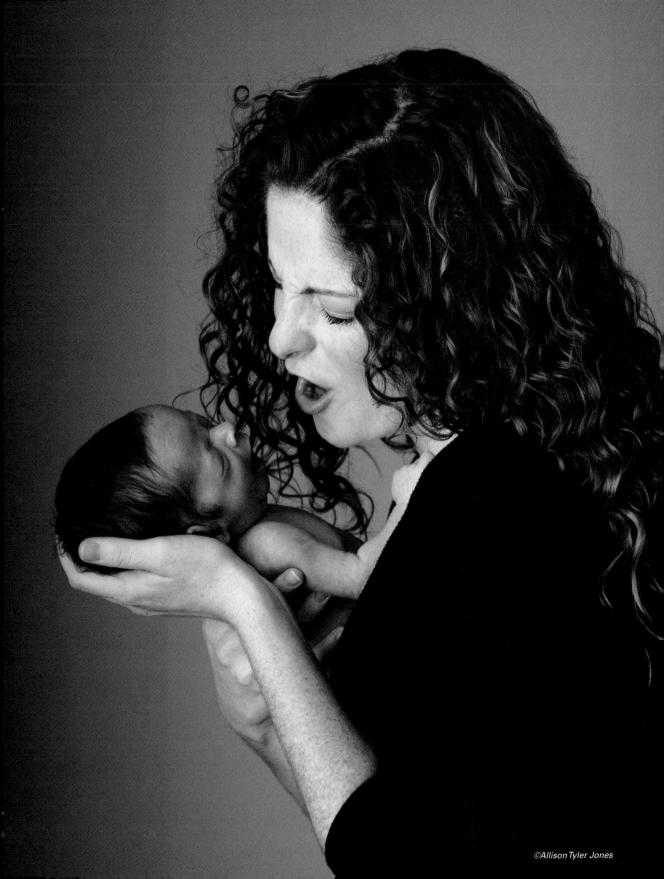

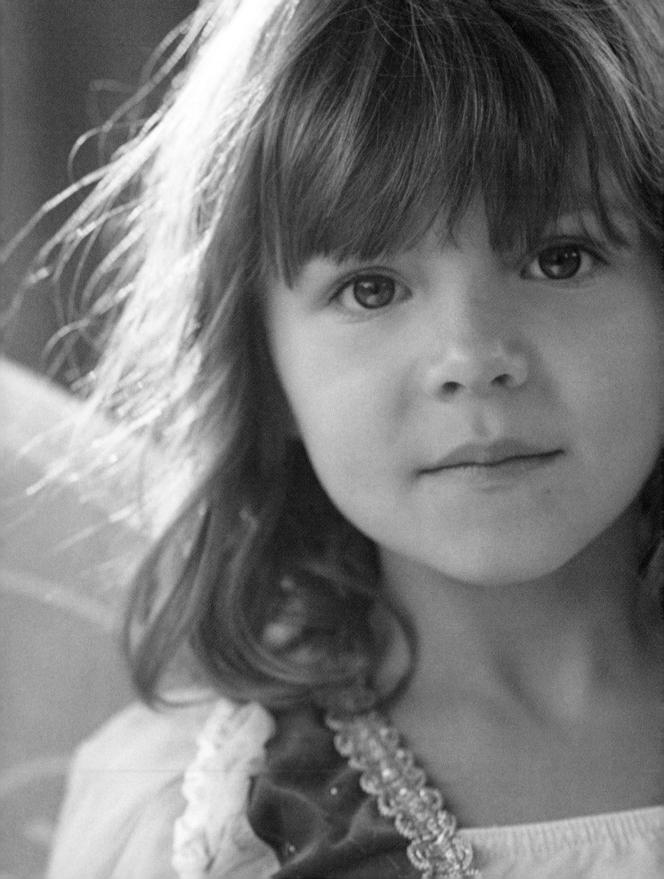

LEARNING TO SEE LIGHT

AVAILABLE LIGHT

THE SWEET LIGHT: DAWN AND TWILIGHT

USING REFLECTIONS AND SHADOWS

PHOTOGRAPHING IN FOG OR WITH OVERCAST SKIES

FINDING CONTOURING LIGHT

USING SOFT WINDOW LIGHT

KNOWING WHEN TO COMPROMISE

©Laura Cottril / www.lauracphotography.com

Learning to see light not only improves the looks of your photos but, more importantly, it changes how your photographs "feel." Used correctly, light can add an emotional element to an otherwise ordinary photograph.

To create dramatic and sensitive photographs, you must simply fall in love with light. Slow down and look at the light around you, right now, this minute. Are you near a window with light spilling into the room? Or perhaps you are reading by the soft glow of a table lamp. Look at the objects in the room and see how their shadows are cast by the angle of the light falling on them. Once you start noticing, you will begin to see the effect of light everywhere you go. It changes your life, whether you have a camera in hand or not. You begin to see how light reveals itself in a soft glow or in diagonal shafts, illuminating the shapes and forms of everything before you. You see the light manifest mood, drama, and dreaminess. You might notice how warm, afternoon light tends to exaggerate color, while the light of dawn, just before the sun crests the horizon, tends to diminish or soften color.

LEARNING TO SEE LIGHT

Ruth Bernhard, a renowned photographer who died in 2007 at the age of 101, once said, "Light is my inspiration, my paint, and brush. It is as vital as the model herself. Profoundly significant, it caresses the essential superlative curves and lines. Light I acknowledge as the energy upon which all life on this planet depends." The first

"Light is the Holy Grail of photography." ~Randy Romano, The Essence of Photography

day in one of Ruth Bernhard's workshops was spent without a camera. Her purpose: to engage students with light. As clouds passed overhead or the sun backlit a flower, students began to see the world in a completely new way: a world full of light and shadow, reflection, and texture. What Bernhard's students realized was that their lives would be forever enhanced, with or without a camera in hand, just by learning to look at light. To slow down and take the time to observe, to really see the beauty and grace of your surroundings, much like a meditation, is the first step to capturing unique and stunning images.

Light itself can be the focal point of an image, as in 3-1, where the warm light of early evening created a beautiful glow on this young girl.

Learning to use light in a sculptural and emotional way when photographing children takes attention, presence, and practice. Take time to observe the effects of light in your environment and then watch closely how that same light falls on the children in your life.

If you have observed children in their environment for any length of time, you might have noticed how velvety-soft their skin appears when they are sitting by a bedroom window, or the golden halo effect of the light in their hair as they run around the playground; how those big, brown eyes seem to catch the light just right when they

ABOUT THIS PHOTO The setting sun perfectly highlighted the profile of this beautiful young girl. 1/125 second, f5.6 at ISO 400. ©Ginny Felch / www.silverliningimages.com

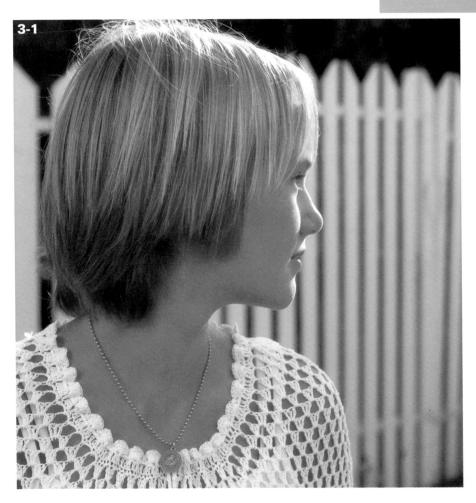

are sitting in their highchair in your well-lit breakfast nook or when they are up to their neck in bubbles in the big, garden tub with the glass block window just above. All of these situations will open your eyes to the possibilities of photographing children using light to convey your feeling about them and that moment in time. Consider the next two photos, both of the same child. Typically, when photographing children indoors, the temptation is to let the flash do its thing and get the shot, but there might be a better way. The photo in 3-2 was taken using on-camera flash. You can see how the flash has washed out the skin tones in the image and left a harsh

ABOUT THIS PHOTO On-camera flash washes out skin tones and makes for harsh shadows. 1/250 second, f/2.8 at ISO 200. ©Allison Tyler Jones / www.atjphoto.com

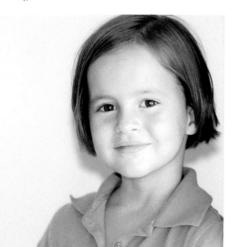

shadow around the little girl. Moving her to a doorway with natural light spilling through as in 3-3 allows the light to wrap around and bathe her revealing the texture of her skin and, more importantly, lending a completely different emotional feel to the image.

It may seem that photographing outdoors is easier because there is so much light, but remember that quantity isn't as important as quality. The photo in 3-4 was taken in direct sunlight making everyone squint and causing harsh shadows on their faces. The photo in 3-5 was shot after considering where the light was coming from and finding open shade to photograph. Moving the family to an area with open shade allows everyone to have natural expressions and gives an entirely different feel to the image. Isn't it amazing the difference light can make?

ABOUT THIS PHOTO Placing the child inside a doorway with natural light allows the light to wrap around the girl's face showing the texture of her skin. 1/250 second, f/2.8 at ISO 200. ©Allison Tyler Jones / www.atiphoto.com

e tip

If you are a beginner, you may want to start out with your camera mode

set to Automatic. This way, you can concentrate on seeing light. As you complete the assignments throughout this book, you will want to put into practice what you are learning; camera settings are included in the image captions for those who are practicing with their cameras and for those who have a more advanced understanding of their camera and want more technical information.

ABOUT THIS PHOTO

The family has been positioned in harsh, direct sunlight causing everyone to squint and the expressions to be less than ideal. 1/800 second, f/3.5 at ISO 100. ©Allison Tyler Jones / www.atjphoto.com

ABOUT THIS PHOTO

Moving the family to an area with open shade softens the light and allows for more natural expressions. 1/125 second, f/2.8 at ISO 100. ©Allison Tyler Jones / www.atjphoto.com

AVAILABLE LIGHT

Many of the images throughout this book show children outdoors captured in beautiful light and natural settings, such as in 3-6, where a young girl is vignetted by tree branches as the light illuminates her face. All the photos in this chapter were taken using available light. Available light is just what it sounds like: using the light that's available; no flash or reflectors, just the existing light in the environment.

The sun hitting the blond hair of the little boy and girl in 3-7 gave the subjects an angelic quality and set them apart from the background, while at the same time throwing their shadows ahead of them.

Chapter 4 explores manipulating or adding light to a scene.

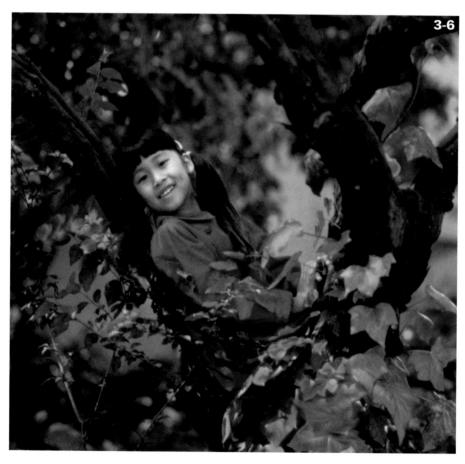

ABOUT THIS PHOTO The dappled light gently touched the green foliage surrounding this bright little girl,

illuminating her face. The complementary colors of red and green give the photograph a punch! 1/60 second, f/4 at ISO 160. ©Ginny Felch /

www.silverliningimages.com

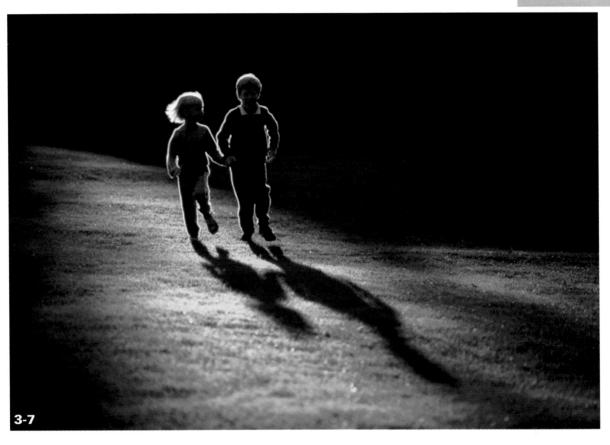

ABOUT THIS PHOTO The beautiful backlighting, the long, angled shadows, and heads placed in the perfect spot of thirds, all pay homage to these frolicking children. 1/125 second, f/8 at ISO 200. ©Sherman Hines

The large white couches in 3-8, 3-9, and 3-10 pick up the light from the windows and reflect it all around the room, adding to the spunky atmosphere of this brother-and-sister series of portraits.

Let's take a practical look at different kinds of lighting situations that you can explore for photographing children.

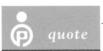

"Look at light and admire its beauty. Close your eyes, and then look again: and what you will see later is not yet." ~Leonardo da Vinci ABOUT THESE PHOTOS The light from these gorgeous windows lights up the room while the white sofa acts as a huge reflector to illuminate the antics of siblings. 1/320 second, f/3.5 at ISO 400 for all three images. ©Stacy Wasmuth / www.bluecandyphotography.com

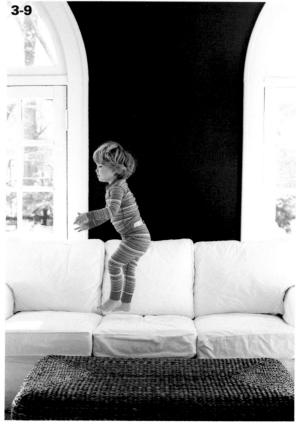

THE SWEET LIGHT: DAWN AND TWILIGHT

Many excellent photographers only make images during the *sweet light*, which is the light surrounding dawn and twilight. This light is often cool in the morning and warm in the evening, each creating its own mood and texture. Because the sun is at a greater angle, and often diffused by the atmosphere, less likelihood exists for unflattering, direct sun (see 3-11 and 3-12).

Check sunrise and sunset times for your local area on www.almanac. com/rise/locations/index.php, and try your own photo shoot at about 30 minutes before and after sunrise or an hour before sunset. Watch carefully how the light changes as the sun moves higher or lower in the sky and what effect that has on the lighting of the child you are photographing.

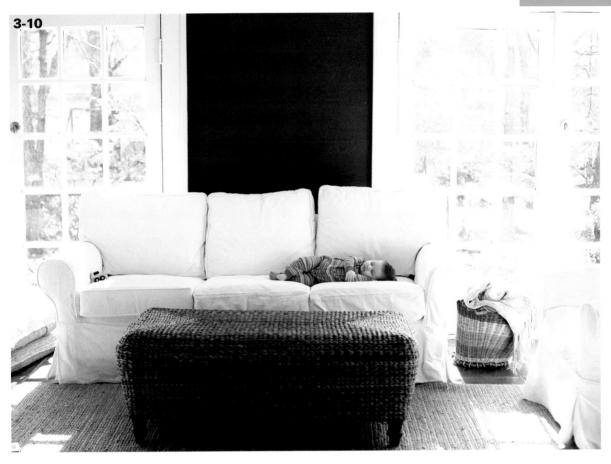

Light is known to affect mood; you might notice the quiet hush that occurs at dawn and twilight, among both man and nature. What a delightful time to be with a child in a photographic session. The lighting and the atmosphere lend themselves so beautifully to exploring nature and having quiet conversations. One of the challenges of working in this light is that it is fleeting. Just as you are enjoying and making use of the light, it disappears, often causing frustration. You must learn to work quickly and spontaneously. After missing your opportunities a few times, you realize just how transient this gift of light can be.

ABOUT THIS PHOTO Skipping rocks at the creek engages these young brothers as the light moves around the surrounding foliage. The composition unites the boys and creates a sense of wonderful intimacy. 1/60 second, f/3.5 at ISO 160. ©Marianne Drenthe / www.marmaladephotography.com

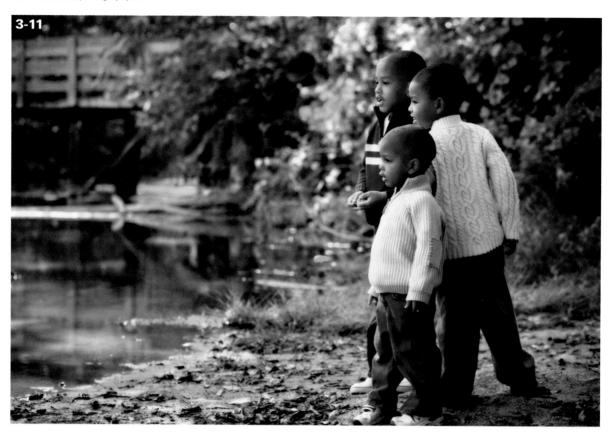

As a pleasant exercise, sit in a park at dusk and watch the light. Watch it make haloes and shadows; watch the colorcasts. It is nice to do this when you don't have the added challenge of photographing children.

USING REFLECTIONS AND SHADOWS

While you are observing light, pay attention to reflections and shadows in the environment. Both reflections and shadows can be used as a dynamic element of design to add that something extra to your photograph. Reflections can be found in obvious places such as window glass or mirrors but

less-obvious reflections can be seen in a rain puddle or the wash of the tide on a sandy beach. Morning or afternoon light, when the sun is at an angle, creates angular or distorted shadows that can add interest and drama. Shadows speak of time passing, which captures the viewer's imagination. Shadows and reflections can help you tell a story while adding dimension to your images.

REFLECTIONS

A puddle on a rainy day can tell a story as in 3-13 of the little boy under the umbrella. Reflections of the subject in water or in windows yield a distorted but painterly quality that adds an artistic touch to the photograph.

ABOUT THIS PHOTO Shafts of golden light of a late afternoon in the park penetrate the spontaneous dance routine of this little performer. Notice the long, angled shadows in front of her. 1/60 second, f/6.3 at ISO 400. ©Ginny Felch / www.silverliningimages.com

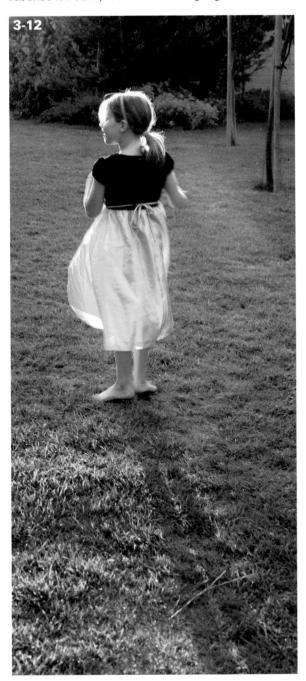

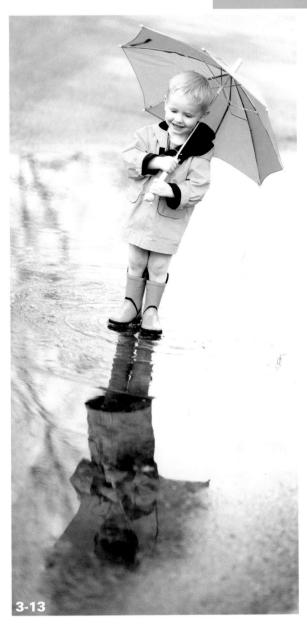

ABOUT THIS PHOTO The reflections add depth and dimension to a photo of a little boy considering his reflection on a rainy day. 1/1600 second, f/2.0 at ISO 200. ©Stacy Wasmuth / www.bluecandyphotography.com

Photographing at low tide on a beach is a perfect place to take advantage of reflections (as in 3-14). The added color, texture, and design can be just another element of your composition that catches the eye. The beauty of reflections is that they suggest the bigger picture without having to show every detail, leaving the viewer's mind to fill in the rest and create his or her own story about that image.

When using the soft light coming from a window, pay attention to your subject's reflection on the glass. If you have the heads turned toward the light, you might not be able to see facial details, except for what is reflected back to you. Again, the reflected image is slightly distorted, washedout in color, and dreamy looking. Using reflection as a visual metaphor, you deepen the meaning of

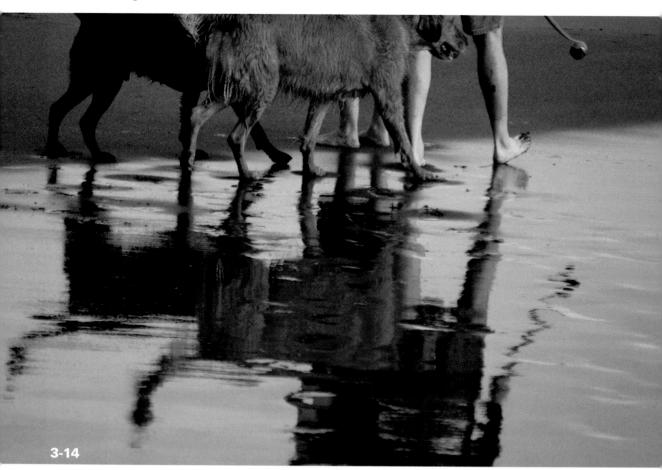

ABOUT THIS PHOTO The reflection of a boy on a beach stroll with his dogs and a ball-tosser reveals the glow of late-afternoon sun. 1/500 second, f/5.6 at ISO 400. ©Ginny Felch / www.silverliningimages.com

SHAPTER 3

your photograph by allowing the viewer to register the obvious first and then look a bit closer, see the reflection, and ponder what else is there.

You could also take the reflection idea very literally. Look for mirrors or windows in your environment and take the same shots two ways as in 3-15 and 3-16.

3-15

Babies love to look at other babies. Even when that baby is themselves! Take advantage of their curiosity by placing a mirror within their reach, as in 3-17, and then watch what happens.

ABOUT THESE PHOTOS The classic subject of mother and children, shown in 3-15, is given a modern twist by shooting into a mirror in the mom's bedroom in 3-16. 1/250 second, f/2.8 at ISO 640. ©Stacy Wasmuth / www.bluecandyphotography.com

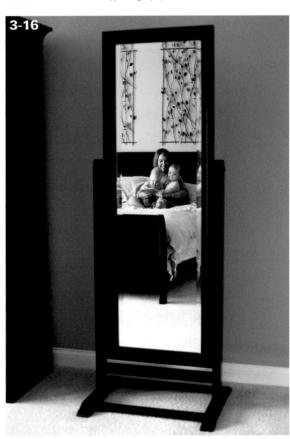

ABOUT THIS PHOTO Because babies are naturally curious about other babies, let them play with a mirror while you take advantage of the sweet reflections of babyhood. 1/320 second, f/2.8 at ISO 400. ©Stacy Wasmuth / www.bluecandyphotography.com

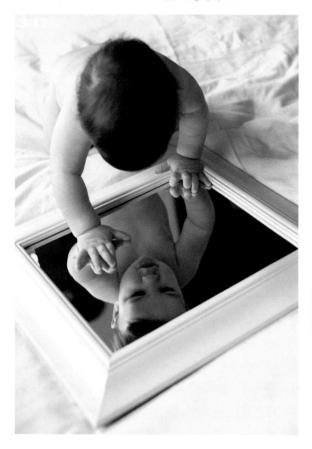

SHADOWS

When you are first learning photography, it is tempting to avoid shadowy light for fear that your subject won't be properly illuminated. Don't be afraid to make a few mistakes and explore how shadows can affect the photos you take; the payoffs are worth it.

You may first want to explore the shadows that fall on the child you are photographing. Shadows created by light coming through a set of stairs, as in 3-18, or through anything that creates patterns make for an interesting element in a photograph.

On sunny days, the play of light and shadow can cast shadows that emphasize the shape or profile of the child, as in 3-19. There are really two pictures here: the actual child and what his shadow is saying about him.

note

When photographing children in a wooded setting, pay attention to

the mottled light cast by the movement of leaves in the trees above. Either move your subject or try the fill flash technique discussed in Chapter 4 to even out the shadows

ABOUT THIS PHOTO

The little artist at work on a sunny morning seems embraced by the shadowed light as he concentrates on his colors. His pacifier adds a bit to the story. 1/125 second, f/5.6 at ISO 200. ©Ginny Felch / www.silverliningimages.com

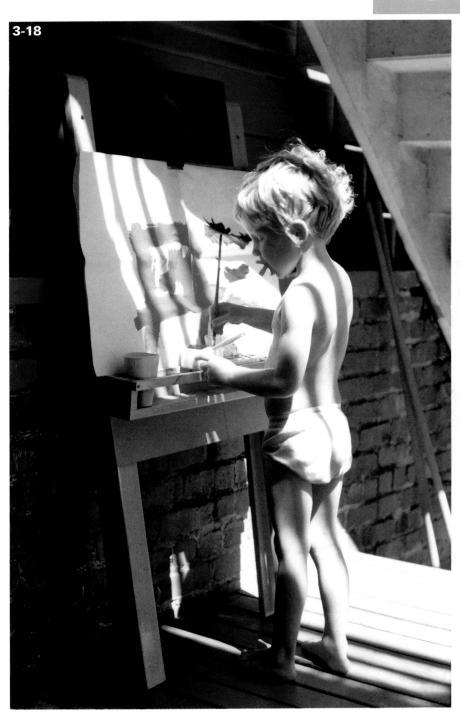

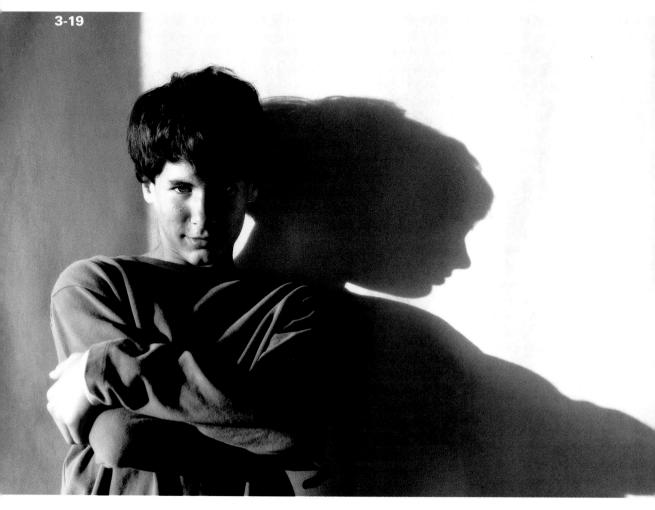

Shadows can also suggest the shape of the child even if the whole child isn't seen in the photograph, as in this photograph of a little boy swinging shown in 3-20. Your eye fills in the missing top half of the boy giving a more abstract feel to this image.

For those with compact digital cameras: Check your manual for information on your flash settings. Does your camera allow you to turn your flash off or set it to a lower setting? This control is helpful as you learn to explore light.

PHOTOGRAPHING IN FOG OR WITH OVERCAST SKIES

While most residents of a beach community relish hot, sunny days, many photographers are thrilled when the fog rolls in so they can take advantage of the other-worldly feeling that shooting in foggy light brings to their photos. Overcast skies provide a soft, flattering light that allows photographers to shoot all day long.

GHAPTER 3

ABOUT THIS PHOTO You don't need to see the whole boy to get the feel of freedom he has as he swings. 1/500 second, f/2.8 at ISO 100. ©AllisonTyler Jones / www.atjphoto.com

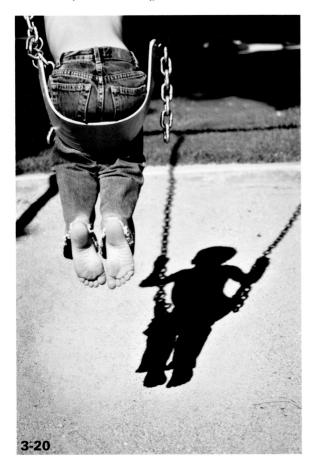

FOGGY DAYS

On foggy days, the light is soft; the scenes more monochromatic or pastel, and contrast is nil. Fog can be light, thick, high, low, and change by the minute. Its very unpredictability adds to its mystery. To use fog to your advantage, you want to avoid high fog because it doesn't create the

beautiful haze needed to cut the contrast in the setting. Look for a low, dense fog that obscures the surrounding hills or vegetation. Fog behaves differently during the various seasons so you may start out your day with perfect fog but by the time the kids show up you are stuck with harsh sun. It's the chance you take when relying on Mother Nature to help with the lighting. But when the weather cooperates and envelops your subjects in the flat, even light that fog provides, children can frolic and play so you do not have to worry about which direction the light is coming from, adding a sense of freedom to your work.

If it is a very foggy day, the light may not be bright enough to shoot in until about 10 or 11 in the morning. In the afternoon, don't wait too late or the fog can get too gloomy and you lose the light. As with all things photographic, experimentation is the key.

Keep in mind that lots of fog can create a low-light situation that might cause your flash to engage on your camera. You don't want to use a flash in fog because the water droplets reflect the light and end up looking like dots on your image. Turn your flash unit off. If you have to choose a different mode on your camera to keep your flash from firing, use Av or Aperture Priority. This setting enables you to set your lens wide open at f/4.5 or bigger, and your shutter speed requirements are determined by your camera.

For more technical information on aperture and f-stop, see Chapter 2.

Photographs of scenes that appear more painterly in this kind of light are considered *high-key* photographs, light subjects against a light background, as in 3-21 and 3-22. If planned correctly, by using lighter clothing for the children, you find that the darkest elements in the photograph are the skin tones, which really draw attention to the children, while keeping the background and even the clothing more subdued. All is in a relative wash of light, with the main emphasis going to the children in the photograph.

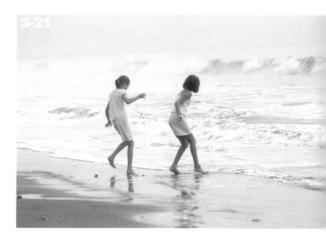

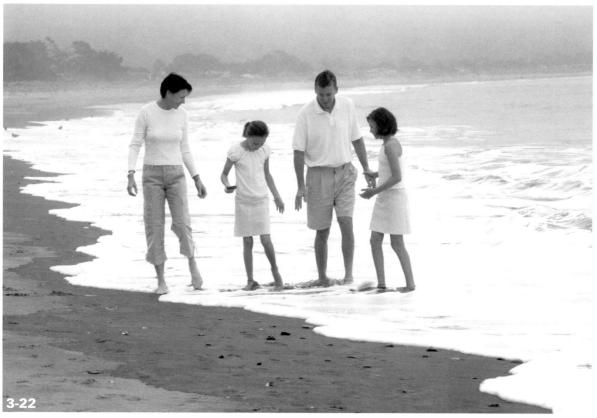

ABOUT THIS PHOTO The foggy day and monochromatic tones set off this lovely family as they interact at the beach. The curves created by the frothy sea envelop them in a dance-like pose. 1/250 second, f/11 at ISO 400. ©Ginny Felch / www.silverliningimages.com

ABOUT THESE PHOTOS This series of three photographs of two sisters playing at the beach shows a unique relationship between the girls and their environment. The monochromatic tones are pleasing to the eye. 1/250 second, f/16 at ISO 400. ©Ginny Felch / www.silverliningimages.com

OVERCAST SKIES

The mood created by overcast skies can be soft and often romantic. Because the light is more subdued and has less contrast, it is much easier to achieve successful lighting with no harsh shadows or too-bright highlights. This more forgiving light frees you up to concentrate on composition and the expressions of the children in your photograph.

Although overcast skies provide more evenly dispersed lighting than does direct sun, if you are shooting in the middle of the day, the light is still coming from overhead and can cause a raccoon eye effect if you're not careful. The next section helps you with getting the light at the correct angle to your subject.

FINDING CONTOURING LIGHT

Contouring lighting gives a dimensional look to an otherwise flat piece of paper — your photographic print. Ideally, three times as much light is on one side of the face than the other, or a 3:1 lighting ratio. Don't panic now; this is not a math

quiz! It is a matter of learning to see the light, subtle as it might be, fall on a face.

One of my favorite exercises that demonstrates the sculptural or contouring effect of light can be done on a sunny, cloudy, or overcast day. Ideally, you find a spot on the edge of a forest or meadow with trees. Your light source is a low and broad sky without direct sun, as in 3-23.

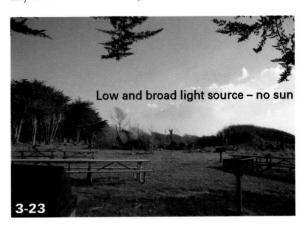

ABOUT THIS PHOTO This view shows a low and broad light source for the portrait — the sky with no sun. 1/2500 second, f/5.6, ISO 640. ©Ginny Felch / www.silverliningimages.com

If you look at the light on the trees as you search for a location to photograph, see whether you can find one with light falling more brightly on one side than another and look for the *specular highlight*, or the bright line dividing the highlight from the shadow, as in 3-24. Don't worry if the location seems crowded with objects that you don't want in your final image. You can focus on your subject and eliminate the distracting details.

If you place a face in that location as in 3-25, you see similar light flowing on it, and the specular highlight can be placed on the nose. The portrait of Daisy reveals the same light on her face as seen

formerly on the tree. She was asked to turn her head until the light appeared there and the little triangle of light appeared on her left cheek. One side of the face should have about three times the amount of light on it than on the other side, and if you turn her face just right, you see a little triangle of light on the other cheek before the shadow falls off the face. Study the illustrations and then go out in the field and practice.

This is really an exercise about observing light, so that you can see the subtle differences between light and shadow and use it as you want for illuminating your subjects.

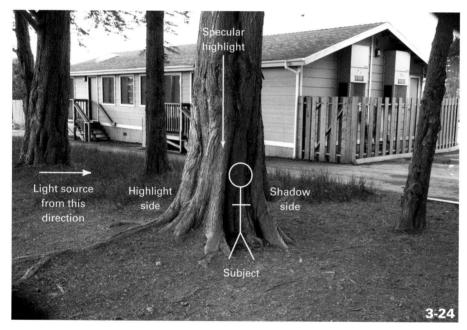

ABOUT THIS PHOTO This is the background chosen because of the sculptural light (see highlight and shadow side of trunk) noted on the tree. Even though there is clutter from building and tree, subject and tree can be isolated in the camera's viewfinder. 1/200 second, f/5.6, ISO 640. ©Ginny Felch / www.silverlining images.com

ABOUT THIS PHOTO

The highlight and shadow side give Daisy's face a more dimensional or sculpted appearance. Notice the specular highlight (brightest line of light) that comes down her nose to add contour to her face. 1/200 second, 1/5.6, 640 ISO. ©Ginny Felch / www.silverliningimages.com

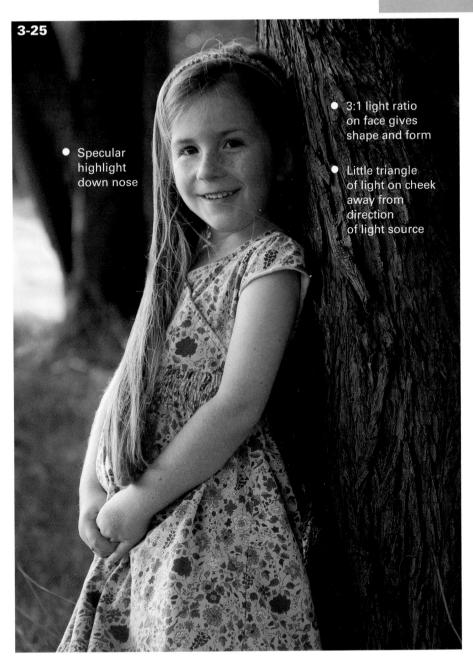

USING SOFT WINDOW LIGHT

Light that flows in through a window, particularly a window facing north, is an exquisite source of flattering, soft light to use when photographing children. Although northern light is known to be ideal because of the lack of direct sun, you should find light on an overcast day just as acceptable. You can really use any window as long as the light is not blocked by outdoor trees and the sun is not shining directly through the window onto your subject.

The exception to this would be if you choose to use direct sun shining through a window to create an image with more contrast. Naturally, this would not produce a soft and diffuse, shadowless light.

Experimentation and your own artistic point of view serve vou well when learning to use window light. However, a few things help you to control it and to use it more effectively. You can see the direction of the light better if you are in a room that doesn't have other windows to bring in distracting light, as in 3-26.

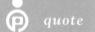

"Think about the photo before and after, never during. The secret is to

take your time. You mustn't go too fast. The subject must forget about you. Then, however, you must be verv quick." ~Henri Cartier-Bresson

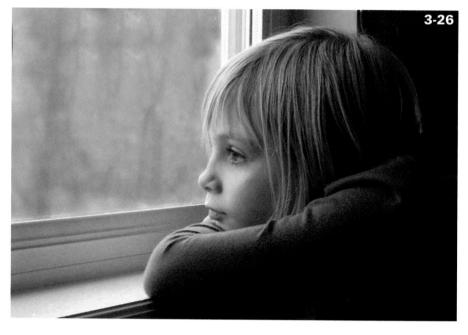

ABOUT THIS PHOTO Olivia's beautiful profile is caressed by light, and the colors are soft and harmonious. This expression relaxes the facial muscles, adding to the

velvety look of her skin, 1/25 second, f/16 at ISO 1600. ©Kim Spilker

Images shown in 3-27 and 3-28 are examples of soft, directional light coming from nearby windows. The children look like cherubs with the sidelight hitting their soft skin.

Of course, you might practice first using an adult or very cooperative child so that you have the chance to really look at the light, move the subject, and move around your subject.

Experiment with having your subject very close to the window and then move her farther away,

as you observe the subtle changes. If your subject is facing you, take a look at your background, making sure it is uncluttered and falls into shadow. To start with, don't use the window as the background. See how the light comes through and highlights the side of the face closest to the window. The other side of the face falls into shadow, and as you turn the face slowly toward the light source, you see how the light gives the face shape.

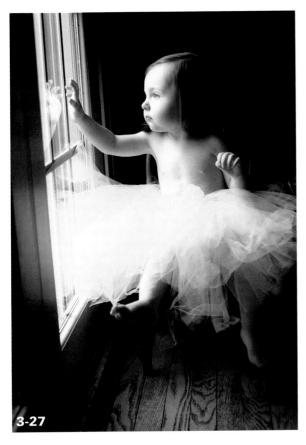

ABOUT THIS PHOTO The soft non-directional light from a set of French doors illuminates this little ballerina beautifully. 1/250 second, f/2.8 at ISO 400. ©Stacy Wasmuth / www.bluecandyphotography.com

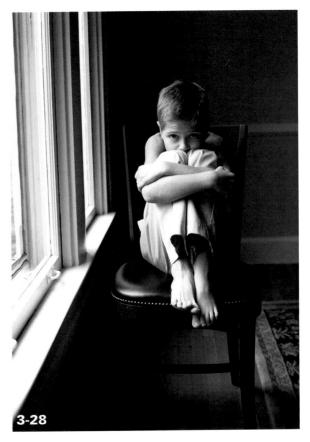

ABOUT THIS PHOTO The dramatic lighting provided by this set of windows adds dimension to this portrait of a young boy that would be completely lost if flash had been used. 1/400 second, f/3.5 at ISO 500. ©Stacy Wasmuth / www.bluecandyphotography.com

As explained earlier in the chapter, the ideal lighting on a face gives a 3:1 ratio of light to shadow. In regard to window light, this means that there is three times the light on the area of the face closest to the window than on the shadow area of the face. Adjust your subject until you see a triangular shape of light falling on the cheek of the shadow side as in 3-29. Again, this helps to model the face, giving it shape, depth, and texture.

For a more detailed look at catch lights and modifying light by using

reflectors, see Chapter 4. Reflectors and other tools used to manipulate light are also discussed in depth in Chapter 4.

ABOUT THIS PHOTO Notice how the light wraps across this little boy's face creating a triangle of light on the left side of his nose. This is contouring light. 1/80 second f8.0 at 800 ISO. ©Ginny Felch / www.silver liningimages.com

If you feel that the light coming through is too bright or strong, you can use sheer curtains or a white bed sheet over the window to diffuse the light. If the shadows are too dark on the shadow side of your subject's face, you may want to add a reflector of some kind on that side, to catch the light coming in through the window and reflect or bounce it back into the shadows. Sometimes, this technique can be used to cast light into the eyes, creating a little glint of light in the eyes that photographers call *catch lights*, which make your subject's eyes come alive.

Above all, experiment. Now that you have some of the basics regarding window light down, put them into practice: Move your subject, turn your subject, walk around her, have her look at you, look out the window, look away from the window, and so on. Take a photograph from a standing position, then at the same level as the subject's eyes, and then from below. You get to decide what appeals to you; that is the beauty of it. Don't forget to look for those beautiful reflections in the window.

KNOWING WHENTO COMPROMISE

As you might have gathered by now, the inspired and intentional use of light when photographing children has an enormous visual and emotional impact on your final image as in 3-30. It is something to seek and to recognize. But what if the light isn't perfect or something great is happening and there is no sweet light to be found?

At these times it is helpful to remember the work of renowned photographer Henri Cartier-Bresson, who is famous for what he termed the "decisive moment," which is a fraction of a second when visual and narrative elements come together to reveal the intention or attitude of the photographer.

Children's photographers can learn a great deal about observing those decisive moments by further researching his work. Cartier-Bresson's "decisive moment" can be elusive, but it is worth your pursuit to strive for that moment when expression, light, and composition all fall together in one glorious moment. As you progress, you figure out exactly when that is; when it happens, simply express gratitude and run with it.

Is all else a compromise? Absolutely not! If you capture a marvelous expression or a great

composition and your lighting isn't spectacular, you can still make a successful portrait.

You have a secret now embedded in your deepest creative recesses that enables you to recognize when you see dramatic light. And you also have some clues as to where you might start looking.

Children's portraiture will always be an art of the soul and of the heart, so, first, keep the child and his or her personality in mind, then using the tools of light and shadow, convey the mood and emotion you want the viewer to feel about this child.

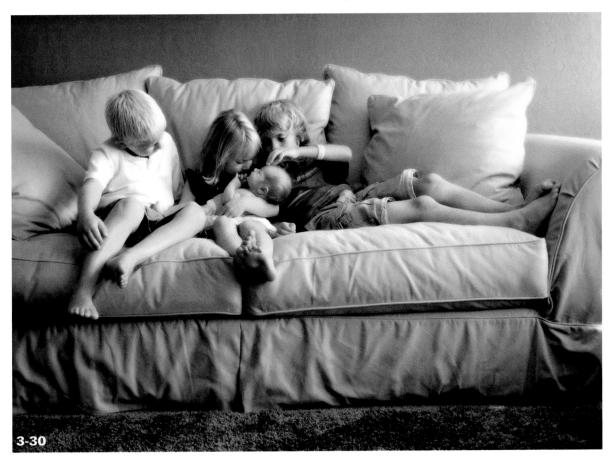

ABOUT THIS PHOTO Learning to notice light in your environment allows you to use that light to tell a story, such as the warmth of this window light in a photo of siblings welcoming their new baby sister. 1/125 second, f/5.0 at ISO 800. ©AllisonTyler Jones / www.atjphoto.com

Assignment

And Then There Was Light!

For this assignment, choose one of the lighting situations described in this chapter. Make sure it is one that inspires you or that caught your attention, so that you enjoy the process of discovery more. Make a portrait of a child or children using this quality of light. In this photograph, make a statement about light and your use of it. Make sure that your flash is turned off or that you set your ISO high enough so the flash does not fire as you should be trying to see and use the available light in the setting.

For example, in this photograph of a father holding his newborn baby, a high-key environment was chosen with a very simple background. The values of the white wall and white pants sit back, while the skin tones of the dad and baby come forward as the focal point of the photograph. A large window to the right side of the subjects provides a soft directional light that gives the figures shape, form, and texture. The overall image conveys a gentleness that surrounds a very sensitive moment. Image shot at 1/125 second, f/8 at ISO 400.

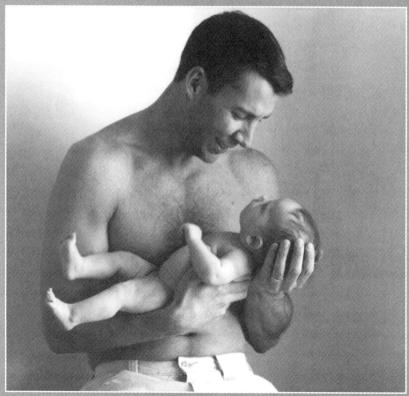

©Ginny Felch / www.silverliningimages.com

Remember to visit www.pwassignments.com after you complete this assignment and share your favorite photo! It's a community of enthusiastic photographers and a great place to view what other readers have created. You can also post comments, and read other encouraging suggestions and feedback.

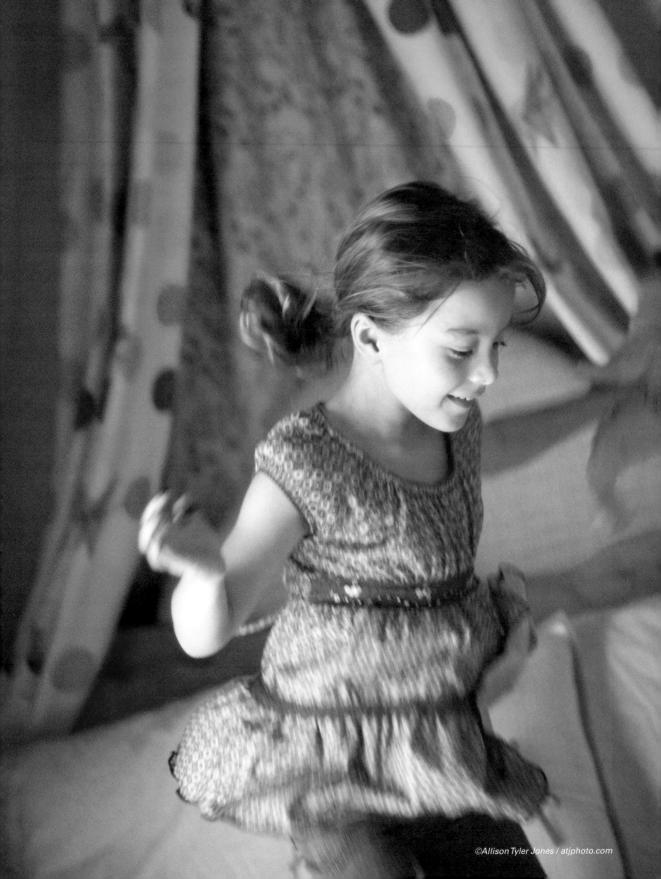

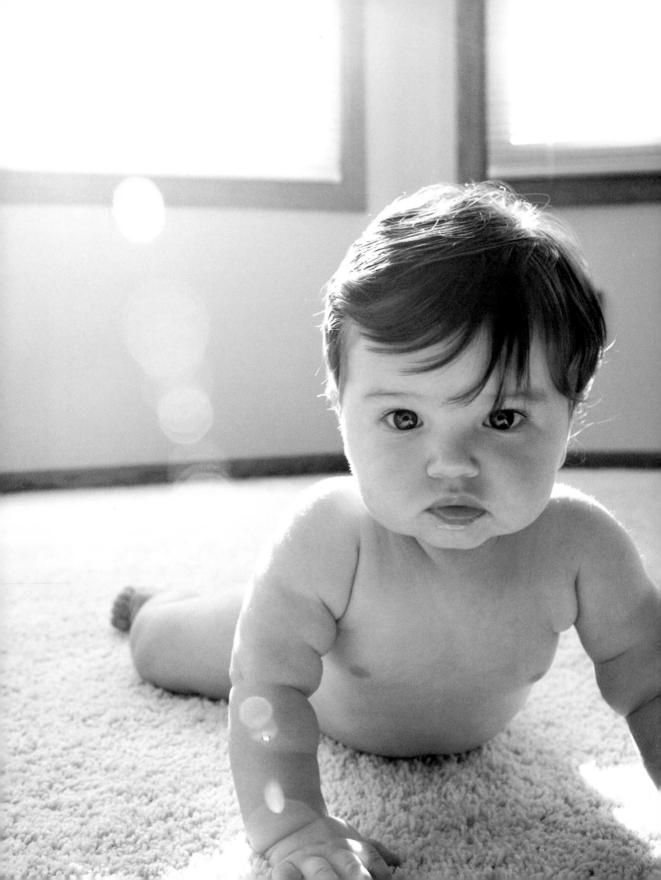

Indirect Light DIRECT LIGHT To Flash or Not to Flash DIRECTION OF LIGHT LIGHT MODIFIERS COLOR TEMPERATURE OR WHITE BALANCE BASIC STUDIO LIGHTING

©Allison Tyler Jones / www.atjphoto.com

When it comes to gorgeous light, natural light wins, hands down, and, in a perfect world, it would be forever sunny and all windows would face north to capture that gorgeousness.

Unfortunately, we live in a world with all sorts of weather, a sun that sets, and windows that may not face the optimal direction. What's a children's photographer to do? Kids are not going to stand around waiting for you to fiddle with your camera and lighting. You've got to work quickly and effectively without too much fuss. Luckily, many intrepid photographers have gone before you and figured out helpful and simple tricks for manipulating whatever lighting situation you may find yourself in.

INDIRECT LIGHT

Beginning photographers are so often concerned with finding light in enough *quantity* to make a good exposure that they don't stop to consider the *quality* of that light and its effect on the child they are photographing. When you start to see how the quality of light can work for you, you will start to use different types of lighting on purpose to create a certain look or convey an emotion.

Indirect light is the light you have been learning to see and use. The light you find coming through the windows of your home or on your front porch can be soft and beautiful because the light is indirect, meaning it isn't coming straight from the source. Indirect light has been bounced off of, blocked by, or diffused through something. The light may be bouncing off the concrete walkway up to the house or the house across the street or, possibly, the light has been diffused by a window. Indirect light creates a softer light with no harsh line between light and shadow. It's hard to see where the light stops and the shadow starts, and that makes for beautiful photographs.

PORCHES OR OVERHANGS

In the previous chapter you learned about window light but windows aren't the only places to find gorgeous light. Beautiful, soft light might be as close as your front porch. Porches block the direct, overhead light leaving a huge window of light in which to shoot your subject. Porches are particularly great places to photograph children because the lighting usually remains constant across the length of the porch allowing kids some room to roam or dance, as in 4-1.

ABOUT THIS PHOTO This little girl is twirling under her family's front porch overhang, which allows her to be illuminated by soft, indirect light. 1/500 second, f/2.8 at ISO 400. ©Allison Tyler Jones / www.atjphoto.com

CHARTER

If you need to find a place to take some photos that has nice, indirect light and you don't have a porch, try your garage.

OPEN SHADE

Open shade is another place to find indirect light. *Open shade*, by definition, is open meaning there is nothing blocking the light from overhead but the direct light is being blocked by either cloud cover or something on either side of your

subject. Open shade can also be found just after the sun dips below the horizon (as in 4-2) or behind your house or another building (as in 4-3). This leaves plenty of light to shoot in but it's not harsh and direct.

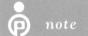

If you are a beginner, your best bet is to start out finding and using indirect

light first. When you're comfortable there, stretch your wings and experiment with direct light. You will have more immediate success, giving you the confidence to move on to more challenging lighting situations.

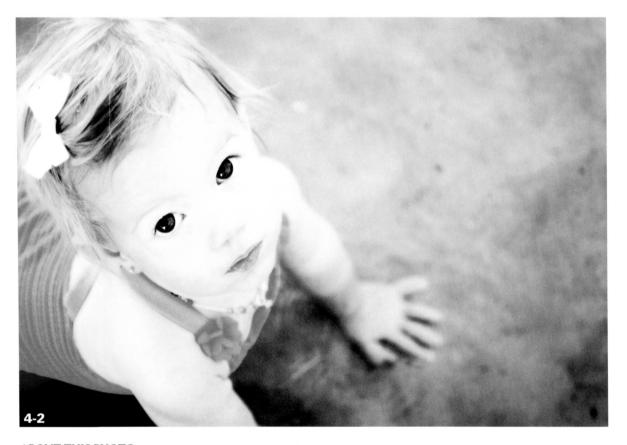

ABOUT THIS PHOTO In this beach photo of a little girl, the sun had set below the horizon, but there was plenty of soft, indirect light to capture her photo. 17-55mm lens, 1/500 second, f/2.8 at ISO 100. ©AllisonTyler Jones / www.atjphoto.com

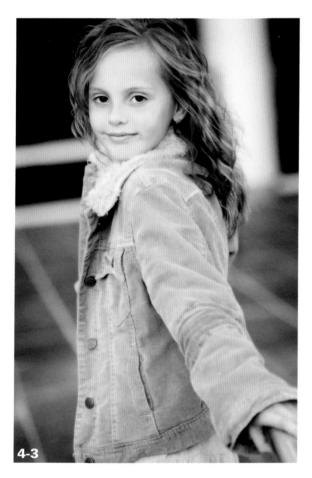

ABOUT THIS PHOTO This photo of a young girl was taken between two buildings that were blocking the direct light. The photographer turned her toward the light to keep dark shadows out of her eyes. 1/125second, f/2.8 at ISO 100. ©Allison Tyler Jones / www.atiphoto.com

DIRECT LIGHT

Direct light is just what it sounds like: It comes directly from the light source to your subject with nothing in between. It can be very hard, harsh, and potentially unflattering unless used with care. You probably have lots of pictures that have been ruined by direct light — overflashed, too bright, or glaring sun photos with ghostly or squinting subjects.

DIRECT SUN

The sun is the most common source for direct light. If you shoot during midday in harsh, direct sun, the shadows are very distinct with a hard line around them and it's almost impossible for your subjects not to squint. The photo in 4-4 is a prime example of what not to do. The sun is so bright the little boy can't even open his eyes! The shadows are harsh and there is no detail in the highlight areas of this photograph.

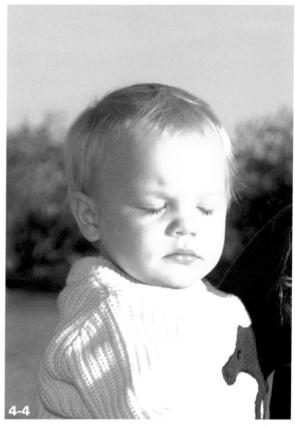

ABOUT THIS PHOTO Shooting in harsh, direct sun can be a challenge. Very often it results in photos of squinting children with little or no highlight detail. 1/25 second, f/2.8 at ISO 100. @AllisonTyler Jones / www.atjphoto.com

Negatives aside, direct light can be used to great effect when used correctly. For beginners, it's important to pay attention to the direction from which the light is shining. Planning to shoot earlier or later in the day allows you to work with the sun at an angle to your subject. This gives you more options for positioning your subject. In 4-5, the photographer waited until the sun was lower in the sky and photographed the same little boy. The light is warmer and softer as it sinks lower in the sky resulting in a much better image than 4-4.

ABOUT THIS PHOTO No squinting necessary when the sun sets lower in the sky. Watch for the sweet light and take advantage of it. 1/250 second, f/2.8 at ISO 100. ©AllisonTyler Jones / www.atjphoto.com

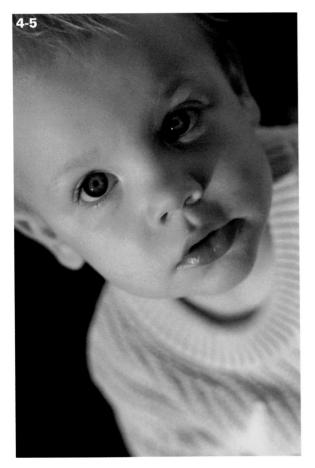

"I have seized the light. I have arrested its flight." ~Louis Daguerre

CREATING A HALO: USING RIM OR BACKLIGHTING

Have you ever been looking at someone, and the low sun behind him creates a light on the rim of his hair? This is a simple example of what is called *rim light* or *backlighting*. Studio photographers emulate this exquisite light by actually placing a strobe behind their subjects. This is just another way to give depth, definition, and drama to an image and helps to separate the subject from the background. Rim or backlighting illuminates and separates the hair and head from the background, as in 4-6. Rim lighting also adds an emotional element to an image.

Working with this type light can be tricky, requiring you to practice everything you learned about exposure in Chapter 2. The best of rim or back lighting occurs either in the morning or late afternoon when the angle of the sun is low, just when sweet light appears. The higher the sun is in the sky, the brighter the light is on the back of the child's head. If the backlight is too bright you may lose all the detail in your highlights. To really make this technique work, be sure you have enough ambient light (which is the available light in the scene) coming from behind you, so that the faces of your subjects are illuminated properly. Sometimes photographers bring along a small metallic reflector that they use to catch the light of the sun behind the subjects and reflect it back onto their faces. Rim or backlighting can also be used to create dramatic silhouettes by leaving out the reflector and exposing your image for the background instead of the foreground.

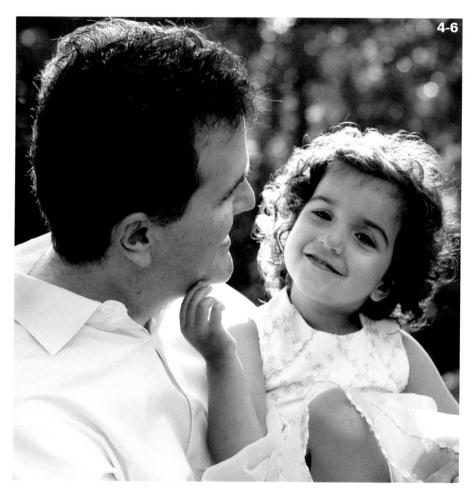

ABOUT THIS PHOTO This father and daughter are bathed in backlight from the sun. The light clothing throws light into their faces, keeping them from being too dark. 1/125 second, f/8 at 200 ISO. ©Melanie Sikma /

www.melaniesphotos.com

Halo or rim lighting requires careful metering to be successful. For more information, see Chapter 3.

TO FLASH OR NOT TO FLASH

Learning to control the flash output of your camera could be the best thing you ever do for your photos. Consult your manual to see if you can adjust your flash output to half power or even turn it completely off. It is almost always a mistake to use your on-camera flash as the main light.

After looking at the not-so-flattering images you have captured using just flash, you may think that you never want to use it again, but there are times when flash has its uses.

CONCEPT OF MAIN LIGHT AND FILL

A basic tenet of lighting theory is learning which light will be your *main light* and which light, if any, will be your *fill light*. The *main light* is the light that provides the primary illumination of your subject. The *fill light* does just what its name

CHAPTER

implies: It fills in the shadow areas to one degree or another. The main light is the most important light because it determines from which direction your subject is lit, which, in turn determines how the shadows fall on the child. You then can add fill light to fill in those shadowy or darker areas. A reflector to one side could act as a fill light, which you learn about later in this chapter, but you can also use a flash as a fill light. Used as a fill light or bounced or diffused in some way, flash can provide a portable source of beautiful light.

BOUNCE IT

If you have an auxiliary flash unit for your camera (often called a speedlight) you may find that bouncing your flash off of a nearby wall, ceiling, or even a piece of white cardboard that you have taped at an angle to your flash unit almost always yields better results than straight-on flash.

Auxiliary flashes typically have heads that swivel and allow you to point the flash unit to a wall or ceiling that allows the light to bounce, softly illuminating the child you are photographing. For example, the hospital nursery in 4-7 had only bad fluorescent lighting and no exterior windows but you'd never know it by looking at this image. The photographer angled her flash head to bounce off of a nearby white wall providing soft, beautiful illumination of the baby. This method of lighting bounced the flash, thereby diffusing the light.

DIFFUSE IT

Diffusing your flash means placing some type of material between your flash unit and the subject so the light is softened, eliminating harsh shadows and washed-out skin tones.

Diffusing your flash is the easiest method for all types of flash units whether they are on-camera or auxiliary units. There are many light modifiers for flash units on the market but some of the best are also the cheapest. One or two pieces of tracing vellum taped across the front of your flash can soften the light enough to keep your subject from looking like a deer in the headlights.

ABOUT THIS PHOTO The photographer bounced her flash off the wall to the left of the bassinet resulting in a more natural, window-lit look. 1/125 second, f/5.6 at ISO 400. ©AllisonTyler Jones / www.atjphoto.com

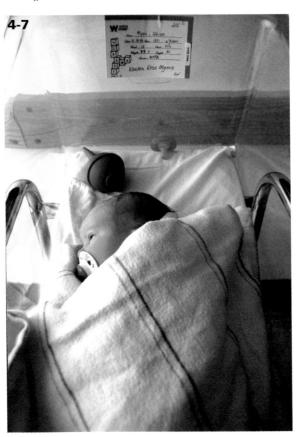

DIRECTION OF LIGHT

Whether you are working with direct or indirect light, the direction from which the light is shining onto your subject greatly affects the look of your photograph. Luckily, kids look good in just about any light so they are the perfect subjects on which to experiment with different lighting directions and patterns.

FLATTER: USING FLAT OR FRONT LIGHTING

It's no accident that just about every cosmetic ad you've ever seen is lit using *front* or flat lighting, which is lighting from the direct front of your subject. Placing your subject face-on to the light source is most flattering because this lighting pattern creates a shadowless light that disguises all the texture or imperfections in the skin. For photographing children, however, there is another benefit to flat lighting. The broad light source needed to create a flat lighting pattern is usually broad enough to allow your little subjects to roam around a bit while still in nice light, like this little girl on her front porch in 4-8.

CONTOUR: USING REMBRANDT OR 3-D LIGHTING

Contouring with light, as seen in Chapter 3, requires that the subject be positioned so that the light is coming in to one side. The light then wraps around the face of the subject giving a 3-D effect to the face, as in 4-9. This type of lighting, commonly referred to as *Rembrandt lighting*, is named after the master Dutch painter who often painted by window light.

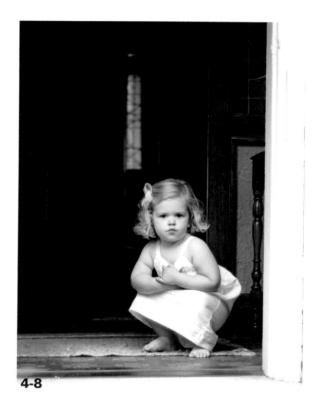

ABOUT THIS PHOTO This sweet little girl has lots of great light to roam in on her front porch. The indirect light is coming from in front of her, providing soft, flat illumination of her face. 1/1250 second, f/1.8 at ISO 250. ©Melani Sikma / www.melaniesphotos.com

Rembrandt lighting is achieved by placing your subject at a 45-degree angle to your light source, such as a single window in a room. The light then plays over the face of the subject creating light on one side of the face and shadow on the other. It also highlights the texture of the skin, hair, and clothing of the subject lending a three-dimensional look; the feeling that you can almost reach out and touch them.

CHAPTER

ABOUT THIS PHOTO Placing a child next to a window allows the light to wrap around his or her face creating a three-dimensional look to the image. 1/500 second, f/3.5 at ISO 1000. ©Melani Sikma / www.melaniesphotos.com

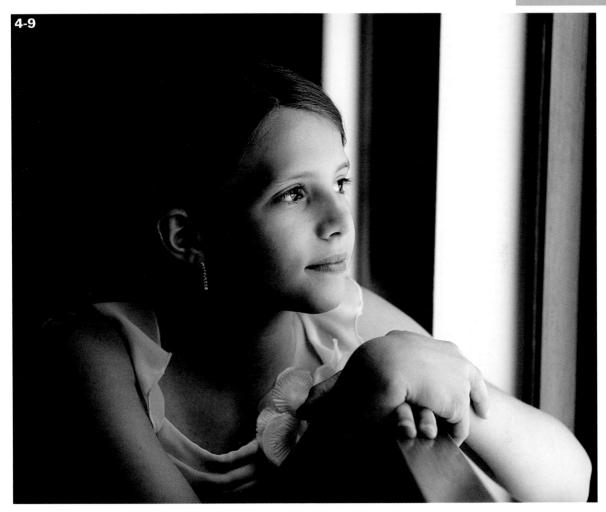

WHAT ABOUT ON-CAMERA FLASH? On-camera flash is another common source of direct light. However, if you think about it, on-camera flash is kind of like turning on the high beams of your car to illuminate your subject. You'll get the shot, but does the lighting convey the mood you were going for?

As was discussed in Chapter 3, using on-camera flash as your only light source flattens your subject and causes harsh shadows to fall behind them. It is also often the cause of red-eye. Unless there is no other option, it is best to avoid using your on-camera flash as your main light.

LIGHT MODIFIERS

There are so many cool gadgets on the market all geared to modifying light in one way or another, but when all is said and done they can all be put into one of three basic categories: reflectors, diffusers, or gobos.

REFLECTORS

Reflectors are the most commonly used light modifier in the photographic world. A *reflector* is

any reflective surface used to reflect light onto your subject. You would use a reflector when the light is a bit too dim on one side of your subject or to correct unflattering shadows on the face; or you might use a reflector to throw a bit more light into any image. Reflectors can be found in the environment, such as a white wall reflecting onto your subject, or they can be commercial reflectors manufactured specifically for photography and found in your local camera store.

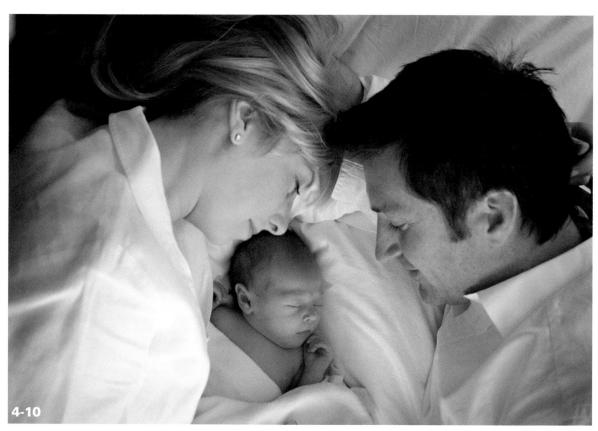

ABOUT THIS PHOTO The white sheets on the parents' bed make for gorgeous, reflective light. 1/125 second, f/2.8 at ISO 500. @Allison Tyler Jones / www.atjphoto.com

Reflectors are everywhere, like in photo 4-10 of a new family. The photographer used the white sheets and duvet cover on the parents' bed as well as the white clothing they were wearing as reflectors to help add light into the image. Even a natural surface, such as the pavement beneath the toddler in figure 4-11, can act as a reflector to help gently light your photos. Commercial photographic reflectors can be purchased and are very handy for reflecting light into too-shadowy areas of your subject's face. Often reflectors come with other materials, such as gobos (which are explained later). A popular reflector style is a two-sided, collapsible reflector as demonstrated by the young lady in 4-12, 4-13, and 4-14. You can find them with different options, such as white on one side and gold on the other, or silver one side and gold on the other.

ABOUT THIS PHOTO The light bouncing off the pavement in front of this little girl's home provides gorgeous, even illumination of her sweet face. 1/500 second, f/2.8 at ISO 250. ©Melanie Sikma / www.melaniesphotos.com

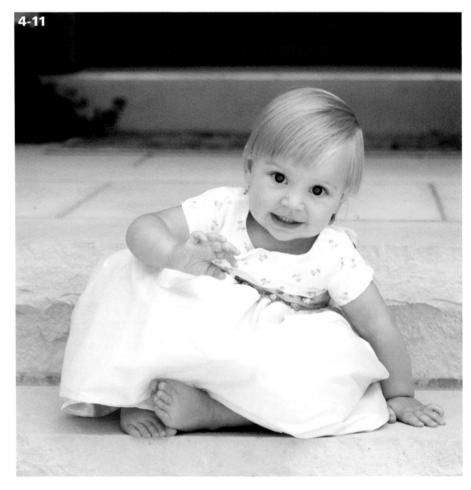

ABOUT THESE PHOTOS Commercial photographic reflectors come in different shapes and sizes. They are great when lighting is less than ideal and fold up easily to stow with your camera gear. ©Ginny Felch / www.silverliningimages.com

A white reflector doesn't add any colorcast into the image and provides a soft fill light into the shadow side of your subject. A silver side is more specular and can give a bit more punch to an image, which is essential when you are working in low light or shooting at sunset and losing light fast. The gold side is great for warming up skin tones in photos taken in shade (which can tend to be bluish in color) or during overcast days. A little experimentation will determine your favorite.

If you're not sure you want to spend the money on a commercial reflector, try using a piece of white foamcore or poster board from your local art supply store. You could even use someone wearing a white T-shirt as a reflector if you're really desperate.

CHARTER A

DIFFUSERS

Diffusers are made to diffuse, or spread out, the light that is shining onto your subject, making the light less harsh and more flattering. When all you have is harsh, direct light, a diffuser can be your best friend. Pop it into a window or have someone hold it between the harsh light and your subject and you'll be amazed at the difference, as demonstrated in 4-15 and 4-16. A diffuser can be a commercial product (similar to the reflector shown in the previous series of images) or you can use a panel of translucent drapes or a white sheet to diffuse the light between its source and your subject.

GOBOS OR SUBTRACTIVE

Sometimes you don't want to reflect or diffuse the light, you just want to block it altogether and that's where gobos come in. Gobos are lightblocking devices. You place it between the light source and the camera or the light source and the subject. Many of the reflector kits mentioned above have a black side that works really well for blocking stray light. Why would you want to block the light when you've spent so much time trying to find it in the first place? Maybe you are trying for the halo light mentioned earlier but the sun is causing flare spots on your lens; in this instance, you can have someone stand holding the gobo to block the light from hitting your lens. Or maybe there is just too much light all around and you have envisioned a more subdued, moody look to your image. Blocking the light from one side of your subject will give you that more Rembrandt-y look.

COLORTEMPERATURE OR WHITE BALANCE

Color temperature refers to the color of light in an image. For example, you have likely noticed that when you photograph indoors and your flash does not fire, the image has an almost orange cast to it. Perhaps you have photographed a subject on an overcast day or on the shady side of a building and found the image to have a bluish tinge to it. Both of these scenarios highlight the importance of understanding how color temperature can affect your images.

ABOUT THESE PHOTOS If you look closely at 4-15, you can see that the light is very harsh on the boy's right shoulder. Have an assistant hold the diffuser between the light source (in this case, the sun) and the subject. In 4-16, you see the results with the diffuser in place. 1/500 second, f/8 at ISO 200. ©Allison Tyler Jones / www.atjphoto.com

Film photographers have long struggled with color temperature in their images requiring special films or filters to correct the colorcasts created by different types of indoor and natural lighting situations. Digital has eased this dilemma by giving us the gift of white balance but you have to know how to use it in order to take advantage of it. If you've experimented at all with your digital camera, you might find that Auto white balance doesn't take care of everything. Photos with weird colorcasts to them (too yellow, too blue, greenish, and so on) mean that your white balance settings aren't working the way you'd like them to. Check your manual or the menus on your camera to see if you can manually set the white balance to accommodate the type of light you are shooting in.

Following are a few examples of lighting situations that might play tricks on your Auto white balance, requiring you to choose a specific white balance setting on your camera.

■ Daylight. By default, digital camera settings are geared to daylight photography. Daylight is considered neutral as far as color temperature is concerned — not too cool or too warm. Real life is different, however. Place a child on the shady side of the house and you might have an image with a decidedly blue cast. Shooting during the sweet light of early evening often casts a very yellow tone onto your subject. Check your white balance settings for Shade or Full Sun options and experiment with them until you come up with a result you like.

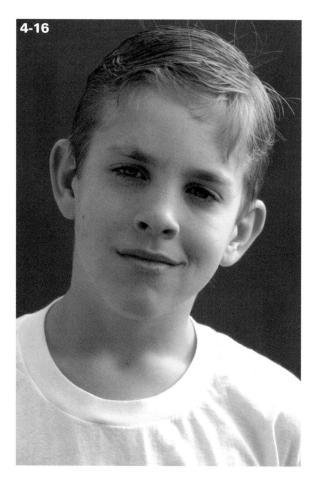

■ Flash. The flash on your camera is balanced to daylight color temperature. This allows you to use your flash as a remedy for lighting situations with extreme colorcasts. Using your flash might be your best option if you are having colorcast problems with your images and don't have custom white balance settings for your camera. For example, when you are stuck in a school gym with horrible fluorescent lighting, your flash is probably your best bet.

■ Fluorescent. Shooting under fluorescent light makes for sickly, greenish skin tones as in this photo of two little girls in dance class (4-17). If your Auto white balance setting isn't handling it well, switch to the Fluorescent setting in the White Balance menu on your camera, usually denoted by a mini fluorescent tube icon.

ABOUT THIS PHOTO The greenish cast of fluorescent lighting can wreak havoc with your Auto white balance. Look through your camera menus for a Fluorescent setting to balance the colors correctly. 1/250 second, f/3.5 at ISO 800. ©AllisonTyler Jones / www.atjphoto.com

4-17

■ Tungsten. Tungsten lighting is just a fancy name for the regular bulbs in your lamps at home. Tungsten or incandescent lights give off an almost orange light that can be used to great effect when photographing your Christmas tree lights or if you are looking for that warm look, as in 4-18. If not, adjust your white balance to the Tungsten setting, usually denoted by a small light bulb icon.

ABOUT THIS PHOTO Using regular tungsten or incandescent lighting casts a very warm glow on your subject that can be used for effect, as in this photo of a young boy in his home. 1/125 second, f/2.8 at ISO 1250. ©Allison Tyler Jones / www.atjphoto.com

- Shade. Shooting on the shady side of a building or under a tree during daylight hours can cause your images to be very bluish in color as in 4-19. Select the Shade setting in your White Balance menu, usually denoted by a little house icon showing shade to one side. The Shade setting offsets the color cast and results in a more pleasing image as in 4-20.
- Custom White Balance. Check your camera manual to see if your camera has a setting for Custom White Balance. This is the manual version of setting your preset white balance options. Most cameras require a white card or some kind of white balance tool (such as Expo Imaging's Expo Disc) to aid in setting a custom white balance. Setting a custom white balance might be a bit advanced if you are just starting out, but it is good to know it is available.

BASIC STUDIO LIGHTING

Studio lighting may seem mysterious and complicated but if you think about the big studio lights as oversized flash units or big windows, you might feel a bit less intimidated. Studio flash was created so that photographers could shoot at any time of day, in any weather and still get natural-looking results. Studio lighting also gives the photographer much more control over the lighting. Photographing children in a studio has its distinct advantages. Some photographers find it a bit easier to corral kids in the enclosed space of a studio. The quality of light produced by studio strobes tends to be a bit more sparkly than natural light and because these lights are essentially big flash units, they can freeze action very well.

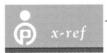

For more about hard and soft light, or light in general, see Chapter 3

ABOUT THESE PHOTOS In 4-19, the little girl was photographed on the shady side of a building. The shade plus the blue color of the surrounding walls made for a very bluish cast to the image. 1/250 second, f2.0 at ISO 400 on Auto white balance. In 4-20 you can see the same image with the colorcast corrected with the white balance set to Shade mode. ©Allison Tyler Jones / www.atjphoto.com

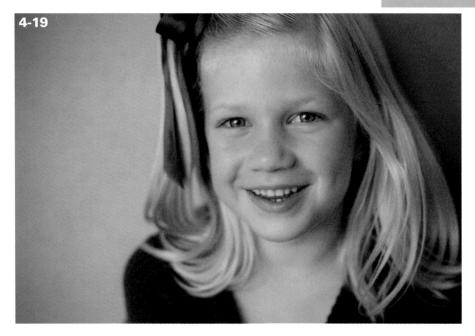

Everything you have learned up to this point is applicable in studio. Do you want the light to be hard or soft? Which direction do you want the light to come from? Are you looking for a flat lighting pattern or a more dimensional, contoured look?

ONE-LIGHT SETUP

Just about everything you want to do in a studio shoot can be done with a single light and a reflector. The single light provides the main light and the reflector fills in the shadows, keeping them from becoming too harsh and dark. This is the easiest and one of the most economical lighting setups if you are just starting out.

In 4-21, you can see that the flash head, in this case a *monolight*, has a large *soft box* attached to the front. A monolight is a flash head that has all the controls and power source built in to the head of the flash unit. Monolights are often less expensive than flash heads that require a power pack to run them. A soft box is a big black fabric box with a translucent front that acts as a diffuser, keeping the light from becoming too direct and harsh. The translucent material on the front of

the box spreads out the harsh light from the monolight creating a large, diffused light source. Also, note how close the light setup is to the subject. Keeping the light close, keeps the light soft. On the other side of the subject is a big silver reflector that throws light back into the face of the child being photographed keeping the shadows from becoming too dark on the right side of his face.

METERING

Monolights are fitted with modeling lights, which gives you an idea of how the light will fall on the subject. The actual illumination of the child, however, is done by the powerful flash inside the monolight unit. Because you can't see how the flash turns out until the photo is taken, it's a good idea to have a flash meter (4-22) that allows you to measure the light and get a starting point for properly exposing your image. Using a flash meter that is tied into your monolight either by a cord or a wireless device, measure the light and set your camera manually to the settings recorded by the flash meter.

WHAT ABOUT RED EYE? Red eye happens because the photographer is using oncamera flash in a darkened setting. The subject's pupils are more dilated so when the flash fires, the light reflects off the retina of your subject and shows up in your photo as red eye. Because most on-camera flashes are very close to the camera lens, the angle of the flash is too close to the angle of the lens allowing the light to more readily reflect off the retina.

How to avoid it? Try the *red-eye reduction* setting on your camera if you have one. If not, you might try raising the ambient light in the room by turning on more lights, which will close down the pupils of your subject, reducing the chance for red eye. If neither of these tips works and you do a lot of shooting in dark environments, you may want to consider a dedicated flash unit for your camera. Flash units typically sit higher on the camera, increasing the angle between flash and lens, thereby eliminating the red-eye problem.

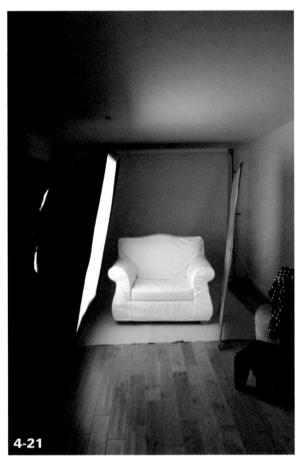

ABOUT THIS PHOTO The main light is fitted with a 4'×6' soft box that creates a large area of soft, even light. On the right side is a reflector to keep the right side of the child's face from becoming too dark. ©AllisonTyler Jones / www.atjphoto.com

If affording a studio strobe setup is not in your budget, you may want to experiment with halogen or tungsten garage lights from your local hardware store. Use caution, particularly with children, because these lights are very hot. For additional information on setting up your own economical home studio go to www.diyphotography.net.

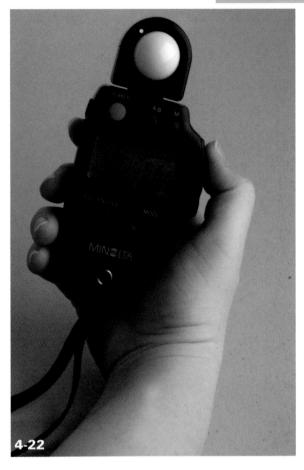

ABOUT THIS PHOTO A flash meter is a vital tool to ensure proper exposure of your studio flash images. ©AllisonTyler Jones / www.atjphoto.com

THE FINAL RESULT

The final result of the setup illustrated in 4-21 shows just how simple it is to create a pocket of gorgeous light to photograph children in, as shown in 4-23. You might also notice that the big chair is white, which catches the light and bounces it back into the child's face. Big chairs are also a good place to corral wild and wiggly kids for a quick photograph!

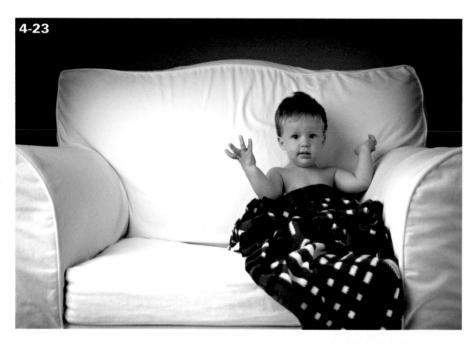

ABOUT THIS PHOTO
The final result of this lighting
setup. He looks like he's saying,
"Is that all there is to it?" 1/250
second, f/2.8 at ISO100.
©Allison Tyler Jones /
www.atjphoto.com

Studio photography doesn't have to produce the overposed, boring pictures of years gone by. The studio is a perfect place to, literally, do a study of and explore the personalities of your subjects. With no distractions in the environment, expressions and relationships are all you have to concentrate on as demonstrated in 4-24.

Learning to manipulate the light no matter where you are shooting will build your confidence as a photographer. Every professional photographer knows that you rarely happen upon the ideal lighting situation; instead, you have to work with what you're given, and sometimes it's that problem-solving that results in some of the best images you ever take.

Although it seems counterintuitive, the closer the light source is to your subject, the softer the light appears. The farther you move the light away, the harsher it becomes.

ABOUT THIS PHOTO This photo perfectly illustrates the personality and relationship between these two sisters. This was shot with the lighting setup outlined earlier in the chapter. 1/250 second, f/2.8 at ISO 100. ©AllisonTyler Jones / www.atjphoto.com

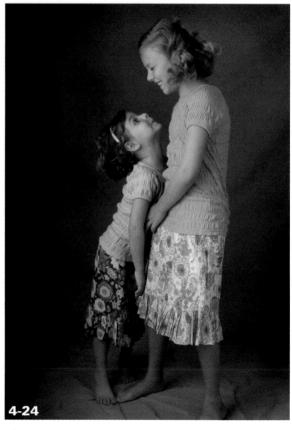

Assignment

Manipulating the Light

Choose one of the lighting situations described in the chapter and try to work out the lighting to best flatter your subject. You may want to experiment using a single window to light your subject or try using rim lighting to separate your subject from the background. Just try one of them and focus all of your attention on the lighting and how it is falling on your subject. Walk all the way around the child you are photographing, snapping photos from different directions and documenting how the light falls from different angles. Examine the results once you are finished and determine which lighting patterns most reflect your individual style.

In this image, the photographer chose to use the direct light shining on the little girl walking away. The light acts as a halo on her hair, which adds to the feel of the image. 1/200 second, f/2.8 at ISO 200.

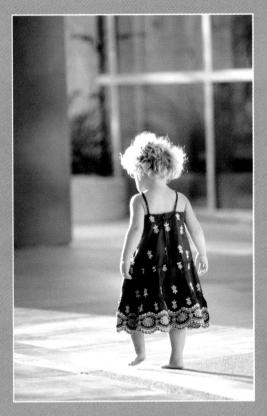

©Allison Tyler Jones / www.atjphoto.com

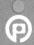

Remember to visit www.pwassignments.com after you complete this assignment and share your favorite photo! It's a community of enthusiastic photographers and a great place to view what other readers have created. You can also post comments, and read other encouraging suggestions and feedback.

SNAPSHOTS VERSUS PORTRAITS

FOCUS ON FEELING

KEEPING IT SIMPLE

FRAMING THE IMAGE

PARENTS AS PROPS

THE RULE OF THIRDS

Using Lines

Breaking the Rules

©Ginny Felch / www.silverliningimages.com

Composition refers to the arrangement of the elements in a photograph to create a pleasing whole. At its very essence, composition is a decision about what to include and, just as important, what to leave out of any given photograph. The human eye appreciates order of some sort and a place to go. As a photographer, your decisions about composition can help lead your viewer's eye to what is most important in your photograph.

Composition in photography is perhaps the most subjective element of all. For many great photographers, composition is unconscious or second nature; their sense of balance and emphasis comes naturally. Other photographers come from an art or painting background and have learned basic composition and graphic elements from that standpoint. Whether or not you have an art background, you can learn composition. All it takes is developing your eye. Learning the basic rules of composition will help you simplify and improve your photos immediately. When you have a firm grasp of the rules, you can afford to bend them a little, maybe even break one or two.

Start paying attention when looking at the work of other photographers. Where do your eyes land first? Was that the intention of the photographer, or was it an accident or a lack of attention to detail? The most common mistakes that amateur photographers make are not honing in on the subject or allowing distracting elements in the environment to lead the eye away from the most important elements in the photograph.

Composition can be learned but needn't be adhered to rigidly. Knowing some things about balanced and dynamic composition can only enhance your vision, but you must have the courage to choose what works best for you. It becomes another tool for expressing what you see and feel.

Visit this great Web page on photo design: www.photoinf.com/General/

Arnold_Kaplan/The_Magic_Of_Selective_Vision__Photo_ Composition.htm.

SNAPSHOTS VERSUS PORTRAITS

A photograph that reveals even one element of thoughtful composition can stand out in the crowds of snapshots filling up computers, hard drives, and online galleries. And why is that? What is the difference between a snapshot and a portrait? While many other factors, such as lighting or background, can be taken into consideration, the biggest difference between a snapshot and a portrait is how the image is composed. What is the point of composition in portrait photography of children? It is to draw the viewer's eye naturally to the child — plain and simple. Beyond that, you can use composition to create a feeling or tell a story. Looking at snapshots of children, what usually differentiates them from portraits is the inclusion of too much information or too much clutter.

Painters don't have to worry about an errant garden hose in the background, or a palm tree growing out of their subject's heads; if it's there, they just don't paint it in. Our cameras, however, capture just about everything we point them at. And because amateur photographers are more often concerned with capturing the subject, they often neglect to notice that they have also captured distracting elements in the background of their photos.

Before you snap the shutter, take a good look at the background. Make it right on your exposure and don't rely on fixing it later in an image-editing

software program. This is the habit of a good photographer. If what you are seeing through your viewfinder isn't pleasing, move around the subject and watch for changes of light, composition, and so on until you get the shot you want. It is this deliberateness to find the best light, composition, and so on, that takes your snapshot to a portrait.

FOCUS ON FEELING

A good place to start when learning composition is with a feeling. What do you feel about this child you are photographing? What do you want to convey about his or her personality?

Are you trying to convey a message that is bigger than just this child, a feeling about childhood in general? Is it the word *freedom* that inspires you when photographing a boy running through a field of grass as in 5-1? Sometimes starting with a word in your mind allows you to make a choice about what you include or exclude from the frame. For example, to convey that feeling, the composition was chosen so the viewer wouldn't know that this photo was taken right next to a busy intersection close to the middle of town.

Once you have an idea about the feeling you want to convey, many of the decisions about composition will flow from that initial idea.

ings about the subject shine through. Often the beauty and prejudices of the photographer show more in the photo than the subject itself." ~Eve Schell, writer

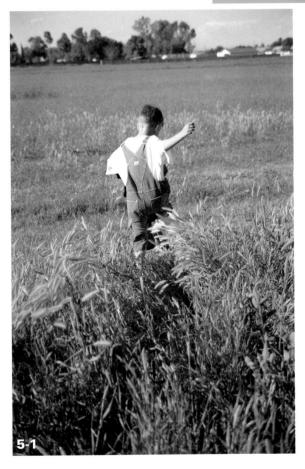

ABOUT THIS PHOTO The photographer left out the road to the right of the boy and only included the grass, the boy, and the horizon he was running toward. 1/500 second, f/5.6 at ISO 400. ©Allison Tyler Jones / www.atjphoto.com

KEEPING IT SIMPLE

Anne Geddes, a photographer famous for her photos of babies as flowers, said, "The hardest thing in photography is to create a simple image." Keeping it simple means showing only what tells the story and nothing else. A good starting place

87

for learning to keep it simple is to get close to your subject — really, really close. Zoom in and get just the face or the bits and pieces that tell the story. In 5-2, a photo of a newborn baby, there is no doubt what the subject of this photo is. This photo could be titled "New" because it highlights features that are unique to a newborn baby: the curled-up body, the wrinkles on the hands and toes.

ABOUT THIS PHOTO Zooming in close and getting just pieces of your subject can sometimes tell a larger story about miracles and new life. 1/250 second, f/3.2 at ISO 320. @Stacy Wasmuth / www.bluecandyphotography.com

WATCH YOUR BACKGROUNDS

You know the expression about real estate: "Location, location, location!" Well, part of your quest is indeed to find a location that is free from distracting elements as in 5-3.

The worst distractions in any image can most commonly be found in the background, behind your subject. When you first start out, it's easy to become so focused on the child that you don't even see what is behind him or her that might be distracting from the image.

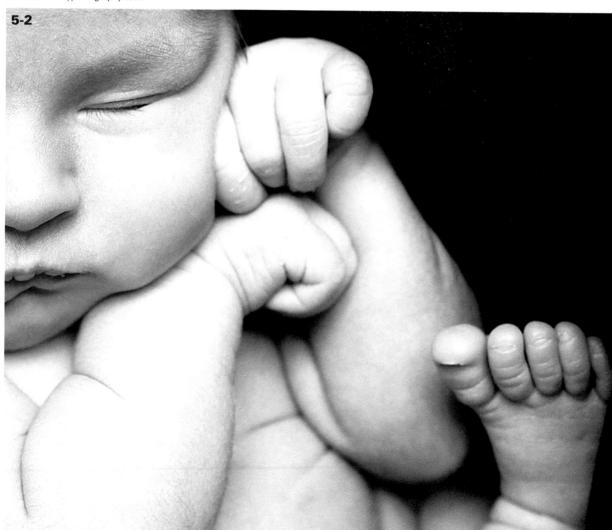

ABOUT THIS PHOTO

This simple composition of a little girl walking up a foggy dune path toward the sea resonates with the idyllic nature of quintessential childhood. 1/250 second, f/4 at ISO 200 (changed to sepia in post production). ©Ginny Felch / www.silverliningimages.com

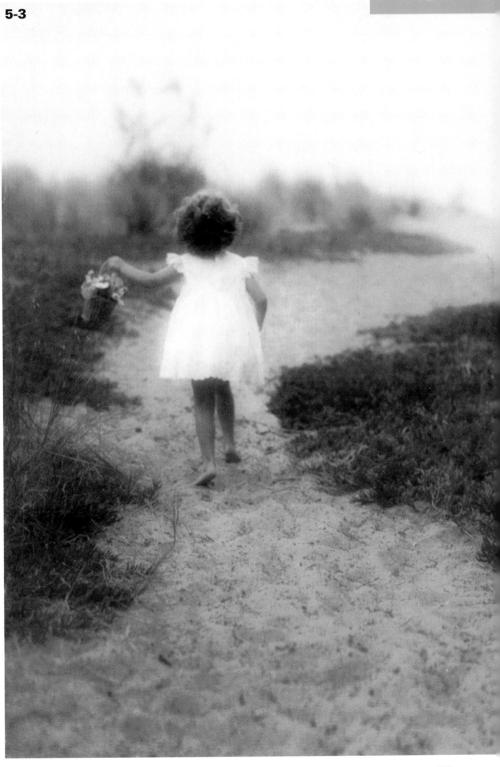

Distracting items such as tree branches going in awkward directions, bright splotchy leaves or holes of sunlight, fences, flowers, poles, furniture, and so on, can combine to clutter up an otherwise beautiful portrait.

The photo of a young family in a field shown in 5-4 is a perfect example of watching your backgrounds.

The photographer has been careful to isolate the family against the green grass while placing the horizon line above the heads of her subjects. The family home is present in the background, which adds an important but not distracting storytelling element to the photograph.

5-4 ABOUT THIS PHOTO

Isolating this family against lush, green grass simplifies the background and allows your eye to concentrate on the interaction of the family. 1/800 second, f/4 at ISO 200. ©Stacy Wasmuth / www. bluecandyphotography.com

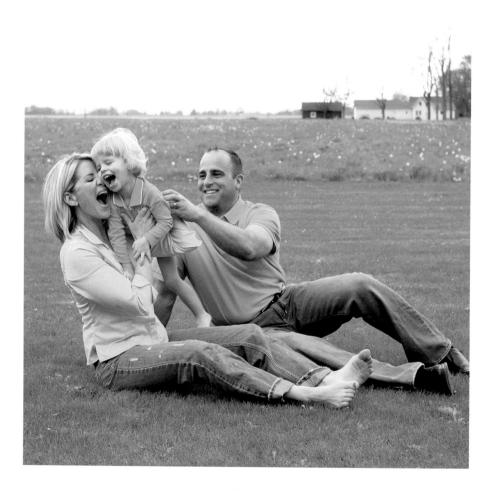

A good photographic practice is to check the four corners of your viewfinder before you press the shutter release, every time. Do you see anything in the background that is detracting from your subject? Does it look like something is growing out of your subject's head? Changing your position or the position of your subject might be all that's needed to simplify the background and improve your photograph.

When it comes to backgrounds, watch out for dark things in light places and light things in dark places. Squinting while looking at the background will immediately isolate distracting bright or dark spots. Watch, especially, for bright or dark spots directly behind and around your subjects that can take the eye away from your intended focus.

USING NEGATIVE SPACE

Use of negative space (space in your image where the subject doesn't appear) in a composition makes great use of the concept of simplicity, but also enhances the story. A little girl standing in the lower corner of expansive grass or a beach might look hopeful, mysterious, or even lonely. Be certain you are telling the story you want.

Negative space can emphasize the child as in 5-5, or it can give a child space to look or walk into as in 5-6. Negative space works kind of like a blank wall with one picture hanging on it; you can't help but notice that one picture. Using negative space in the composition of a photograph simplifies the composition and draws your attention to the child.

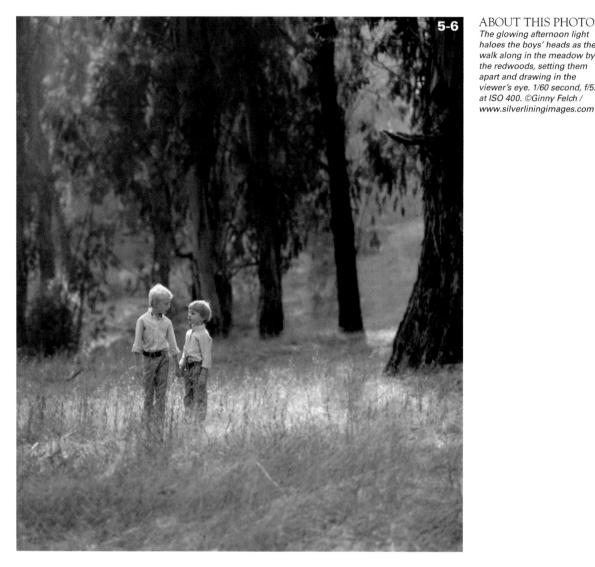

ABOUT THIS PHOTO The alowing afternoon light haloes the boys' heads as they walk along in the meadow by the redwoods, setting them apart and drawing in the viewer's eye. 1/60 second, f/5.6 at ISO 400. ©Ginny Felch /

FRAMING THE IMAGE

Even though digital editing makes it easier to crop and remove clutter in the background, it is a much better practice to learn to crop in the camera by just framing the image better to begin with rather than relying on cropping later. It is good training in observation to look carefully through the lens,

create a pleasing composition, and to keep an eye out for hot spots (bright highlights such as shiny leaves and other distractions). After you move the lens in and out and walk around the subject, if necessary, and you still can't avoid certain obstacles, consider using some of the techniques discussed in Chapter 2 for throwing the background out of focus by adjusting the depth of field.

GENERAL FRAMING GUIDELINES

Learning to frame your images while you are capturing them will improve your sense of composition immediately. Learn to benefit from the experience of photographers who have gone before you and made all the mistakes. The following are some general guidelines for framing your photo when working with children:

■ Hold the camera at the child's eye level.

This means you may need to stoop, bend, or kneel. Not only does this make the child more comfortable, but it creates a much more

pleasing image because this angle helps eliminate lens distortion (also known as big head, little feet syndrome demonstrated by 5-7), while at the same time imparting a sense of dignity and respect to little people, as in 5-8, who are often shot from above.

■ Never crop off the hands or feet. Either crop in close to the head and shoulders, move out and crop below the hands, or back off completely and include the whole body. Cropping at the joints (wrists, ankles, hips, or knees) generally makes for an awkward-looking photo.

ABOUT THIS PHOTO This is how children are often photographed: from a a standing position, looking down on them. This angle makes heads appear larger and feet tiny. 1/250 second, f/2.8 at ISO 100. ©AllisonTyler Jones / www.atjphoto.com

ABOUT THIS PHOTO Photographing a child straight on requires you to position the camera at the child's waist height, but the results are worth it. The proportions of her body are correct and there is a sense of dignity that is lacking in the earlier shot. 1/250 second, f/2.8 at ISO 100.
@Allison Tyler Jones / www.atiphoto.com

- As a general rule, don't place your subject in the very center of the photograph. Refer to general composition guidelines as discussed later in the chapter in the Rule of Thirds section.
- Leave plenty of growing room around the child in the image, particularly above the head. It is comforting visually to create a sense of space.
- If a horizon line is visible, be sure it is straight.
- Look carefully to see whether distracting elements are in the background. Look for hot spots, trees growing out of heads, wires, and so on; if you see distracting elements, move around until they are gone if possible or crop in close to simplify the image.
- If you are photographing a child in profile, be sure to crop leaving more space in front of their line of vision, as though they have some space to look into. This also applies to photos of children walking across the horizon line; give them space to walk into.

A well-composed photo is a photo in which every element has earned a right to be included.

FRAMES WITHIN THE FRAME

Employing simplicity in the design of a child's portrait includes the possibility of using certain strong elements, such as archways, windows, and doorways, to literally frame your subject within the frame of your viewfinder. Remember, all design elements should lead to, illuminate, or enhance your subjects. Finding frames in the environment to highlight an important part of your image can hold the viewer's attention.

Arbors, curving trees, and foliage can create a natural vignette to surround and frame your

subject as well. If the background is generally light, a darker shape that subtly or distinctly surrounds the subject can be extremely effective.

Consider the pleasing shapes in the environment that you can use as a frame, particularly circles, ovals, squares, and rectangles.

x-ref

The environment you choose to shoot in can dramatically affect the

style of your photography. Look through the different styles explored in Chapter 6.

Paying attention to what is beyond, behind, or surrounding your subject can make a world of difference in adding drama and focus to your photographs. Your eyes become trained to notice these elements as you pay attention and observe. After you become more experienced and spontaneous, you can take chances with new locations that you haven't preobserved. Many children's photographers use the same locations over and over because it is safe, and it is easy to understand why. There is already so much unpredictability when working with children. However, the more experienced and observing you are, the more you can take the risk of exploring new territory, with possibilities of great serendipity.

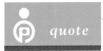

"Kids: they dance before they learn there is anything that isn't music." ~William Stafford

Psychologically, framing can make a statement as well. A soft, circular vignette can give a sense of security, comfort, and safety; while a bold or rugged rectangular frame gives strength to the image, as in figure 5-9. Making these choices carefully and thoughtfully will result in making stronger images that leave no doubt as to what you're trying to say.

ABOUT THIS PHOTO I often use architectural walls, doorways, or archways to lend strength to a portrait, as shown here. The void space above gives a scale to the size of the children as well. 1/60 second, f/4 at 160 ISO. ©Ginny Felch / www.silverliningimages.com

Notice where the subject is placed in a frame or vignette. A child gazing out a window might denote pensiveness as in 5-10. A small child in a large frame might look free and adventurous with a lot of growing ahead of him.

"To take photographs is to hold one's breath when all faculties con-

verge in the face of fleeing reality. It is at that moment that mastering an image becomes a physical and intellectual joy." ~Henri Cartier-Bresson

ABOUT THIS PHOTO A pensive mood is captured here as the boy is looking out; his diminutive size is emphasized by the scale of the window frame. 1/500 second, f/4 at ISO 400. ©Melanie Sikma / www.melaniesphotos.com

PARENTS AS PROPS

Adding parents to the photograph can help your composition in a variety of ways. It allows the child to feel more comfortable being photographed while adding a storytelling element to your image as in 5-11. Plop an insecure toddler or a floppy newborn over mom or dad's shoulder as in 5-12.

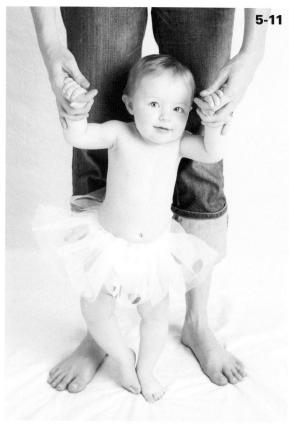

ABOUT THIS PHOTO You don't need to see the whole parent to know that this is an image about a family. Use the height difference of adults and children to your advantage and frame a toddler using the legs of her parents as a backdrop. 1/125 second, f/3.5 at ISO 100. ©Kim Heffington / www.kimheffingon.com

THE RULE OF THIRDS

For centuries, artists and architects have been guided by the Rule of Thirds, which is thought to have derived from the Greek Golden Ratio. The Rule of Thirds is just a technique for learning to position the elements within a photograph in a pleasing way, which is a great starting point for advancing your knowledge of composition. The Rule of Thirds, as applied in photographic terms, takes into account that the format of a camera viewing screen is usually rectangular in shape and that placing your subject in certain areas of that

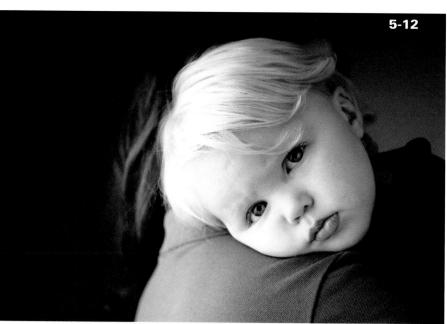

ABOUT THIS PHOTO A shy toddler might be more comfortable and expressive viewed from the comfort of mom's shoulder. 1/250 second, f/2.8 at ISO 100. ©Allison Tyler Jones / www.atjphoto.com

•

tip

Check your camera manual to see if your camera has custom viewfinder

settings. Many digital SLRs allow you to select a grid in your viewfinder, which is a fabulous aid when practicing the Rule of Thirds in your own composition.

rectangle can make the difference between a so-so image and a much more interesting photo. You can use this rectangle horizontally (landscape) or vertically (portrait) as in 5-13. Divide the viewfinder into thirds both horizontally and vertically (see 5-14). The points where these lines intersect are points where your subject or parts of your subject can be placed for more dynamic composition.

5-13

ABOUT THIS FIGURE The diagram shows the Rule of Thirds so that you can see where the lines intersect. Those intersections are where you want to place your subjects in this kind of composition. The circles indicate placement possibilities.

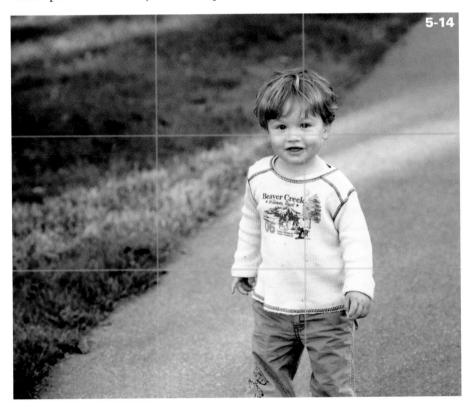

ABOUT THIS PHOTO

This bright and expressive child comes right to you on the diagonal path; notice the diagram showing that his head has been placed in one of the four points of interest. 1/400 second, f/5.0 at ISO 800. ©Ginny Felch / www.silverliningimages.com

Often, one of the first things you hear as a photographer is, "Don't center your subject." Or, "Don't center your horizon." Try centering a few photos and then retake them using the Rule of Thirds. Compare them and it becomes clear that centering the subject often creates a static effect — think twice before using that composition.

These guidelines are a wonderful starting point to get yourself thinking about composition and noticing where the eye flows. The way to find your own signature, to express your own vision, is to decide every time you click the shutter what it is you feel and how you want to reveal it. Remember, these are merely guidelines to teach a technique.

■ Rule of Thirds in the environment. The easiest way to begin using the Rule of Thirds is in an environmental shot. It is easy to place your subject in the upper or lower third of the picture and let the environment help tell the story as in 5-15.

"When you are dealing with a child, keep all your wits about you, and sit on the floor." ~Austin O'Malley

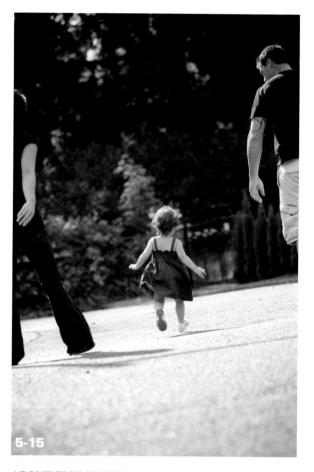

ABOUT THIS PHOTO Placing this little girl escaping from her parents in the lower third of the frame and including parts of the parents tells a story about an independent little girl who has ideas of her own. 1/250 second, f/2.8 at ISO 100. ©Allison Tyler Jones / www.atjphoto.com

DISCOVERING THE GOLDEN RECTANGLE: DIVINE PROPORTION Another interesting compositional shape or formula is the golden rectangle, Golden Ratio, or divine proportion. This concept dates back to the ancient Greeks. If you think of the shape of the nautilus shell, with the outward spiraling-shape within the space of a rectangle, you might begin to comprehend the Golden Ratio.

Check out http://fotogenetic.dearingfilm.com/golden_rectangle.html to see great descriptions and examples of this theory. You can also try an e-book of the out-of-print book by Cartier-Bresson called *Decisive Moment*. It can be found at http://e-photobooks.com/cartier-bresson/decisive-moment.html. As you browse through Cartier-Bresson's images, try the exercise of observing the motions of your eyes as they scan the compositions. I found it rather breathtaking to see his consistent use of divine proportion.

■ Rule of Thirds in a headshot. What if you favor close-ups? How does the Rule of Thirds apply then? You can immediately see the impact the Rule of Thirds can have on a simple headshot by comparing 5-16 and 5-17. In 5-17 the placement of the boy's eyes is more dynamic, keeping your attention longer.

USING LINES

Lines are everywhere from the curves of a child's sweet profile to the lines in the horizon or a pathway through the woods. Learning to see lines and shapes when creating images can open a whole new way of photographing your subject, allowing you to direct the attention of the viewer exactly where you want it to be.

ABOUT THIS PHOTO When photographing a close-up of a child's face it is best not to have their eyes at dead center which makes the forehead appear too large and gives a static appearance to the image. 1/125 second, f/2.8 at ISO 400. ©AllisonTyler Jones / www.atjphoto.com

PARALLEL LINES

A useful visual dynamic in composition is learning to see parallel lines in your photographs. This is particularly useful in nature or landscape portraits, where visual lines are often formed by horizontal planes created by land and sky. A literal translation of this dynamic would be a view of the beach, in which the sand might form one line, the dark and textured water forms the second line, and the sky forms the third parallel line. You don't always have to think in thirds, but the composition is more pleasing, less static, and more balanced if you use parallel lines in uneven numbers.

In general, seeing and using parallel lines, both horizontal and vertical, makes for dynamic compositions.

ABOUT THIS PHOTO Placing the eyes of your subject in the upper third of the frame creates a more dynamic composition. 1/125 second, f/2.8 at ISO 400. ©AllisonTyler Jones / www.atjphoto.com

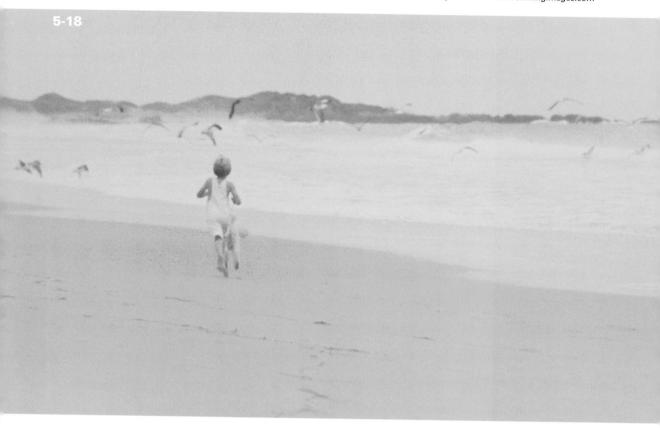

After you become used to seeing the Rule of Thirds proportions in a landscape, start to evaluate and plan how you might use this knowledge in a portrait. You can actually use the spaces between the lines to frame the subject(s). You want to be careful not to have one of the lines running through a child's head, for example. In 5-18, a boy and his dog are running on the beach, and although the lines aren't straight, a sense of direction and framing still exist in the lines created by the sky, the beach, and the sand. The photographer intentionally clicked the shutter when she felt that his head and body would be

nicely set apart by the white foam of the sea. The fact that the line of the beach is not straight creates a nice directional line that leads to the subjects. The footprints in the foreground show direction as well as add nicely to the texture. You can see here how successfully the composition sets up the story of the photograph.

Trees, columns, and other vertical and parallel objects can give a sense of balance in a photograph. Vertical parallel lines can lend solidity to a photographic composition and psychologically provide stability.

DIAGONAL LINES

Another commonly used principle of design is the diagonal lead-in line. This diagonal can come from such things as a shadow, path, road, swath of light, fence, lined-up objects, and so on, and it can occur anywhere in the photograph that effectively points toward the subject. Use of diagonals can add a sense of movement to your photographs. The diagonal line in 5-19 gives the boy a place to go and captures the viewer's imagination. Where is he going? What's at the end of the path?

The diagonal can be taken into consideration in posing children or families. For example, legs or arms can be used as a diagonal leading line. Using walls, walkways, or even the patterns of bricks in a wall as in 5-20 and 5-21 can lead the viewer's eye to your intended subject. Taking just a second to see the lines in your surroundings can make an enormous difference in the dynamics of your photographs. If you have children walking on a path, you can always move slightly until the path runs diagonally in your viewing screen.

ABOUT THIS PHOTO Notice how the diagonal line formed by the path through the grass leads your eye into Nick and then gives you a sense of forward movement and direction as well. 1/250 second, f/5.6 at ISO 200. ©Ginny Felch / www.silverliningimages.com

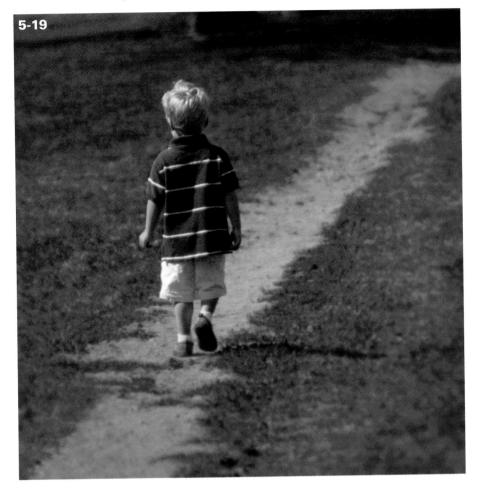

ABOUT THIS PHOTO The photographer used the brick pattern on the side of an abandoned building to draw the viewer's eye directly to the little boy. The big wall also provides a sense of scale. 1/320 second, f/5.6 at ISO 200. ©Jeffrey Woods / www.jwportraitlife.com

CONVERGING LINES

Converging lines play a similar role in composition to diagonal lines in terms of a powerful lead-in to the subject. These lines are even more commanding, because two diagonal lines come together at one point, giving you direction to the subject. You can see a great example in 5-22 where the lines of the handrails leading to the beach frame this little man who seems to know just where he is going.

ABOUT THIS PHOTO Using a wide angle lens allowed the lines created by the architecture of this building to draw the viewer's eye directly to the family. 1/40 second, f/16 at ISO 200. ©Jeffrey Woods / www.jwportraitlife.com

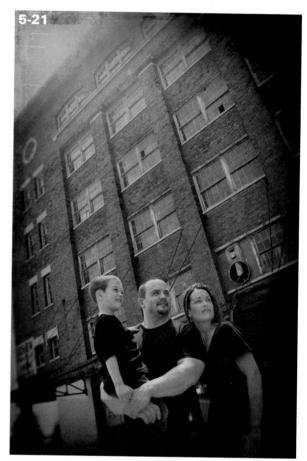

S AND C CURVES

Straight lines are just one way to add impact to a photograph. Exploring curving lines is one more way to explore lines in your work. Although the diagonal leading line is more direct and perhaps more powerful, a curve is a subtle and gracious way to direct the eye. S-curves and c-curves are very graceful and beautiful compositional elements and can often be found in the environment as well as in the body, posture, or face of the child you are photographing.

CHAPTER 5

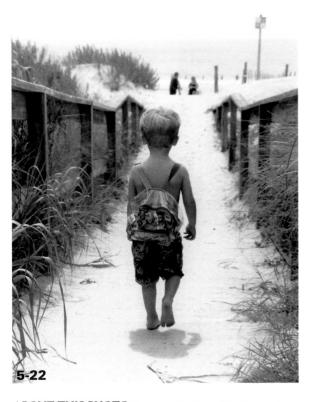

ABOUT THIS PHOTO The converging lines of the fence and placement of the little boy lead you to his destination, the beach. 1/250 second, f/4 at ISO 400 (sepia toned). ©Heather Jacks

Photographing children on curved paths gives a sense of freedom and adventure, forward movement, security, and direction. It offers a way for the viewer to visually enter and leave an image in a pleasing way. Curves can be found on curved beaches, rivers, paths, roads, and so on. They create a sweeping movement toward your subjects if you set it up to do so. You can find a location in just the right light for optimizing the appearance of the curve and have the child just start walking

in one direction or another. As she walks, you start to see where the positioning becomes a powerful visual and click the shutter, as in 5-23. It becomes a wonderful opportunity for free movement and very spontaneous poses.

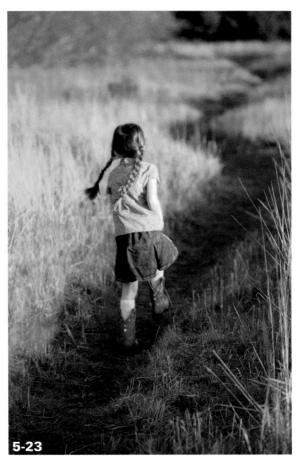

ABOUT THIS PHOTO Daisy skips along the coastal path, which forms a wavy s-curve. Placing her in the foreground and leaving space above her gives her lots of room in which to move. 1/250 second, f/5.6 at ISO 400. ©Ginny Felch / www.silverliningimages.com

Curves are naturally pleasing compositions for creating stunning children's portraits, but curves like those in 5-24, the strong curve of a father's arm, and 5-25, the line of handprints in the sand, are not always easy to find, so keep your eye out for possibilities.

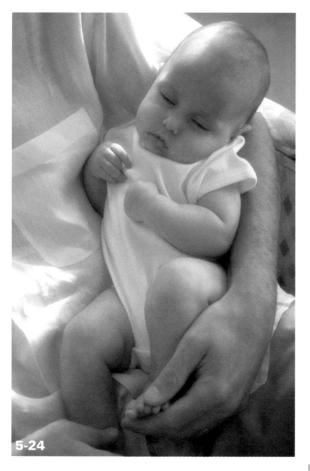

ABOUT THIS PHOTO The strong curve of the dad's arm gives a sense of security and connection, framing the sleeping baby. This image has the feeling of a cozy nest. 1/125 second, f/4 at ISO 400. ©Ginny Felch / www.silverliningimages.com

Curves in the bodies of your subjects can be hard to see when you are actually taking the photo, but sometimes you'll get lucky and see it after the photo has been taken. Learn to see the curves in the stance of a little ballerina with her hand on her hip or the curve of a baby's cheek when sleeping peacefully.

BREAKING THE RULES

There is a common and ironic secret that wise photographers hold: You must learn all the rules to know when you are breaking them. Studying and learning to apply the rules correctly gives you the confidence to stray from the path when the creative urge strikes.

It is unfortunate that many photographers have painstakingly learned the rules only to turn out photograph after photograph that adheres to the rules yet leaves the viewer cold. So learn the rules and then take some chances. You'll make a lot of mistakes along the way, but those mistakes often teach you more than your successes ever do.

As you go through the process of learning the rules and looking more analytically at images, you begin to develop an eye for composition. Once you've seen a horizontal line running through a child's head in one of your photos, you'll never again look through your lens and allow that to happen. A lot of practice and a little patience help you learn from your mistakes.

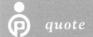

"There is a garden in every childhood, an enchanted place where

colors are brighter, the air softer, and the morning more fragrant than ever again." ~Elizabeth Lawrence

And, by learning from your mistakes, you can be bolder and take more risks. For example, observe the composition in 5-26. This image has an unconventional composition, yet it is a very strong image.

Many professional photographers would say that no image is ever really final. They gather inspiration by continuing to critique, to edit, and to look through the lens or at an image with a new eye. After years of practice and lots of trial and error, accomplished photographers look through the lens with confidence in their eye and skill. They have learned what works for them, and they can spend their time pursuing more creative images rather than worrying about the rules or techniques.

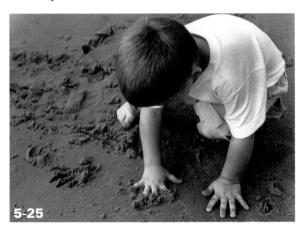

ABOUT THIS PHOTO The curved shape of the prints in the sand swirl your eyes to his hands and then up to his shirt and head. 1/250 second, f/4 at ISO 400. ©Theresa Smerud

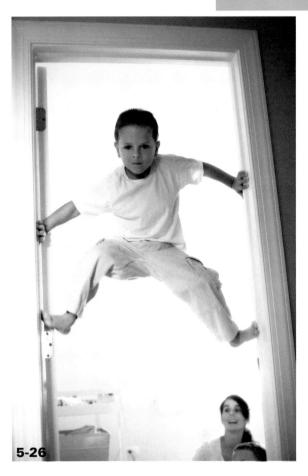

ABOUT THIS PHOTO What a dynamic photograph of this little boy showing off his Spidey abilities. The strong composition employs use of framing and placing his head in a place of impact. 1/80 second, f/2 at ISO 500. ©Marianne Drenthe

The conscientious choice to break rules that you have learned to understand and see when framing a photo is a creative choice as in 5-27. You make this choice perhaps without even thinking of the rules. You click the shutter at the right moment for you, and you love what you see. It might have the sub-

ject centered, or it might show the child with a big cheesy grin. The expression might be extraordinary, the lighting only adequate, but somehow it works.

"You can do anything with children if you only play with them." ~Prince Otto von Bismarck

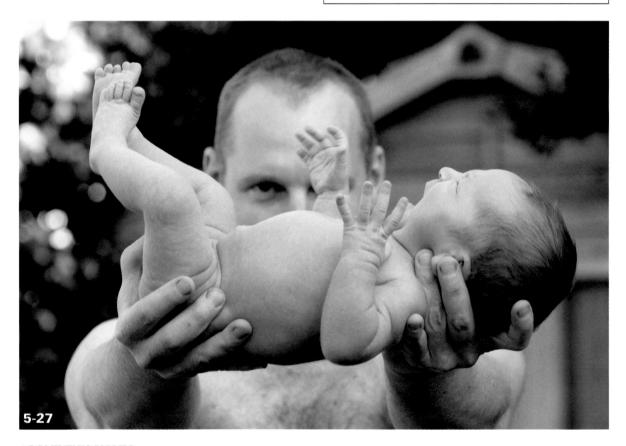

ABOUT THIS PHOTO Keeping an eye on his baby son, this masculine pose exquisitely breaks all the rules with a powerful result. 1/60 second, f/4.5 at ISO 200. ©Leslie Chapman

How often have you been in a situation where you just miss a shot because the light disappears, the child moves, and so on? Working in the environment of children's portraits, so much is out of control and unpredictable in even the best of circumstances. If you stay open, ready, flexible, and patient, you will be graced with happy accidents like the image in 5-28.

Don't be discouraged. Keep your eye to the viewfinder, stay open and spontaneous, and those happy accidents may become some of your favorite images.

"We find delight in the beauty and happiness of children that makes the heart too big for the body." ~ Ralph Waldo Emerson

ABOUT THIS PHOTO This shot could never have been planned, but the photographer recorded a riotous moment in a toddler's day, 1/800 second, f/1.2 at 100 ISO. ©Scarlett Photography

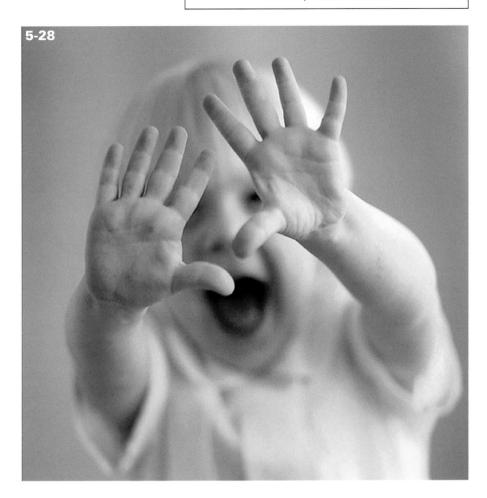

Assignment

Delivering Your Subject

Choose one of the elements from the chapter (for example, c-curve, s-curve, diagonal leading line, and so on) and create a strong composition using this element. Be sure that the child or children as subjects are delivered to the viewer.

I chose to use the vertical, parallel lines of the iron fence shown here. The color harmony, as well as the placement of the little girl's head, comprises a compelling image. 1/125 second, f/4 at ISO 200.

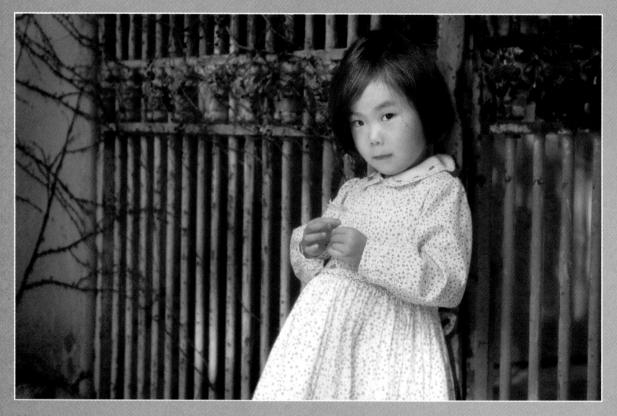

©Ginny Felch / www.silverliningimages.com

Remember to visit www.pwassignments.com after you complete this assignment and share your favorite photo! It's a community of enthusiastic photographers and a great place to view what other readers have created. You can also post comments, and read other encouraging suggestions and feedback.

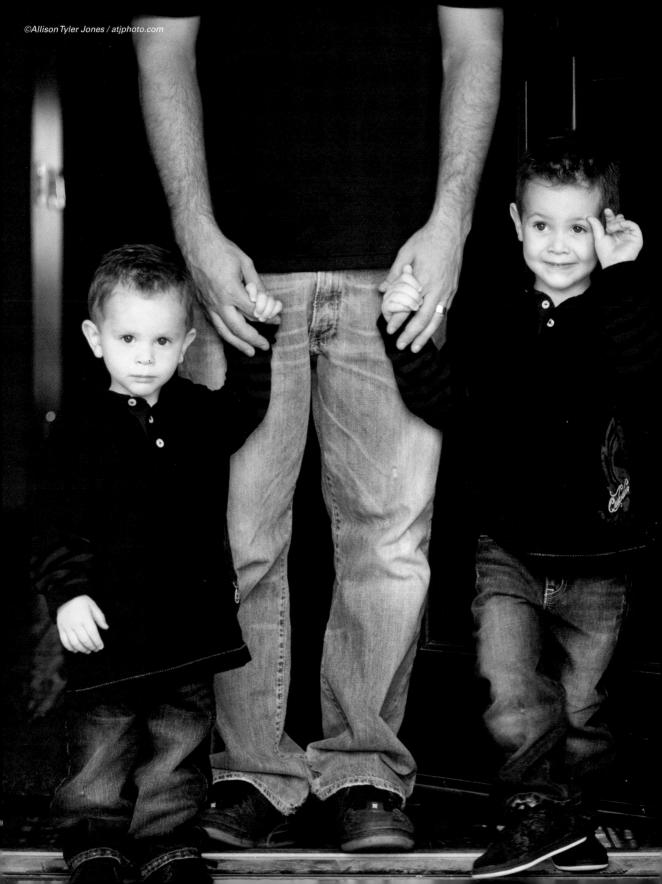

CLASSIC AND ROMANTIC

CONTEMPORARY

PHOTOJOURNALISTIC STYLE

PREPARING PARENTS FOR THEIR CHILD'S PORTRAIT

PORTRAIT PLANNING

If you asked ten different photographers to photograph the same child in the same setting, you would have ten different interpretations of that same child. Just as the children you photograph, each photographer is unique in his or her view of the world. Some bring a fresh, hip perspective to their work with children, while others prefer to capture childhood in a more timeless, less trendy fashion. What is your style? Do you have one yet? While most photographic work can't simply be slotted into one category or another, it is helpful to make some broad generalizations when you're starting out to give you a point of departure for your own work.

No matter what style of photography inspires you, it's a good idea to try a little bit of everything when you start out. Learning to experiment with different locations and settings can give your inspiration a boost. This chapter shows you some ways to expand your skills and try some new styles.

CLASSIC AND ROMANTIC

Many parents appreciate portraits that reveal a sense of timelessness. The classic style of child photography has its roots in the paintings of the old masters. Drawing on the style of painters such as Rembrandt, Vermeer, and others, the classic and romantic style of children's portraiture can often be seen as an idealized version of childhood.

Start an idea file of photos that you've clipped from magazines and/or bookmark your favorite Web sites that show photography that inspires you. As your skill level increases, these references give you inspiration for your own work.

IN THE STUDIO

When shooting in the studio, a classic portrait becomes a study of the child you are photographing. There are no distracting elements to take your attention away from the child, leaving only their expressions and gestures to tell the story. In many ways, capturing a storytelling image in the studio is much more challenging than shooting on location where you can rely on the environment to tell part of the story.

In a photograph that is low key, the background is darker and perhaps more colorful, as in a garden or forest. If the clothing is darker as well, the attention again goes to the skin tones, or the lightest thing in the photograph, as in 6-1. Classic and romantic styles work well with painted muslin or canvas backgrounds that give a painterly feel to the image.

ABOUT THIS PHOTO A classical portrait of two sisters was captured in the window light in front of a painted backdrop. The tones of the dresses and the background make a low-key image. 1/30 second, f/4 at ISO 400. ©Lizbeth Guerrina

CHAPTER 6

Classic and romantic needn't mean stuffy and stylized. In 6-2, a baby portrait is given a fresh look by framing the baby in the lower-right portion of the image while using a classical background and lighting treatment.

ON LOCATION

For classic and romantic portrait styles, seek soft light and a quiet, peaceful location. Figure 6-3 of the little girls on the pier reveals a little bit of the

ABOUT THIS PHOTO A twist on the classical baby portrait is achieved by ingenious composition. 1/60 second, f/2.0 at ISO 400. @Jeffrey Woods / www.jwportraitlife.com

relationship between them just by body language. The older girl puts her arm out to her younger sister who has found something in the water that has caught her eye.

When children are quiet and wistful, their eyes are often open wide and their cheeks are soft and full. On the other hand, never let a spontaneous, energetic, or spunky moment, as in 6-4, go unphotographed! Shooting these moments on location allows you to tell a more layered, romantic story. Photographing on the family's property or at a favorite place adds meaning to the photograph that just isn't possible in a studio environment.

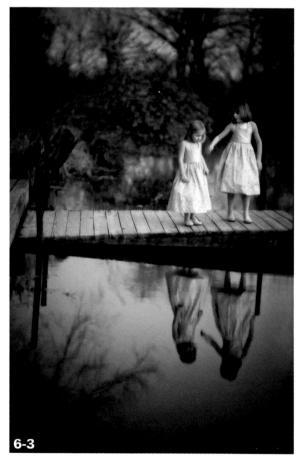

ABOUT THIS PHOTO The soft, almost misty atmospheric light accentuates the color of the sky and pond and surrounds these two sisters and their reflections in pink. Their placement allows for a sense of place and space. 1/125 second, f/1.2 at ISO 800. ©Marianne Drenthe

ABOUT THIS PHOTO Does it get any better than wearing your tutu on a summer day? This expression begs otherwise! The backlighting and framing by the foliage adds to what is already a beautiful image.

1/125 second. f/5.6 at ISO 320. ©Patrisha McLean

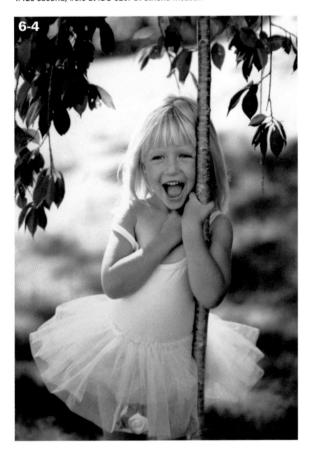

Talk to parents about your desire to work in the best and most dramatic lighting situations you can find as in 6-5. Many times, they aren't as aware as you are of what that actually means, so you need to help them understand so they are cooperative.

As you know, choosing the best location is dependent on available light. You can't always count on the very best, but you can surely try. Let parents know that late afternoons, when the sun is at an angle, provide a beautiful and luminous warm light. Foggy days work really well at the beach. Visit ahead of time to see what you can expect the day of the session. Maybe the parents can along with you to see what you are looking for and, thus, are able to further collaborate to make a better portrait. Whatever it is you personally want to convey, share it with parents so you are in accord with what is going to be created.

In almost every major metropolitan area there are botanical gardens and parks. These are good places if you live in an urban area and want to add the feel of nature in your work. Don't overlook buildings or areas with classic architecture to enhance your images. If you live in rural areas, meadows, orchards, and fields are at your disposal. Take advantage! If you are lucky enough to live near the ocean, beaches are a lovely place to photograph children.

CLOTHING

For a classic portrait, you want the clothing to be as timeless as possible. Distracting logos, plaids, and large stripes can often distract from the child. Solid colors and timeless clothing designs such as white dresses for girls and button-down shirts and jeans for boys leave the emphasis on the child. Avoid huge hair bows and uncomfortable clothing for babies. Babies are often best photographed au naturel (with no clothes at all)!

Watch out for shoes as well. Nothing dates a photo faster than ever-changing shoe styles, so when in doubt, go for bare feet.

ABOUT THIS PHOTO

The young ballet dancer practices her moves as the afternoon light adds a capricious shadow to her performance.
1/200 second, ff.6. at ISO 400.
©Scarlett Photography

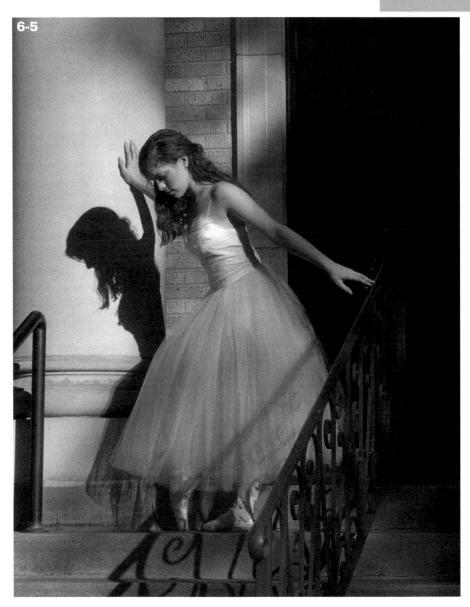

In 6-6 you can see that the subjects are all dressed in light-colored clothing and the background is pale and muted; the clothing is purposely selected to be as light and airy as the surrounding background so that the faces of the children stand out as the primary interest.

Clothing should not overwhelm or distract from your subject. In both 6-7 and 6-8 you see the boys, not their clothing. If either had been wearing a T-shirt with a big logo or stripes, these images would have had a completely different look.

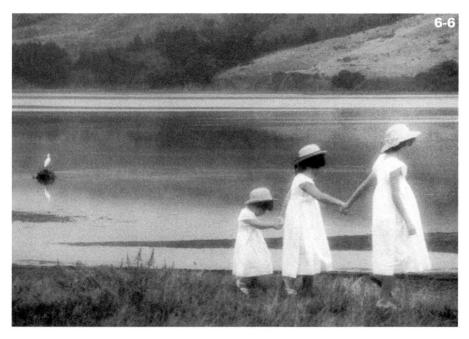

ABOUT THIS PHOTO Romantic, painterly, and tranquil, this composition of three sisters at the foggy lagoon is pleasing to the eye. Notice the unity of color as well as the horizontal parallel lines. 1/250 second, f/5.6 at ISO 200.

©Ginny Felch / www.silver liningimages.com

THE KEY OF LIGHT Just as music is played in different keys, light can also be keyed to the mood you want to portray. A great deal of latitude exists in between these examples, but they demonstrate an important point: The faces, eyes, and skin tones of the child are emphasized by choosing clothing and surroundings that suit the mood of the portrait envisioned by the photographer. Parents might have a preference for one style over another, so it helps to show them photographs you have made beforehand that demonstrate the following styles.

A low-key portrait is one in which the tones of the image are predominantly dark (or low), leaving the skin tones of your subject as the lightest part of the image. Typically high in contrast, a low-key image can be very dramatic and moody.

A mid-key portrait is made up of predominantly middle tones such as grays in a black and white photograph. Low in contrast, a mid-key portrait can be soft and soothing.

A high-key portrait is predominantly light in tone with the skin tones being the darkest part of the image allowing them to stand out. Usually low in contrast, a high-key image can be ethereal and romantic.

GHAPTER 6

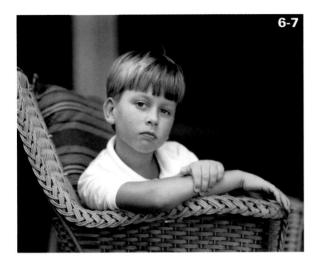

ABOUT THIS PHOTO The slight tilt of the head, the penetrating eyes, and the curved framing accentuate the relaxed pose of the boy in this strong composition. 1/250 second, f/1.8 at ISO 100. ©Scarlett Photography

ABOUT THIS PHOTO Although this photo was made many years ago, the timelessness of the location and clothing selection keeps it as classic today as the day it was photographed. 1/250 second, f/1.8 at ISO 100. ©Ginny Felch / www.silverliningimages.com

CAPTURING THE MOOD

All of the decisions you make, whether it's the location, the lighting, or the clothing you've selected, add or detract from the mood you are trying to convey. Deciding ahead of time what mood you would like to convey in your image is the key. What are you trying to convey about this child and her personality? What elements in the surrounding environment can you use to support

your vision? Do you want an image full of energy and whimsy or is the child more thoughtful and shy? For example, the soft light and bright sari that surrounds this young girl's peaceful countenance in 6-9 highlight her beautiful brown eyes and enigmatic smile causing the viewer to ponder what she might have been thinking when this photo was captured. The mood is serene and thoughtful.

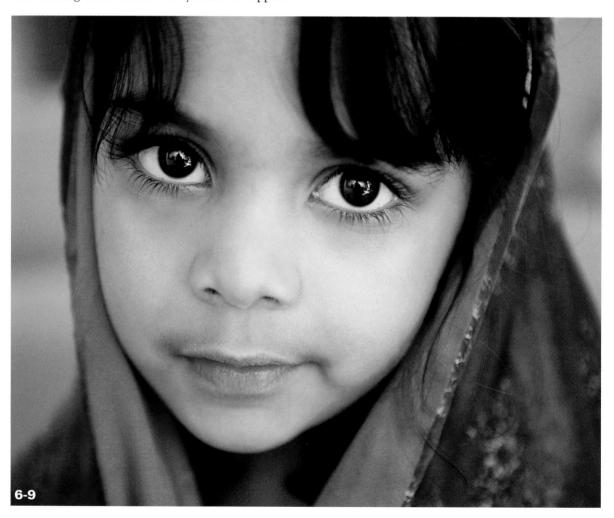

ABOUT THIS PHOTO The photographer just let this little girl be herself, resulting in a beguiling little smile rather than a cheesy grin. 1/125 second, f/2.8 at ISO 1600. ©Melanie Sikma / www.melaniesphotos.com

A tranquil, otherworldly feeling permeates the image of two sisters on a chair in the middle of a meadow as the wind plays through the grass in 6-10. An entirely different mood would have been captured had the girls been in bright-colored dresses while running through the grass.

quote

"When the first baby laughed for the first time, the laugh broke into a

thousand pieces and they all went skipping about, and that was the beginning of the fairies." ~Sir James M. Barrie, in Peter Pan

CONTEMPORARY

Contemporary children's portraiture is whatever is trendy and cool at the moment but even within current trends there is a strong thread of timelessness to these images. A contemporary style tends to break with tradition. Instead of stylized posing, the idea is to encourage the real personality of the child to come to the forefront. Chopped-off heads and full-out belly laughs are just right for this style of portraiture.

IN THE STUDIO

Studio photography lends itself very well to contemporary portraiture, as much of this style is inspired by magazine advertising. Seamless paper backgrounds work well for a contemporary feel. Inexpensive and available in a wide variety of colors, seamless backgrounds can give you many background choices for much less money than canvas or muslin backdrops.

ABOUT THIS PHOTO These sisters were placed in an antique chair in the middle of a meadow of blowing grass for

antique chair in the middle of a meadow of blowing grass for an image with a romantic mood. 1/320 second, f/3.5 at ISO 400. ©Jeffrey Woods / www.jwportraitlife.com When attempting a contemporary style in the studio, the idea is to set up the lighting so that a fairly wide area is well lit allowing the subject a bit of room to move around. As in the photo of two sisters in 6-11 — the background doesn't compete for attention and a fan blows their hair giving movement to the image.

Sometimes, extreme cropping can give an edgy, contemporary feel to your images. The images in 6-12 and 6-13 both take advantage of negative space allowing all the focus to fall on the subject. Who says your subject's head has to be in the photo? In 6-13 you get a good sense of this little boy without ever seeing his face.

ABOUT THIS PHOTO A more contemporary treatment of a sisters' portrait utilizes a white background and fan to provide movement in their hair. 1/125 second, f/2.8 at ISO 100. ©Jeffrey Woods / www.jwportraitlife.com

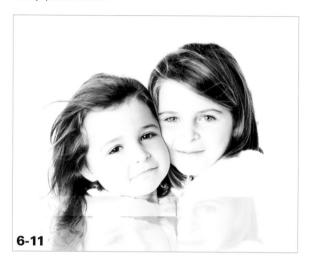

ABOUT THIS PHOTO The photographer placed this little girl in the far right of the frame, which adds to the contemporary feel of the image. 1/125 second, f/3.5 at ISO 100. @Jeffrey Woods / www.jwportraitlife.com

ABOUT THIS PHOTO Those hands in the pockets tell a story all on their own. Extreme framing with lots of negative space gives this image an of-the-moment contemporary vibe. 1/60 second, f/10 at ISO 125. ©Jeffrey Woods / www.jwportraitlife.com

6-13

GENERAL CLOTHING GUIDELINES Parents need to know that the whole idea of fussing about clothing serves but one purpose: not to draw attention away from a child's beautiful, soft face. That is why it's important to have certain guidelines about clothing, which, when followed by parents, result in great photos. Regardless of your style, the general guidelines here should serve you well.

- Suggest avoiding bold stripes, plaids or prints, insignias, logos, and so on. Textures
 work beautifully in sweaters, just in case it's cool, but be careful that the texture isn't
 overpowering.
- Have tools handy to fix a child's hair. Ask parents to tell you ahead of time what they do and
 don't like. You can simply carry a little bottle of spray water and another of light hairspray.
 You don't want to be in a situation where you have taken a series of great photographs and
 find out later that mom dislikes her daughter's hair pulled back, or some such disaster.
- If a child has braces, tell parents not to worry. Braces are a rite of passage, and most people will look back with smiles as they remember those times. However, if parents wish, you can decrease the brashness of the metal or even have them completely removed in post-production.

Sometimes contemporary style consists of turning the traditional style on its head, as in 6-14. The lighting and background just scream classic and romantic. But a topless baby in a pair of jeans with a (Photoshopped, of course) tattoo on his chest is anything but traditional.

ABOUT THIS PHOTO The background and lighting are traditional but the pose and treatment are anything but. 1/125 second, f/7.1 at ISO 125. ©Jeffrey Woods / www.jwportraitlife.com

In this day of media saturation, you are all much more image savvy than you have ever been. Ads on television, in magazines, and on the Internet all influence our taste and style. This young girl in 6-15 is only 12 but that doesn't prevent her from wanting to look like a super model.

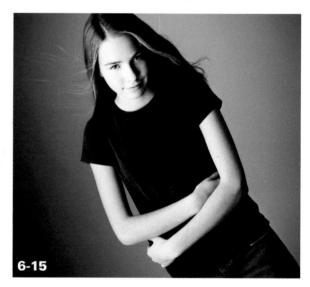

ABOUT THIS PHOTO A seamless gray background and an angled camera provide an edgy ad-like feel to this image of an adolescent girl. 1/100 second, f/2.8 at ISO 100. ©Allison Tyler Jones / www.atjphoto.com

Traditional family portraits rely on careful posing and arrangement of each family member. A contemporary style seeks to get a little closer to reality by allowing the family members to pose themselves and interact with each other in a more natural way as in 6-16.

ABOUT THIS PHOTO Pull up a big chair, stuff the whole family in, and watch what happens. 1/100 second, f/2.8 at ISO 100. ©Allison Tyler Jones / www.atjphoto.com

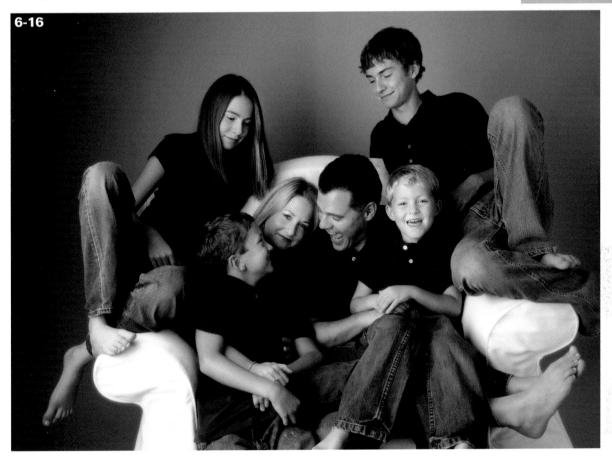

ON LOCATION

Any location can work for a contemporary style because the style depends on how the photographer sees the subject more than on the actual location itself. However, you may want to look through this section for ideas on similar locations in your town. As you look through them, you may see how each location could be used in a classic

and romantic or a contemporary or photojournalistic way. It all depends on your point of view.

Urban decay is part of the world we live in, and contemporary portraiture is geared to take full advantage of what some might see as old and ugly. Using a background of a rusted, corrugated metal door adds texture and interest to the background of the young girl in 6-17.

An old, stained concrete wall acts as a gritty, yet interesting background for the teenaged brothers in 6-18. Very often, teenagers just aren't into the "cutesy" that their moms still love. They are just as influenced by images as their parents and they want to look cool. In 6-19 for example, the old cobblestone road acts as a textural background for this young boy while the strong light coming from the left keeps him from fading into the pavement.

ABOUT THIS PHOTO The rusted metal door adds texture and interest to the background while the girl's silly expression convey her personality. 1/1320 second, f/2.8 at ISO 500. ©Jeffrey Woods / www.jwportraitlife.com

ABOUT THIS PHOTO These teen brothers aren't about to hug and smile sweetly for the camera. Their cool attitude is reflected in the stained concrete background they stand against. 1/160 second, f/2.2 at ISO 250. @Jeffrey Woods / www.jwportraitlife.com

ABOUT THIS PHOTO A strong sidelight adds drama and keeps the boy from fading into the cobblestone pavement. 1/1000 second, f/2.8 at ISO 125. ©Jeffrey Woods / www.jwportraitlife.com

Libraries, art centers, and other public buildings (even parking garages) can be great places to capture children and their families. Use the lines in the architecture to frame your subjects or draw attention to them, as in 6-20.

A path or road or lane can draw attention to your subjects when you place them along a lane somewhere, as in 6-21. Notice how the shadow of the family falls into the path behind them as they walk, telling a story all its own.

PHOTOJOURNALISTIC STYLE

The photojournalistic style takes into account time as well as place and captures whatever is transpiring at the moment. True photojournalists act as a fly on the wall observing and capturing what is happening before their lens. They don't interfere with their subjects in any way. Photos are not set up, there is no wardrobe change or fixing of hair — the photo opportunity presents itself and the moment is captured.

The photojournalistic style borrows elements of true photojournalism with a few, key differences. You might plan wardrobe and location which is, obviously, not very photojournalistic; however, once the setting is set and kids are in place, the photojournalistic style requires you to get out of the way and let kids be kids. Forget posing or fixing hair as you go, just let them run and be ready with the camera.

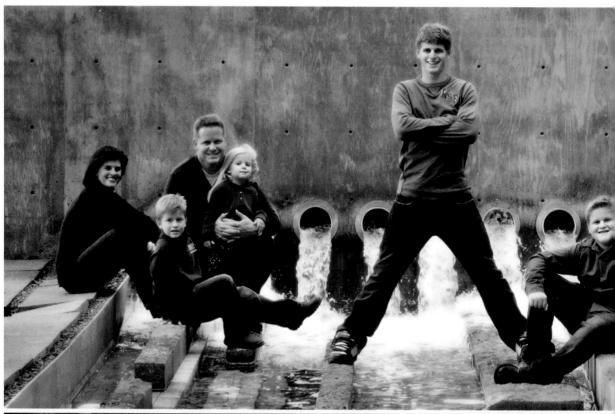

6

ABOUT THIS PHOTO Yes, all those kids belong to one family! The oldest boy is getting ready to leave home, so he is featured as the focal point of this image. 1/160 second, f/5.6 at ISO 400. ©Allison Tyler Jones / www.atjphoto.com

ABOUT THIS PHOTO A family walks into their future together. The composition of this image is what gives it its contemporary feel, but the subject matter is timeless. 1/1000second, f/4.0 at ISO 1000. ©Melanie Sikma / www.melaniesphotos.com

ON LOCATION

As a family photojournalist, it can be hard to capture those spontaneous moments if your kids always want to pose for the camera. The best antidote to this is to keep your camera out and use it often. Before long, they become bored with you and go about their business, allowing you to capture the creatures in their natural habitat.

Telephoto lenses come in handy when you want to capture your prey unobserved, as in 6-22 of a big brother giving a piggyback ride to a sibling. The longer lens allowed the photographer to get in close and simplify a cluttered background by focusing on just the subjects and a blue sky above.

ABOUT THIS PHOTO The expressions on the faces of these siblings tell the story. The little girl adores her older brother and he adores her but just doesn't want to show it. 1/1250 second, f/4.5 at ISO 200. ©Jeffrey Woods / www.jwportraitlife.com

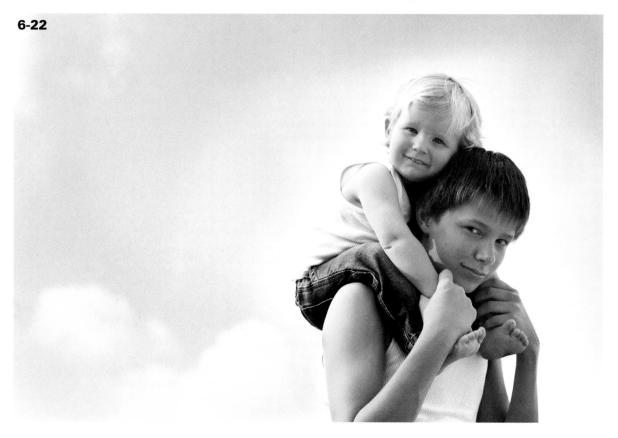

When striving to achieve a photojournalistic style of photo, you want to capture the kids wherever they are, whatever they are doing. Can you imagine if the photographer had waited to shoot until the little girl in 6-23 was sitting up straight in her chair?

ABOUT THIS PHOTO This shot gives a great sense of this little girl's personality. 1/160 second, f/2.8 at ISO 400. ©Stacy Wasmuth / www.bluecandyphotography.com

Shooting children in their natural environment, such as in 6-24, allows them to be more comfortable, and the images have the added value of triggering memories later in life of their childhood home. Let a child show you his bedroom and his favorite toys as in 6-25. Even let him jump on his bed for a minute as in 6-26 (just don't tell mom!).

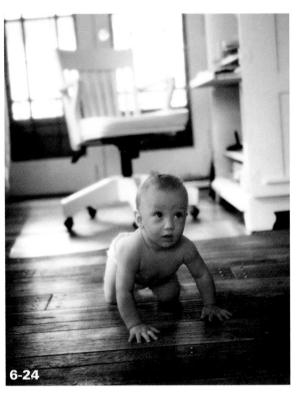

ABOUT THIS PHOTO Years from now, this photo will be a reminder of the home this baby grew up in. The composition emphasizes how tiny the baby is in this big world. 1/125 second, f/2.8 at ISO 1600. ©Melanie Sikma / www.melaniesphotos.com

"The portrait photographer who understands his work will never seek a formula for success. Those who would simplify portraiture to a few rules and diagrams will serve you pretty cold potatoes, for the vital essence of the good portrait is too elusive to be caught and bottled. Portraiture will always be an art of discovery." ~ Edward Weston, photographer

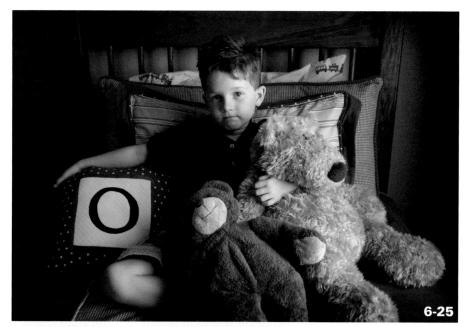

ABOUT THESE PHOTOS

Kids love to show off their bedrooms and their toys which, in turn, conveys part of their personality. 6-25 and 6-26 both taken at 1/125 second, f/2.8 at ISO 400. ©Allison Tyler Jones / www.atiphoto.com

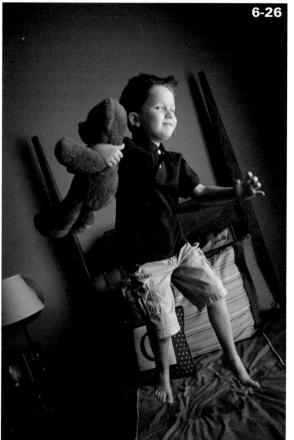

MOOD

It's not very realistic to think that you will just happen upon amazing moments and capture them. Sometimes that happens, but most times, it doesn't. That's where a little *assisted reality* comes in. Put the kids in their environment and then let them have fun. For example, the little girl in 6-27 was sitting on her favorite ball when the photographer called her name. The light was low in the room, so the photographer used a wideopen aperture to get the shot. It might not be that easy and you might have to bribe them with a snack or tell funny stories or make pig noises, but it's all in the quest of great photos.

ABOUT THIS PHOTO It doesn't get much sweeter than that little smile. The photographer called the child's name and she responded with a smile. 1/60 second, f/1.8 at ISO 250. ©Melanie Sikma / www.melaniesphotos.com

The golden sweet light of early evening highlights the family in 6-28 as they play in front of the barn on their farm. The clothes and setting and lighting were all planned, but the fun and emotion are the real deal.

Another way to portray a family is by just capturing part of them as in 6-29. Lining up the family on the mom and dad's bed in their light-filled bedroom allows for a new take on the traditional family portrait.

ABOUT THIS PHOTO Setting up the lighting, the clothing, and the setting allows the family to be spontaneous and free in their expressions and actions. 1/640 second, f/3.2 at ISO 125. ©Julia Woods / www.jwportraitlife.com

Cropping in tight to capture the child sharing a mischievous grin while enjoying his snack creates an instant connection with the viewer as in 6-30.

ABOUT THIS PHOTO This family portrait is fun and definitely creative, telling a story about a lifestyle. The simple background and horizontal lineup make a strong composition. 1/125 second, f/2 at ISO 400. @Marianne Drenthe / www.marmaladephotography.com

ABOUT THIS PHOTO This mischievous smile is emphasized by cropping in close. The darker tones surrounding his face draw your eyes to the place of interest. 1/125 second, f/4 at ISO 500. ©Ginny Felch / www.silverliningimages.com

PREPARING PARENTS FOR THEIR CHILD'S PORTRAIT

Whether you are photographing children as a hobby, a passion, or as a career, communicating with the parents of your subjects is an important part of creating a unique and meaningful portrait. Ultimately, your portraits contain a large part of you and your vision even when you are following parents' wishes. If you are interested in developing your photography interest as a vocation, both your images and your business will reap the benefits from collaboration and communication.

GHARTER 6

OUTLINING EXPECTATIONS

It is a good idea to give the parents some idea of what your expectations are for photo sessions. Many professional photographers give parents a form explaining the his or her philosophy and working style as well as clothing suggestions and other important information. Take the time to get an idea of what the parents' goal is for the final result of the photo session. For example, do they want a large wall portrait or just a couple of shots for the annual Christmas card?

This kind of communication works to establish trust in you as an artist and respect for your time and opinions. The clarity of the information up front prevents miscommunication and misunderstandings later.

The most important thing you can do to prepare parents for an upcoming portrait session is to ask them to play the session down when speaking to their child. Children should come into your time together without feeling the pressure of any expectations. Many of the photographs in this book may look as though the children were perfectly behaved and everything was going according to some master plan, but nothing could be further from the truth.

Everything that you plan and discuss ahead of time is valuable and helpful in order to make a meaningful children's photograph. However, when you work with the highly unpredictable nature of children and weather, both you and the parents need to let go of the exact results.

More often, if both parties (parents and photographer) are savvy to this, photographs are likely turn

out better than expected. Surprises that come along won't be frustrating, but creatively challenging.

ON THE SHOOT WITH PARENTS

Many child photographers prefer to work with the children they photograph one-on-one, with the parent off to one side or in another room completely. One of the main reasons parents want to remain with the child and photographer is that they want to make sure that the children don't exhibit their funny smiles, their little quirks, and so on. The irony is that when they are separate from parents, these expressions rarely occur. If the parents still insist on being present during a session, you might ask that they stand back, watch quietly for awhile, and then drift off for 45 minutes if they feel comfortable doing so.

Tell the parents that you take pride in evoking expressions from the children, and that is usually possible only without distractions. If you are photographing outside, allow the child to be quiet and listen to the surroundings. Bring the silence to their attention and ask them what they hear. These quiet moments can evoke wonderful, natural, whimsical expressions, as in 6-31. Evoking these moments requires uninterrupted time between photographer and child.

Leave the big, cheesy smiles to the school photographers. If there is a smile or a hint of sweetness, let it be a reaction to something you have said. If you must work with an assistant, which is helpful if there are two or three young children, ask him or her not to distract from the relationship unless requested.

ABOUT THIS PHOTO This little ballerina, while gazing into the lens, has a look of daydreaming. The soft window light and selective focus give a whimsical feeling. 1/60 second, f/2 at ISO 400. ©Judith Farber

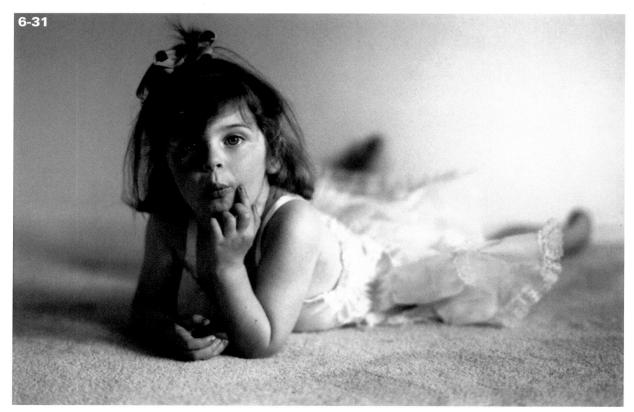

Ask the parents not to prime their kids about smiling or to discuss behavior issues. You should expect children to be children, and the more relaxed and happy they are as they enter the session, the better it all works for everyone. Parents should also try to be relaxed and confident because they can influence the attitude of their children. If parents convey confidence and make very little fuss about leaving their kids with you, they can set the tone for the entire session. Always do your best to distract the children during those potentially tender moments.

If you choose to make a career in children's photography, you will experience a wide array of behavior from very good to downright horrible.

quote

"In the faces of children I have seen a look of wisdom and of kindness

expressed with such ease and such certainty that I know it was the expression of the whole race." ~Robert Henri, American painter

That's what makes it challenging, fun, and creative for those who love children.

Some children are soothed by having a creature comfort along with them. You might suggest in your communication with parents that they can bring along a blanket, stuffed animal, or favorite toy. Special treats can also be a good idea (always check with parents first). You can offer them during the session, as long as they aren't too messy.

6

KEEP SHOOTING

Even when you think the shoot is over and it's time to pack up and go, inevitably something sweet and endearing will happen (as in 6-32) and you won't have your camera in hand. Make it a practice not to put your camera away until you are in your car ready to leave.

Some of the most memorable photographs were taken from behind. Remember the classic image

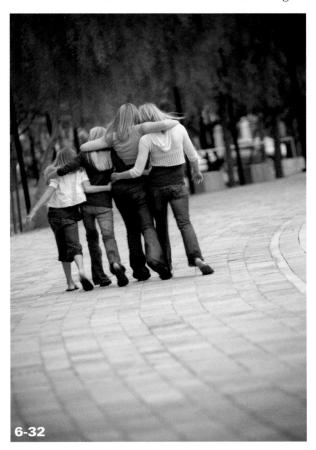

ABOUT THIS PHOTO Shot from behind as these sisters walk away together, this image gives a unique perspective of their relationship to one another. 1/50 second, f/2.8 at ISO 400. ©AllisonTyler Jones / www.atiphoto.com

of JFK walking with John-John at the beach? You can barely see the faces, but the story is unmistakable. It takes some education ahead of time to convince parents that portraits of their children are beautiful when taken that way. Showing them examples of work you have already created can help inspire them.

PORTRAIT PLANNING

Sometimes you will be creating individual portraits as well as family portraits. Ask parents to decide beforehand which is more important to them. Try not to go beyond the comfort zone and attention span of the children. That can be a brief period, depending on the ages of the child or children. Better to start off with individual portraits and move on to the groups if time and temperament permit.

Many people want to have more natural and unposed photographs. Of course, the more people you have in a portrait, the more posed it tends to be as you try to corral everyone into the frame, unless you have the luxury of scheduling a session during a more natural event (family reunion or picnic). Be sure to communicate that knowledge with parents so they are prepared to see less spontaneity when there are more people in the photograph.

quote

"In order to be a portrait, the photography must capture the essence of

its subject. Herein lies the main objective of portraiture and also its main difficulty. The photographer probes for the innermost — the lens sees only the surface." ~Philippe Halsman, American portrait photographer

Assignment

Create a Special Portrait

Ask friends with a child whether you can create a portrait for them. Communicate with them your desire to make a special portrait and collaborate with them, with you as their guide. Use the information you learned in this chapter. Post your best image of the child.

To complete this assignment, I chose to try to capture some photojournalistic-style photos. A low camera angle and a backlit subject allowed this photographer to capture a spontaneous moment between young girlfriends at the end of the day. 1/160 second, f/3.2 at ISO 640.

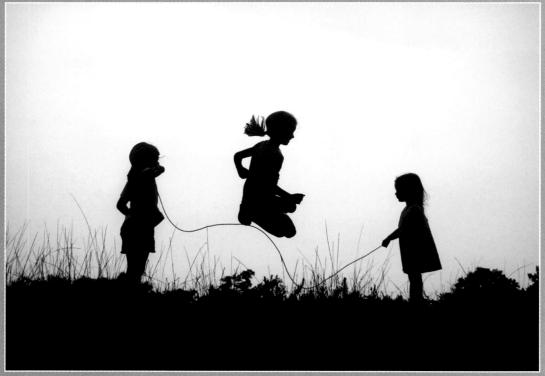

©Wendi Hiller

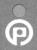

Remember to visit www.pwassignments.com after you complete this assignment and share your favorite photo! It's a community of enthusiastic photographers and a great place to view what other readers have created. You can also post comments, and read other encouraging suggestions and feedback.

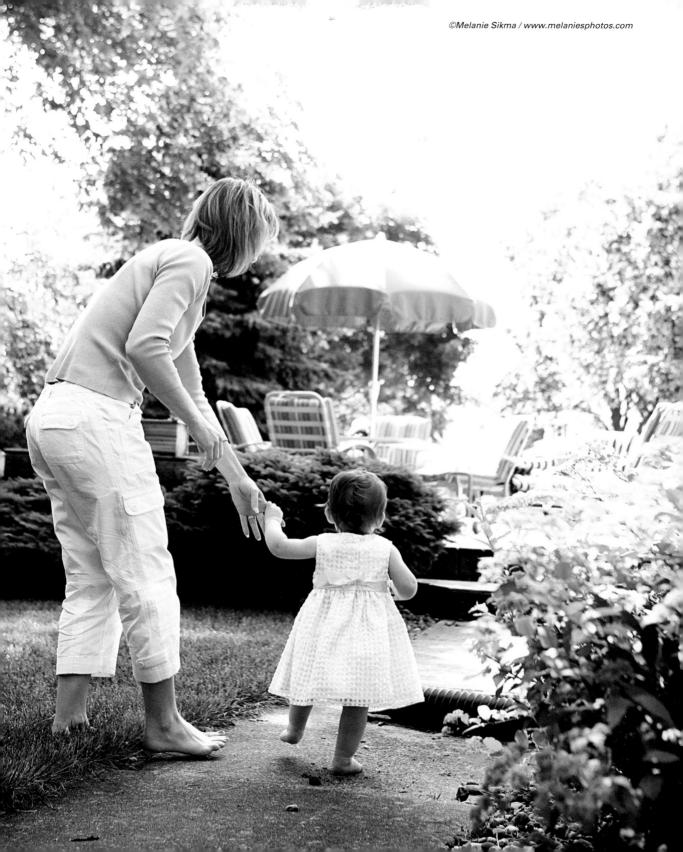

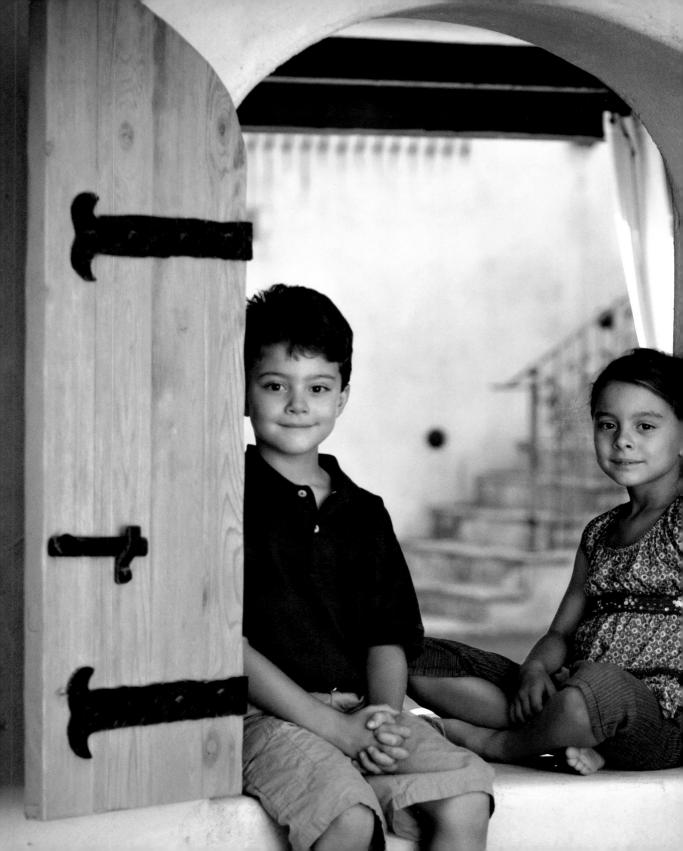

EVOKING EXPRESSION AND EMOTION

OBSERVING EMOTIONS AND MOODS
REVEALING THE EYES: GATEWAY TO THE SOUL
INVOLVING YOUR SUBJECTS WITH NATURE
STUDYING BODY LANGUAGE, GESTURES, AND
MOVEMENT
TELLING A STORY WITH YOUR PHOTOGRAPHS
THE PSYCHOLOGY OF PHOTOGRAPHING CHILDREN

As you look through photographs, whether they are your own family photographs, a friend's collection, or even magazine images, you intuitively flip through them at a certain pace. Every so often you might come across one that stops you, slows you down, and invites you to explore or engage more deeply. It might make you smile, think for a minute, or take you back to a place in time. What a wonderful exercise this is to encourage your own observation skills and to see what pulls you in. The chances are very good that the photograph that stops you or slows you down contains something profound or alluring in the expression, mood, and emotion.

This is particularly true in children's photography. Children's expressions and emotions are usually close to the surface and readily available. As a children's photographer, you just need to be there, to witness, and to capture what is offered so freely.

The great advantage of digital photography over film is that you can be spontaneous and capture special moments and a child's natural enthusiasm as in 7-1 and 7-2 without the high cost of processing. This technology offers you the opportunity to learn as you shoot, and the immediate results allow you to erase and try again. For those who learned to photograph with film, this convenience is really a dream come true.

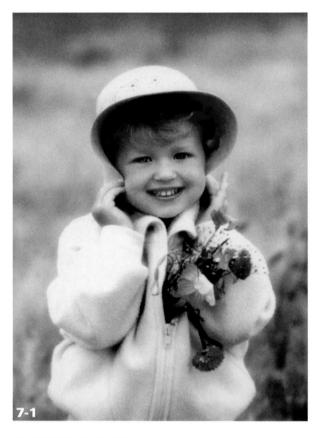

ABOUT THIS PHOTO The sheer delight and spontaneity evoked by this little girl gathering flowers for her mom is undeniable. The gesture she makes with her hat adds spunk to the photograph. 1/4000 second, f/5.6 at ISO 500. ©Ginny Felch / www.silverliningimages.com

quote

"Saturate yourself with your subject and the camera will all but take

you by the hand and point the way." ~Margaret Bourke White, first female photojournalist for *Life* magazine

OBSERVING EMOTIONS AND MOODS

When photographing children, the elements of expression, emotion, and mood are of utmost importance. Here, for example, are some expressions or moods you might observe:

ABOUT THIS PHOTO Pictured with a distinctive toy and quilt, this girl's body language and expression are very natural and characteristic of her age. The dirty feet help tell the story. 1/80 second, f/1.8 at ISO 400. ©Marianne Drenthe / www.marmaladephotography.com

- Joy
- Delight
- Intrigue
- **■** Frustration
- Thoughtfulness
- Tenderness (as in 7-3)
- Engagement
- Pensiveness

ABOUT THIS PHOTO Tenderness and pride are revealed in this portrait of a boy with his newborn sibling. His penetrating eyes add to the story, and the close angle creates intimacy. 1/100 second, f/4.5 at ISO 1600. ©Wendi Hiller

- Restfulness, peacefulness, sleepiness (as in 7-4)
- Involvement
- Daydreaming
- Observing
- Activity
- Flirtatiousness
- Surprise (as in 7-5)
- Playfulness
- Surprise
- Curiosity
- Despair
- Attachment

quote "You are the camera, your eyes are the shutters. What you absorb

through them is what you paint, and it's you that is mixing the colors, not the camera." ~Richard F. Barber

VISUALIZATION

If you are a parent, you have probably stumbled on many instances when you wish you had a camera in your hand. How many times have you looked through your rearview mirror to see the soft, round cheeks of your sleeping toddler in the backseat of your car. Wouldn't it be great if all you had to do was blink and a photo would be recorded with all the emotion you were feeling about that person at the moment? Actually, practice in visualizing these moments makes it far more likely that you can capture them in the

ABOUT THIS PHOTO What a joy it is to see and capture this fleeting expression. The curved composition created by the textured blanket holds you in and gives a warmth and sense of security to the photograph. 1/2000 second, f/1.4 at ISO 200 ISO. ©Wendi Hiller

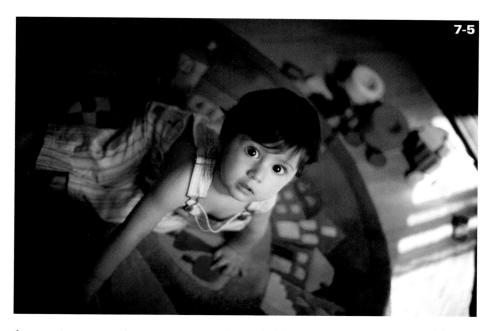

ABOUT THIS PHOTO The angle looking down on the child as he looks up, surprised, is very unusual and creative. Colorful toys in the background frame him, but the eyes are what captivate. 1/250 second, f/1.8 at ISO 400. ©Marianne Drenthe / www.marmalade photography.com

future. As you go about your day and see children around you, compose and mentally click off a few frames; it will make you a better photographer when you actually get the camera in your hands.

In an ideal world, you would just come upon "the moment" and photograph it, but those kinds of happy accidents are few and far between. It is more likely that you either won't have your camera with you, or that the moment you turn toward the subject, all spontaneity dissolves, and the magic moment disappears, only to become another beautiful memory.

If you've ever tried to re-create a moment just to get the photo, you know that it just doesn't work. However, you can remember the feeling of that moment and try to pull it out of your bag of tricks for the next time.

Take your camera everywhere you go with your child, and you will have opportunities galore to

capture innumerable precious moments. Your kids will become used to the camera if it's part of their daily life. They will quit mugging and go about their lives, which is exactly what you want.

The following sections explore ways to encourage, create, and capture these magic moments while photographing children.

REVEALING THE EYES: GATEWAY TO THE SOUL

The anonymous quote varies: Eyes are the gateway to the soul, the mirror of the soul, or the windows of the soul. The concept remains the same and is paramount when photographing children. In portraiture, the face is the most expressive part of the body, and of the face, the eyes are most important. You might be forgiven for getting any part of the image out of focus, except the eyes. Pay close attention to how the light is illuminating the

child's eyes as well. Look for the *catchlights*—the little reflections in the eyes that show life and sparkle. Very often it's just a matter of turning the child to get the light just right in his or her eyes.

When school photographers and, in fact, most photographers and parents, choose to show children with big, squinty-eyed grins, it makes everyone feel good. The universal appeal of a smiling and happy child can't be disputed, but at least consider the possibility that some appealing alternatives exist.

Take into consideration that when a child is in full-smile mode, the facial muscles are contracted, and the eyes become smaller, less open. Are there other alternatives that you haven't explored that could convey the personality of the child as well, or better than, the full, cheesy grin? A child's face in repose is often the most revealing of the eyes and personality.

Don't be disappointed if a child you're photographing covers his eyes and shows his bashfulness, as in 7-6. The picture of this little boy turned out to be very charming and a true reflection of his personality at age 3.

The little boy in 7-7 has a far-away look in his eyes. The photographer was able to take his picture when he wasn't looking directly at the camera, and the result is a tender photograph. Notice how his eyes are big and bright, and his facial expression is soft. Most children eventually become comfortable with having their picture

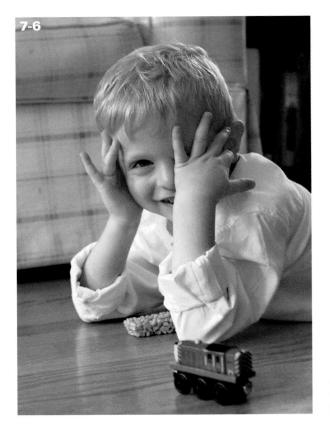

ABOUT THIS PHOTO Getting down on the floor with a child is key to making him feel comfortable with you. 1/60 second, f/4 at ISO 640. @Melanie Sikma / www.melaniesphotos.com

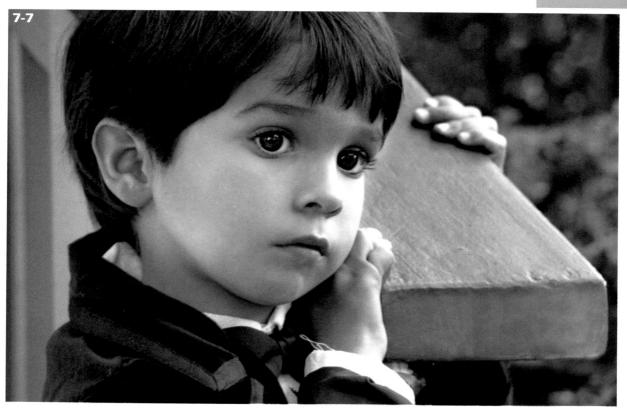

ABOUT THIS PHOTO Waiting and watching intensely, this little boy's eyes create the magic of this photograph. The light gives his face a delicacy and softness that is beckning. 1/125 second, f/8.0 at ISO 1600. ©Ginny Felch / www.silverliningimages.com

taken, as you can see in 7-8. This young boy has a gleam in his eyes because he was given time to get to know the photographer and to relax. A typical photography session can often take an hour or more to achieve photographs like these.

Toddlers can be a joy to work with, especially if you can distract their attention away from the

camera. You can observe their quirky expressions and movements. The blond boy in 7-9 is sucking his fingers and gazing at something in the distance. Notice that the image is cropped closely around his head and upper body. Don't be afraid to make the face and eyes the focal point of the image so that they take up the entire frame.

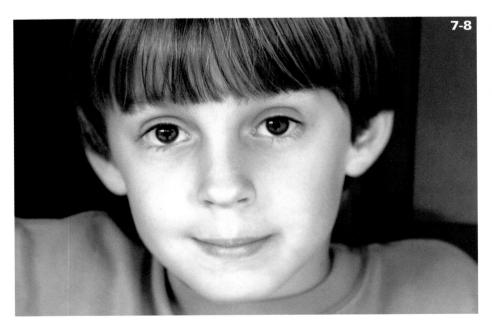

ABOUT THIS PHOTO Benjamin exhibits a savvy yet elfish sweetness that beautifully reveals his nature. His dark and penetrating eyes convey openness and trust. 1/50 second, f/5.6 at ISO 800. ©Ginny Felch / www.silverliningimages.com

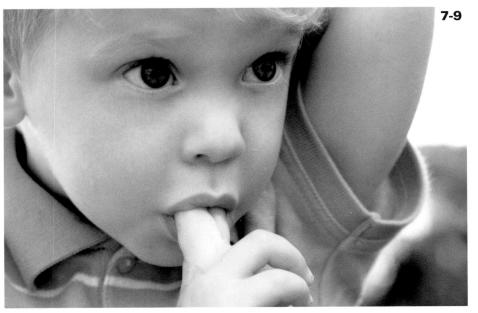

ABOUT THIS PHOTO Rex is having one of "those moments" that parents often forget about when children grow older. His expression begs the question of what could be going on in that little mind. 1/640 second, f/5.6 at ISO 1600. ©Ginny Felch / www.silverliningimages.com

CHAPTER

Sometimes, beginning photographers believe that they need to include the whole head or the entire body. That's not necessary. Getting up close and personal can result in images that are more visually interesting and intimate.

When a child is gazing, observing, listening, or thinking, the eyes are generally wide open, and

7-10

ABOUT THIS PHOTO This reflective and musing expression really draws you into this portrait of the little girl in the garden. The circular line of her shirt frames her face delicately. 1/125 second, f/5.6 at ISO 320. ©Patrisha McLean

the face is soft and relaxed, as in 7-10 and 7-11. If you can encourage those moments while making a photograph, by all means do so. After you go beyond the fear that you should be making the child smile or laugh, you might be pleasantly surprised by the character and soulfulness that comes forth in your imagery.

ABOUT THIS PHOTO This is a shy and watchful moment in this little boy's life, and the impact of his face is striking. His eyes are wide open, and his cheeks look soft and tender. 1/125 second, f/4 at ISO 1600. ©Ginny Felch / www.silverliningimages.com

Smiles are okay, too, if they are not forced just for the photograph. Even if you choose to have a child smile, try to find the moment in which the smile is subtle or natural looking as in 7-12.

Of course, a fine line exists between pensiveness and petulance, and you learn to discern the difference with experience. This difference often lies in a characteristic that could be called "sweetness." When a child is looking at you, all it might take to evoke that sweetness is a little smile of your own, or a subtle tilt of your head.

"Children are natural Zen masters; their world is brand-new in each

and every moment." ~John Bradshaw, American author and philosopher

INVOLVING YOUR SUBJECTS WITH NATURE

When you are outside with a child, isn't it inspiring to see what attracts her? You brought along the bubbles, balloons, and other entertainment only to find that she looks down, picks up an interesting rock or a broken shell, tosses it, smells or tastes it, and absorbs it in any way she can. You planned the trickery, and it didn't work! In 7-13, the little girl dropped down into the sand and began making an angel. Try to avoid reverting to "Put that down, it's dirty" or "Look at the red balloon." You might lose the chance to let the child be a child, full of wonder.

A child sees a blue bird, skips over to try to touch it, and then plops down in the tickly grass, getting grass stains on her clean shorts. That's when

ABOUT THIS PHOTO Brothers Sam and Nick show off their intense blue eyes and inner wonder. Sometimes getting in close with the camera can add to the drama and power of a photograph. 1/250 second, f/5.6 at ISO 1600. @Ginny Felch / www.silverliningimages.com

CHARTER

ABOUT THIS PHOTO Playful and spontaneous describe the energy of this little beach angel. A portrait like this certainly tells a story that draws in the viewer. 1/80 second, f/9.0 at ISO 400. ©Theresa Smerud

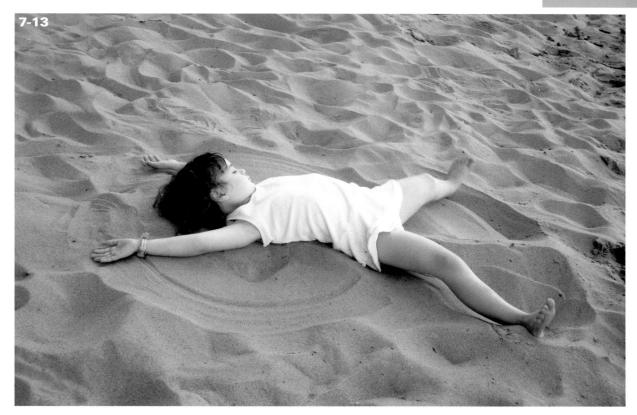

to click the shutter and thank your lucky stars for the gift of the expressiveness of childhood (if you can just get the mothers to play along!).

Are you getting it? Don't fight the child's natural instinct for wonder and play; join in — even anticipate and encourage it. What is more interesting in your photograph, a red balloon or a seashell? I make this point here and repeat it many times: Plan it, find the light, be prepared, and then let go. Let go in the spontaneity and remarkable whimsy of the child.

When at the beach or the park, find a location where the light is compelling and settle into the

spot with your subject, as in 7-14, where the light is hitting the side of the toddler's face while she plays in the flowers. Find a comfortable place to sit down on the grass, on a rock, or stump. Try to keep your voice at a whisper. "Shhh, listen! Tell me what you hear." The child will quiet down, perhaps widen his eyes, maybe look a bit to the side with his eyes, and begin to listen. Wherever you are, there will always be something to listen to. It might be the bird chirping, the branches scratching together, a truck honking, or a dog barking. In that very brief moment when the child is making the switch from being conscious of having his photograph taken to the quiet act of

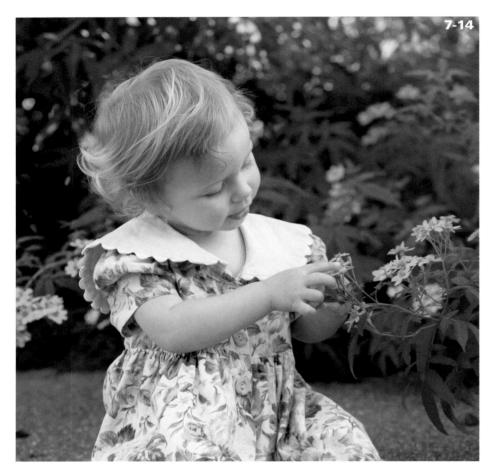

ABOUT THIS PHOTO This toddler is easily entertained and involved in the garden setting. The photographer caught her looking to the side, which gives a more natural feeling to the photograph. 1/200 second, f/5.6 at ISO 400. ©Ginny Felch / www. silverliningimages.com

listening, you can capture some natural, candid, and expansive expressions. In 7-15, the children are so engaged in nature that they are no longer aware that their picture is being taken.

Trees, rocks, ponds, flowers, and so on are readily available props and backgrounds that abound in nature. Trees can be used to lean on, hide behind, and sit under. Their umbrella of branches and leaves can provide shade, cool air, and relief from the unappealing raccoon-eye look that strong overhead light can create.

Sometimes the environment itself can set a mood that can be captured without even showing the faces of your subjects, as in 7-16. You get the feeling of camaraderie and adventure from their body language and the magical mood from the setting.

Find a field, an expansive meadow, or shoreline, and ask the children to line up in a plane parallel to your camera view. Tell them you are going to walk away, and when you wave your hand, they can move toward you, but not to look at you or the camera. They can look at each other or at

ABOUT THIS PHOTO

You can see a unity between these siblings as they gather flowers. The diagonal leading line adds to the beauty. 1/500 second, f/4 at ISO 1600. @Ginny Felch / www.silverliningimages.com

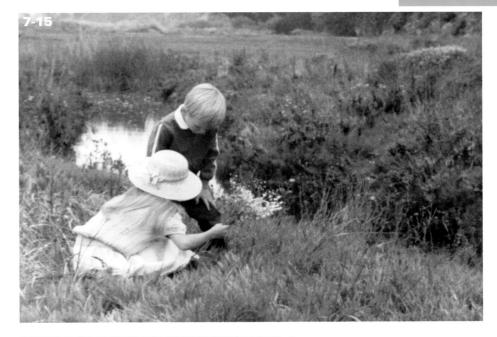

ABOUT THIS PHOTO The enjoyment of a school

The enjoyment of a school snow day is revealed in this photograph. Notice the leading lines created by the edge of the forest. 1/60 second, f/11.0 at ISO 400. ©Theresa Smerud

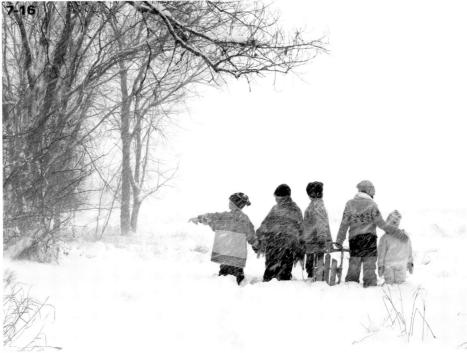

something in the distance and talk to each other or tell stories or secrets. After you wave your hand, you can start shooting away. You have set the scene and given them freedom within it.

When they arrive by your side, ask them to turn around and go back to where they started. Follow them closely as well as from a distance, developing your photographic story as you go.

When photographing children in nature, please be wise, careful, and safe. Don't leave toddlers unsupervised and watch

out for prickly or poisonous plants, snakes, and other intruders. Work with an assistant if you want to be extra cautious.

STUDYING BODY LANGUAGE. GESTURES, AND MOVEMENT

People-watching in general and child-watching in particular should become your hobby as you seek to capture ever more interesting photos of children.

The images in 7-17 were taken as a result of intense people-watching on the part of the photographer. She began to take walks at the local beach in her town, during low tide on foggy days. Often these walks took place in the morning when the mist was lifting from the sand as the sun rose over the nearby mountain. It was so peaceful and quiet, and the few figures she might see would really stand out as light silhouettes

ABOUT THIS PHOTO

Series of beach scenes reveals the grace of the natural movements and gestures of beachgoers ambling unaware of a camera. 1/125 second, f/16 at ISO 100. @Ginny Felch / www.silverliningimages.com

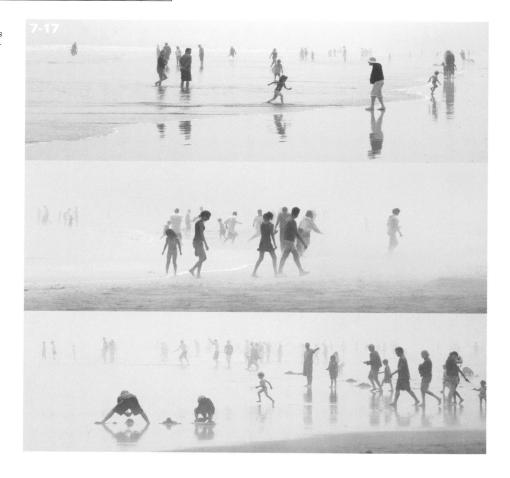

"Allow children to be happy in their own way, for what better way will they ever find?" ~Samuel Johnson

against the sand and shore. It became intriguing to observe the simplicity of the elements: the birds, footprints, dogs, and people. The low tide created vast smooth surfaces that offset the living and moving creatures. The photographer started to see the tide line as a music staff, and the people, birds, and dogs as notes of music writing songs of life. Their gestures, as she stood far away with a telephoto lens, were spontaneous, often playful, and sometimes somber. After months of observing these intriguing scenes, her eye for children's portraits changed. This experience encouraged her to let go more, to try to control less, to appreciate the purity and uniqueness of the natural, human gesture. You can do a similar

exercise in the surroundings where you live or on your next vacation. This type of quiet observation improves your appreciation and your ability to capture more natural and sensitive portraits.

Of course, while the beach may be an ideal place for you or others to observe people, the financial district in the city, a sports field, a local park, a shopping mall, or even a farmers' market are also excellent venues. If you are going to photograph children, watching their natural movements and spontaneous gestures can give you great insight and inspiration, as in 7-18, where the little boy is playing in the sand near the boat, or 7-19, where the little girl digs her hands through the sand and low tide. Her reflection in the water and the line drawn to her hands creates a perfect composition. Becoming familiar with natural gestures might just make the difference between a static-looking pose and a genuine one.

ABOUT THIS PHOTO The shape of the boat draws your eye to the boy quietly playing with his truck in the shadow of the boat. His gesture is very natural and typical of little boys playing in solitude. 1/1500 second, f/5.6 at ISO 200. ©Ginny Felch / www.silverliningimages.com

ABOUT THIS PHOTO How refreshing it is to watch children as they frolic and invent games when left to their own devices. 1/200 second, f/5.6 at ISO 200. @Ginny Felch / www.silverliningimages.com

note

When shooting on location, it is always recommended to get permission from the owners of the property before conducting your photo shoot.

The children in 7-20 are no longer aware of being photographed. If the photographer had asked them to pose or try to look natural, she would not have captured the easy gestures that you see in that image. The little boy is pretending to fly around his sister, who is looking out toward the waves.

TELLING A STORY WITH YOUR PHOTOGRAPHS

Creating intimacy in a child's photograph always captures the parents' heart. A portrait is a wonderful opportunity to allow unabashed cuddling, kissing, or otherwise relating to another person, pet, or toy. Adding a warm and inviting environ-

ABOUT THIS PHOTO Siblings dancing in the surf show involvement and playfulness between them. The reflections add to the painterly quality. 1/250 second, f/5.6 at ISO 200. ©Ginny Felch / www.silverliningimages.com

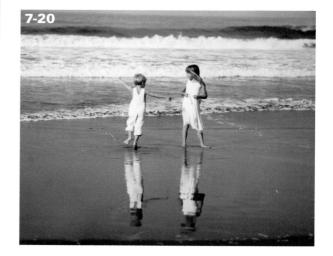

"Give a little love to a child and you will get a great deal back." ~John Ruskin

CHAPTER

ment and soft lighting to a child's outward affection can enable you to create a photograph that is so much more than a snapshot.

As an exercise, the next time you are at a park or crowded shopping center do a little people watching, specifically, watch children and parents relating. If you keep your eyes and heart open, you can see obvious and subtle exchanges between mother and child or father and child. Sometimes, it is a glance, a gentle pat, holding hands, or a quiet talk. Take a minute before you launch into your next photo shoot and observe how the children interact with their parents and use their natural body language and interactions to add life and spontaneity to your work.

As you photograph children with parents or grandparents, you can invite a situation in which this kind of exchange might happen. It might take a little coaxing, such as "Okay, you can get a little cuddly now" or "Can you snuggle a little closer?" You might suggest that a parent read to a child, or vice versa. Dreamy looks out windows or into the sea give a sense of togetherness. A mother looking into her baby's eyes conveys intimacy.

A father or grandfather walking down a path with a child, even if you can't see the faces, tells a story about a relationship as in 7-21. Don't underestimate the power of this kind of photograph. Faces only tell part of the story.

It often takes the challenge out of making a strong statement in a photograph by involving a child with something or someone adored, or in play. It is a great distraction to the child and often a great comfort. Consider some of these scenarios when taking photos of a child or children:

- Two sisters reading quietly on a couch
- A child playing a piano
- A toddler with her cuddly stuffed lamb
- A child and his dog or cat

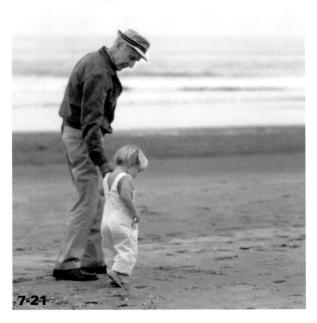

ABOUT THIS PHOTO This tender moment between a grandfather and his young grandson is a nostalgic and narrative photograph. The simple warm tones keep you focused on the subjects. 1/250 second, f/6.3 at ISO 200. ©Ginny Felch / www.silverliningimages.com

- Children playing dress-up
- Sisters picking flowers together
- A father and children fishing
- A child looking at his reflection
- A child tossing stones into water

Sometimes, a poignant story can also be told about a child by photographing his essence or only part of him. For example, try photographing the following:

- Baby or toddler shoes that are well worn
- A small chair with a child's loved doll or stuffed animal

- A baby's feet peeking out from under the covers
- A baby's hands in the hands of a parent
- The back of a toddler holding onto mom's skirt or dad's pants
- A summer dress blowing in the wind or hanging on a door

What you are going for here is a feeling, a mood, an expression. All of these elements take your photograph one step closer to becoming a stunning, dynamic, and beautiful portrait.

Chapter 8 can help you understand the specific challenges and rewards when photographing each developmental stage of a child's life.

THE PSYCHOLOGY OF PHOTOGRAPHING CHILDREN

Unless you are one of those beings to whom children are attracted immediately and unconditionally, you might at some time need a few tricks of the trade. Arriving as a stranger, carrying a strange black object (the camera), you could indeed be frightening for a younger child. Many children, however, by the age of four or five are ready and waiting with a generous smile pasted on their face the moment they realize you are there to make a photograph.

Most photographers would prefer to photograph without gimmicks, tricks, or toys, but even without them, psychology is always in use. Try to beckon your innermost child to relate to the child or children before you. Take into consideration that they have been put up to this by parents, and may have been told to behave, not to make their usual faces, and so on. This suggests to

them that this is going to be drudgery at best, so send the message to them that this will be fun, perhaps interesting, and over with quickly. Tell them that you don't need for them, or even want them, to smile like they do for a school photograph. If they are old enough (over two), immediately involve them with the camera to see whether you can strike up an interest.

While you supervise, let the children have a look at your camera and maybe even fire off a shot or two. They will be amazed at being allowed to play with an adult's "toy." They will want to make lots of shots so you can use this as a reward for doing as you ask.

Can you whistle like a bird or grunt like a pig? Talking like Donald Duck is a definite plus in the business of child photography. Silly noises are helpful in getting the attention of your subject and often result in some very interesting and silly expressions. Disagreeable or frustrated young children (especially those younger than 3 years old) sometimes require the use of toys or gimmicks to distract or please them. Even crying children can sometimes be cheered up with a simple toy. Child photographers are often great connoisseurs of toys! If you want to engage a child in a photo session, try packing a few items like these: quacking ducks, barking dogs, oinking pigs, harmonicas, whistles, clickers, castanets, balloons, or bubbles. A favorite of photographer, Ginny Felch is Obie — the rubber doll shown in 7-22. When you squeeze it, the ears, eyes, nose, and mouth pop out.

"The great man is he who does not lose his child-heart." ~Mencius, Chinese philosopher

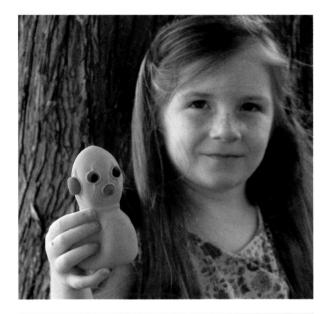

ABOUT THESE PHOTOS Daisy demonstrates how Obie works. The ears, eyes, nose, and mouth pop out to the delight of children when he is squeezed. 1/200 second, f/5.0 at ISO 640. @Ginny Felch / www.silverliningimages.com

A good time to get out the "sure thing" toy is the end of a session when the children are finished, but you are not! Another time to take out your sure-fire toy is when you sense negativity, petulance, or scowling from a child.

In order to engage children, ask them questions such as:

- What is your favorite flavor of ice cream?
- Do you like pizza?
- Do you ever misbehave?
- Does your sister have a boyfriend?

These questions are sure to evoke unique expressions and distract the children from the camera.

Children are the least-inhibited humans on the planet. Take advantage of this unselfconscious time of life to capture their wonder and innocence. Avoid the temptation to make a photo shoot more complicated than it has to be. Forget the props and extraneous camera equipment and just spend some time getting to know your little subjects. Talk to them and find out what they like. Put the camera down for a minute and listen to them. Let them look over your equipment and explain what you are going to do. Once they are more familiar with you and know that you are truly interested in them, getting honest expressions is easy.

"In a portrait, I'm looking for the silence in somebody." ~Henri Cartier-Bresson

Assignment

Tell a Story

Take a photo that captures a child's image — with a sibling or parent or not — telling a story. You can use a prop if you want, but be careful not to be too cutesy or have the subject(s) too posed. That is the challenge. It might literally be posed, but to the viewer it should look natural. Practice some of the attitudes you have learned in terms of involving yourself with the child in order to evoke a sense of comfort and flow. This should reflect back into your image.

Here the assignment was completed with this photograph of a little girl showing the photographer how old she is. It illustrates an understanding of a child at 3. Children of this age love to tell you how old they are. Focusing just on the fingers throws the child's face out of focus and puts the emphasis on her age while still allowing you to see her in the background. Taken at 1/250 second, f/4.5 at ISO 100.

Remember to visit www.pwassignments.com after you complete this assignment and share your favorite photo! It's a community of enthusiastic photographers and a great place to view what other readers have created. You can also post comments, and read other encouraging suggestions and feedback.

AGES, STAGES, AND GROUPS

Newborns

BABIES

TODDLERS

PRESCHOOLERS

SCHOOL-AGE CHILDREN

TWEENS AND TEENS

GROUPING FAMILIES

©Ginny Felch / www.silverliningimages.com

Although it can be helpful to speak of children in terms of ages and stages, it is vital to keep in mind that every child is unique and individual. Your intuition is your best guide as to how to handle different ages and stages. Paying attention to the child's unique presence teaches you a great deal about how you might react and connect with him, in order to capture more of his true personality in a photograph.

If you are a parent, you will likely want to document your child's life to preserve your own memories of his or her birth and childhood. By capturing these photos you are literally illustrating a life story. How many times has a son or daughter asked, "What was I like when I was little?" Posed portraits from a photo studio or a school yearbook never tell the whole story. It's the pictures of children laughing or sleeping as babies, skiing down a hill for the first time, running in circles, reading quietly as a teenager, or a million other shots that record a history of childhood that tell the real story. This chapter is a guide to each developmental stage of a child's life; the challenges and rewards of photographing each stage with tips to help you along the way. The ideas covered in this chapter are meant to serve as guidelines rather than hard-and-fast rules. Your own experience with children is your best advisor.

NEWBORNS

Photographing newborns is not for the faint of heart. It takes a great deal of patience, but it is rewarding for many reasons. Who can deny the miracle of a newborn baby? Perhaps at no time in a child's life do stunning changes take place on almost an hourly basis. This stage of development

is endlessly fascinating to the parents as they watch each captivating gesture and expression to figure out what part of this baby looks like mom or dad. To capture a photo of a newborn looking like a newborn (wrinkly skin, furry ears, and all), try to photograph the baby in the first couple of weeks of life. At this stage the babies are still very flexible and can be "folded" over into the fetal position and, for example, easily placed into dad's hands, as in 8-1. In many instances, very young babies haven't yet developed the baby acne so their skin is more clear, which results in less retouching after the photo session.

p tip Fo

For optimum results when photographing a newborn, keep the

room a bit warmer than is comfortable for the adults. This keeps the baby comfortable even when stripped for the naked-baby shots.

CHALLENGES

Newborns seem to arrive prewired with a sensor for tension in a room. If mom is stressed about the photo shoot and tension is high, most often the baby can sense it and becomes very fussy. Calm moms make for calm babies so spend a minute soothing the mother's concerns about the photo session. Let her know that she can stop and comfort or feed the baby at any time. Newborn's sessions are almost always a hurry-up-and-wait proposition. The baby nods off for half a second and you snap a few shots before his or her eyes open and start to scream. You might be surprised to know that many of the serene-looking infants in these photos were hysterical mere moments before their photo was snapped. Go ahead and snap a few of the crying baby, as in 8-2; they change so quickly, even their cries sound different.

ABOUT THIS PHOTO The sleeping baby is literally folded and placed into his father's hands. This can only be done with a very new newborn. 1/200 second, f/2.2 at ISO 320. ©Lisa Russo

note

Because newborns are often reddish or slightly jaundiced, it might

be more flattering to convert the images to black and white for a more timeless look.

Don't photograph a naked baby on any surface that isn't washable. Backgrounds, furniture, parents, and photographers can and will be wet on or spat upon by the little bundle of joy, so plan accordingly. You may want to have on hand a stash of inexpensive solid color (white is always great) blankets to wrap or lay the baby on.

Very young newborns have not developed the ability to focus their eyes yet, so it is easy to get a shot of a very cross-eyed baby. If they are getting the cross-eyed look, you may want to turn their head into a different position or just wait a minute for a more pleasing expression.

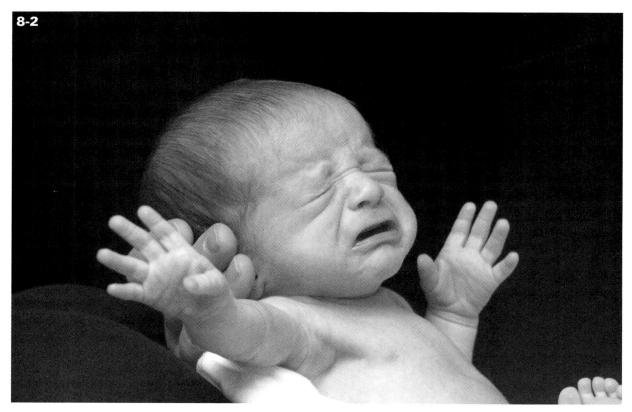

REWARDS

The soft cheeks, wrinkly skin, and tightly curled fists of a newborn are unmistakable. Capturing this stage is well worth the effort, and there are many photographers who specialize in newborn photography. Newborns can't talk back or run away. They are so flexible you can curl them up and let them sleep while you shoot away. Take the time to get the baby to sleep. Ask the mother to feed the baby just before she comes to the photo session so the baby arrives full and ready to nap. Wrapping an infant snugly in a blanket so that the arms and legs are tight against the body (also called swaddling) is an almost-guaranteed

sleeping pill for infants. Rock the tightly swaddled baby until he or she is fast asleep (this usually takes about 15 minutes, so you have to be patient). When the infant is finally sleeping, you can move around freely, placing props, blankets and even the baby, in just the right places, as in 8-3. There is nothing more universally appealing than the sight of a sleeping baby.

quote

"In the sheltered simplicity of the first days after a baby is born, one

sees again the magical closed circle, the miraculous sense of two people existing only for each other." ~Anne Morrow Lindbergh ABOUT THIS PHOTO The striking and surprising portrait of a newborn shows the form and shape of the baby nesting in an unusual antique chair. 1/60 second, f/5.6 at ISO 640. ©Ginny Felch / www.silverliningimages.com

CHAPTER

8-3

Newborns tend to be very floppy, so use the parents as a prop to hold the baby in their arms or even lay the baby over their shoulders, as shown in 8-4. This works well for a newly postpartum mother who isn't thrilled about being photographed. She can be part of the picture but she's not prominently featured. These are also great shots for the dad, as this is the view that mom often has as dad holds the baby.

BABIES

The first year of life is one milestone after another. As babies grow older and can recognize and respond to people around them, their range of expressions and gestures increases, giving the children's photographer much more to work with. Darling expressions can be evoked by the simplest click of your tongue or breath on their cheeks. It seems like their smiles come unwarranted at this point because they have learned that smiling pleases the people around them.

"A baby is God's opinion that the world should go on." ~Carl Sandburg

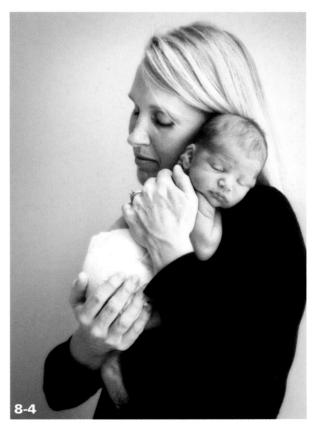

ABOUT THIS PHOTO Putting the baby on a parent's shoulder is a good solution when working with floppy newborns. 1/400 second, f/4 at ISO 400. ©Lisa Russo / www.lisarussophotography.com

THREE TO SIX MONTHS

Before they are able to walk, you can photograph babies in the three to six month age range sitting in a chair, lying on the grass, or holding themselves up by a table or wall. At this time, the mother, a babysitter, or older sibling can be a great asset to you as an assistant, just to watch carefully and make sure that the baby is safe at all times. It is important that you are comfortable with your

camera and its settings so you can spend your time fully focused on the baby and her expressions rather than fiddling with your camera.

Between three and four months babies can usually hold up their heads. You can get darling photos of them on their bellies holding their heads up. Get down on the ground with them for the best angle, as in 8-5.

ABOUT THIS PHOTO The photographer got down on her belly to capture this sweet photo of baby lifting his head. 1/100 second, f/5.0 at ISO 100. ©Robin Johnson / www.robinjohnsonphotography.com

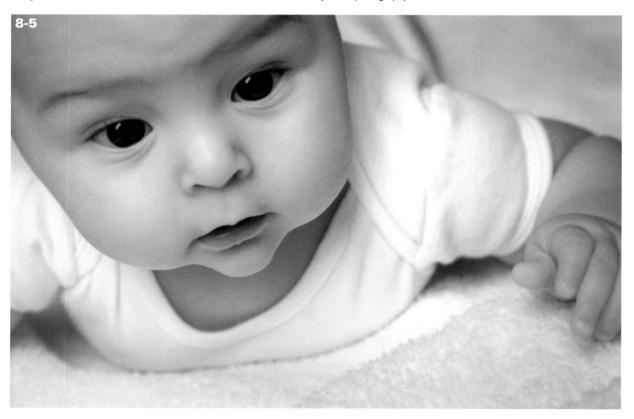

CHARTER 6

SIX TO TWELVE MONTHS

Between six and nine months, a baby is usually able to sit up, but isn't yet crawling; ideal for a photo op. Babies often lean to one side or another like they are going to crawl, giving you ample opportunities for capturing their chubbiness. Perch them on a table, a chair, or even a favorite dish for a more creative twist on the typical baby portrait, as in 8-6. They imitate the faces you make at them and are able to hold on to a toy. Remember, every-

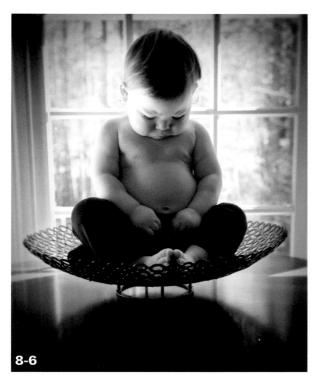

ABOUT THIS PHOTO This darling little Buddha-like baby is intent on examining her belly button. The gorgeous window light highlights every roll and dimple to perfection. 1/125 second, f/3.2 at ISO 320. ©Lisa Russo / www.lisarussophotography.com

thing goes into their mouth at this stage so be careful what you leave within their reach.

Between nine and ten months, many babies begin crawling and might even be able to stand next to a chair while holding on. Make sure that any chair or prop you use to photograph a baby on is sturdy and won't tip over onto them. If the baby isn't steady, use mom or an assistant to stand just out of camera view to prevent any mishaps. Most babies start walking at about the one-year mark and this is a common milestone for parents' to mark with a portrait. It is a perfect time to capture those first tentative steps when they walk with their arms up high to give them balance, as in 8-7.

P quo

"If a child is to keep his inborn sense of wonder, he needs the com-

panionship of at least one adult who can share it, rediscovering with him the joy, excitement, and mystery of the world we live in." ~Rachel Carson

TODDLERS

The stage of a toddler is defined by activity and movement. Toddlers are usually very responsive to toys and to your words and expressions. These little ones need to be in an environment where they have freedom to move and explore in complete safety. Their walking skills usually progress quickly from being a little clumsy to ambling at the speed of lightning.

The toddler stage is characterized by much growth and change, mood swings, and some negativity. Toddlers are long on will and short on skill. This is why they are often frustrated and misbehave. Some adults call the toddler stage the terrible two's.

When working with toddlers, assess whether an assistant or parent present is an asset or liability.

The parent in 8-8 was an asset. This photo turned out beautifully because she was holding and interacting with her child with no regard to the photographer resulting in a candid pairing of mother and child. A relaxed parent usually creates an atmosphere for a relaxed child and the opposite is almost always true. If you have a parent that is overly coaching the child, you may want to kindly suggest that the child might perform better if she

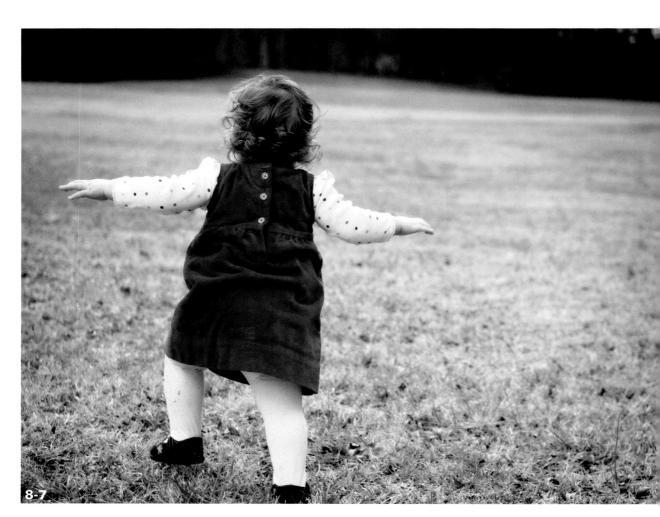

ABOUT THIS PHOTO Arms out to stabilize newfound freedom is the hallmark of the newly walking one-year-old. 1/750 second at f/3.5 at ISO 250. ©Lisa Russo / www.lisarussophotography.com

were out of the picture for a moment. This takes courage but is often worth it in the end.

Activities such as Peek-a-Boo and blowing kisses are likely to induce charming reactions. Whistles, bells, and squeaky toys are likely get an expressive response. Some photographers like to make noises like dogs barking and cats meowing for a reaction. You might be better at pig noises or

talking like Donald Duck. Toddlers are distractible, so be armed with many entertaining and spontaneous diversions.

Asking a child to sit around a tree as in 8-9, or propping a child on a window ledge, as in 8-10, frames the child and provides a "perch" — someplace that is just off the ground that makes him or her hesitant to jump down and run around,

ABOUT THIS PHOTO Classic and soft window light portrait of a mother and her toddler son caught in a moment of reflection. The dark tones frame and deliver the child visually. 1/60 second, f/4 at 800 ISO. ©Ginny Felch / www.silverliningimages.com

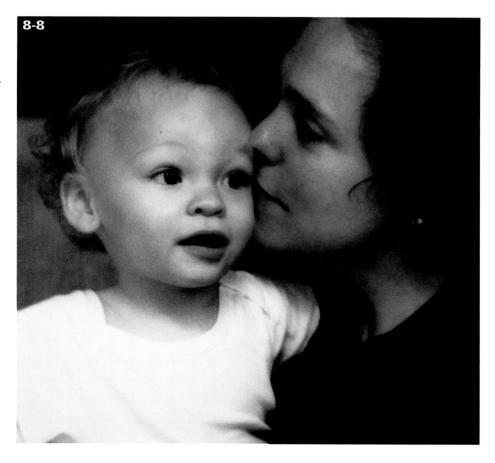

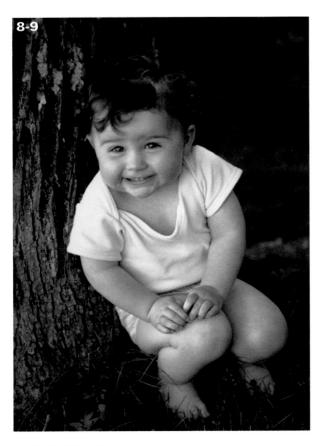

ABOUT THIS PHOTO This little toddler in his undershirt crouching by a tree is a delightful snapshot of toddlerhood. 1/125 second, f/5.6 at ISO 320. ©Patrisha McLean

allowing you a fleeting few seconds to get the shot. Other good perches are benches and tables. Always make sure there is an adult next to the child, just out of camera range, to catch the child if he or she should decide to make a jump for it.

Give toddlers something to become involved with while photographing them. The portraits in

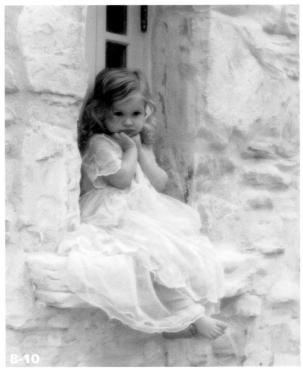

ABOUT THIS PHOTO The stone window, lace dress, and curly locks add a texture to this monochromatic image capturing a natural and involved expression on this child. 1/60 second, f/5.6 at ISO 160. ©ImagesbyDeidre

8-11, 8-12, and 8-13 show different tactics taken with toddlers during a photography session. Props such as ledges, chairs, and other furniture work well if the toddler is willing and able to sit still. If not, offering them flowers or crayons or something to keep their hands busy can keep their attention for a few minutes. Of course, if you are a parent at home with your children, these things happen quite naturally, and then all you need to do is capture them!

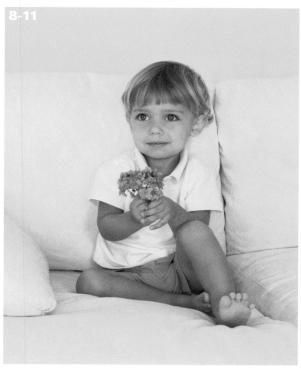

PRESCHOOLERS

Every child photographer has a favorite age. For many, preschoolers present the best of all worlds. Preschool children are communicative, responsive, spontaneous, playful, silly, talkative, and generally charming.

quote

"A three-year-old child is a being who gets almost as much fun out of

a fifty-six dollar set of swings as it does out of finding a small green worm." ~Bill Vaughan

ABOUT THIS PHOTO Another monochromatic, high-key portrait taken in window light softly embraces the sweetness of this little boy after a visit to the garden. 1/125 second, f/5.6 at ISO 400. ©Ginny Felch / www.silverliningimages.com

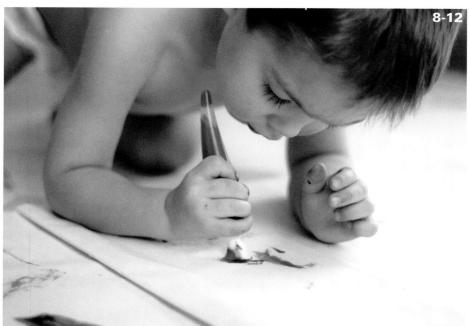

ABOUT THIS PHOTO

Big efforts in creativity captured here showing busy hands and very long eyelashes! Quiet time when children are absorbed in activities is a great time to make unposed images. 1/250 second, f/1.8 at ISO 200.

©Melanie Sikma / www.melaniesphotos.com

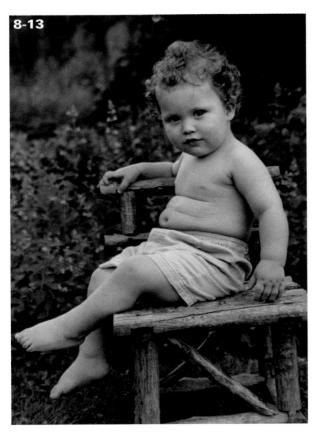

ABOUT THIS PHOTO There is such a lack of self-consciousness with toddlers; their hands and feet, so wonderful to look at, create the most natural poses. 1/125 second, f/5.6 at ISO 320. ©Patrisha McLean

Many preschoolers are trusting, engaging, and fun to be with. Children who are three to about four-and-a-half years old stand out because they are still babies in all the best ways. They haven't usually lost their chubby little cheeks, as in 8-14, nor given up their unself-conscious and innocent movements of their feet and toes.

ABOUT THIS PHOTO Wide-open eyes give a sense of openness and depth in this timeless portrait of a child in the window light. Her round cheeks and cute feet hint at her youthfulness. 1/60 second, f/4 at ISO 160. ©Ginny Felch / www.silverliningimages.com

You can entice a three-year-old to stay put for a few minutes as you engage him or her in conversation. This is one of the times to ask quietly "Shhh! What do you hear? Do you hear the birds? Can you hear the truck?" The expressions that come forth are looks of inquisitiveness, engagement, preoccupation, and delight. Your reactions can elicit further responses as well.

"A mother understands what a child does not say." ~Susan Sarandon

Stuffed animals, shells, flowers, pets, and little trucks can be great props and also encourage more natural body language as in figures 8-15 and 8-16. However, you usually don't have to worry about a child at that age overposing, because he is not that self-conscious yet.

Capturing quiet activities such as reading, daydreaming, or snuggling with a pet also makes compelling images.

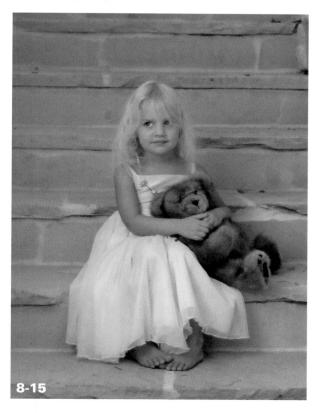

ABOUT THIS PHOTO The toes touching, the eyes looking sideways, and the bear held tenderly all tell a story about a seemingly delightful little girl. The color harmony really adds to the strength of the image. 1/60 second, f/5.6 at ISO 160. ©ImagesbyDeidre

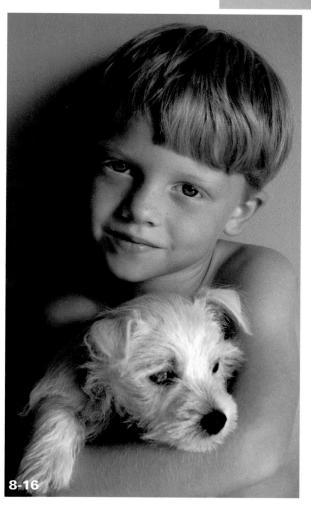

ABOUT THIS PHOTO A puppy can certainly divert a child's attention from the business at hand, fortunately. His affection comes through both in expression and gesture. 1/160 second, f/6.3 at ISO 200. ©Heather Jacks

ABOUT THIS PHOTO This little girl really feels like a princess in this photograph taken looking down into her satisfied and pensive eyes. The simple background keeps the viewer's eye right on spot. 1/400 second, f/2.8 at ISO 250. ©Melanie Sikma / www.melaniesphotos.com

SCHOOL-AGE CHILDREN

As children grow up and start school they are exposed to more social interaction and, as a result, become more self-conscious. There is something about 5- and 6-year-olds that makes them ever-ready to pose with the big, cheesy grin with no provocation. It takes more of your ability to listen and learn about these children, so that you can engage them in conversation or activity that distracts them from themselves.

They are on to the "say cheese" tricks of the trade and consider it cooperative to smile broadly no matter what (well trained by some school photographers and well-meaning parents). It then becomes your challenge to distract them from that as in 8-17. There are several ways to do this. Snap a shot of the cheesy grin and let children see the image. Then tell them that they don't have to do a big smile; they can do a quiet smile and ask them to do it. Take the shot and show them again. Eliciting their help can make your job much easier.

As they get older, children have developed interests and passions that you can find out about in a sincere conversation.

Most of the difficulties that arise with overly cheesy kids are when parents are present. Children know their parents' buttons and push every one of them if they can. It is natural for parents to want their kids to look good, to not make those funny faces that Uncle Harry makes, to sit up straight, and so on. The tension this can add is palpable. Diffuse the situation by letting the parents know ahead of time what you expect from the photo session; that you don't expect the kids to be perfect and that, while you are photographing them, you are in charge.

Children of just about any age tire of the whole process, no matter how interesting you make it,

within a relatively short period of time. Take advantage of these precious moments and work as quickly as you can. Depending on the age of the children, this magical time can last from 10 minutes to 45 minutes at the most. Let this be a warning, particularly if you are being hired to get the job done.

TWEENS AND TEENS

Adolescents, also known as tweens and teens, at their best, can be respectful and involved and, at their worst, sulky and disinterested. They are least likely to buy in to any hype and appreciate a more straightforward approach. Many teens want to look cool, and it will behoove you to figure out

what cool is for them. Their parents might differ in their opinions, however. It is up to you as a photographer to make it work.

In some way, you must invite teens into the process, whether it is subtle or direct. Involving them in the photography discussion is a good possibility, giving them the respect they would like

to have and making them feel they have a choice in the matter.

Some of the most beautiful and profound images can come from a quiet photography session with an adolescent child whose trust you have earned. Notice the eyes and the serious facial expressions of the girl in 8-18 and the young man in 8-19.

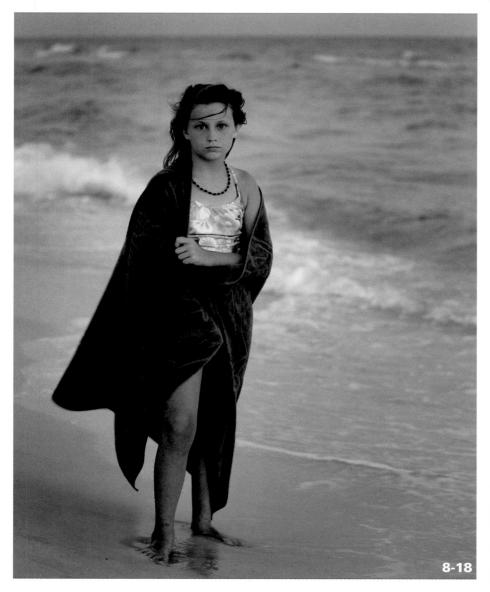

ABOUT THIS PHOTO An intense and bold photograph taken of an adolescent girl at the beach shows a contemplative moment. The dark towel wrapping her draws attention to her and separates her from the background sea. 1/80 second, f/2.8 at ISO 250. ©Scarlett Photography

ABOUT THIS PHOTO This is a direct, captivating close-up of an adolescent boy that makes you want to look deeply into his eyes. 1/250 second, f/2.8 at ISO 100. ©Matthew Reoch

Some day, they will look back on those photographs and probably remember how they felt at that age and, maybe, what they were thinking at the time the images were captured. In the meantime, you will have captured very meaningful portraits. These photos portray children on the cusp; they are still children, but there is an older, wiser look in their eyes.

When the photographer arrived to photograph these young teenaged sisters in their home they were scurrying around, trying new makeup, fixing their hair, and excitedly throwing around clothing.

If the photographer had been in a hurry to get this done, she would have been frustrated, because she expected them to be ready when she arrived.

Instead, the photographer decided to reawaken the teenager in herself and jump right into the preparations and excitement. The drama and playfulness added great energy to the day, and by the time they were photographed as shown in 8-20, she had earned their trust and respect.

The theme here is that all human beings want to be respected and honored. When children are little, you might be able to get away with tricks and treats for a while, but basically, you really need to relate authentically to your subjects in order to produce natural and illustrative photographs.

ABOUT THIS PHOTO This glamorous shot of two teenage sisters is bold yet soft, just as the girls are. 1/125 second, f/4 at ISO 400. ©Ginny Felch / www.silverliningimages.com

GET TO KNOW YOUR KIDS AGAIN Sometimes, taking photographs of other people's children is easier than taking photographs of your own. In fact, almost always. But maybe that's because it is easier to get frustrated with your own kids when you are trying to get them to cooperate for photos. While you might wheedle and cajole your neighbor's kids into doing what you want, you expect your own to hurry up and get with it! Try to step back and pretend like you're getting to know your kids for the first time. The results may be photographs that are timeless in quality.

Often photos taken tweens and teens commemorate a milestone — graduations, first dances, rites of passage, and so on as in the photograph in 8-21. The clothing choice, setting, and lighting make it a timeless portrait.

If you are photographing two or more teens together, as in 8-22 and 8-23, the mood will probably be quite different (more energetic and fun) than when you're photographing them by themselves. Adolescence can be an awkward time for children, and it's okay if they don't smile all of the time. You might even want to get a shot that doesn't show their faces at all yet still captures their youth and vitality as in 8-22.

"A sister is a little bit of childhood that can never be lost." ~Marion C. Garretty

ABOUT THIS PHOTO Zach after sixth-grade graduation, so mellow and laid back at the beach in his new clothes. The bright, clean background and the L-shape of the window frame him beautifully. 1/125 second, f/5.6 at ISO 200. ©Ginny Felch / www.silverliningimages.com

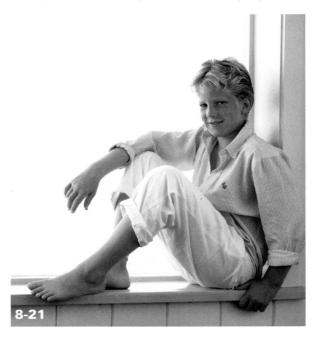

ABOUT THIS PHOTO

This is a casual and fun portrait of teenage siblings on the steps of an art center in Arizona. The sassy teen poses with the somber puppy make a fun juxtaposition. 1/125 second, f/2.8 at ISO 200. ©Allison Tyler Jones / www.atiphoto.com

ABOUT THIS PHOTO Two casual and cuddly siblings on a white porch look really engaged with one another, something that certainly can't be forced at these ages! 1/125 second, f/5.6 at ISO 320. ©Patrisha McLean

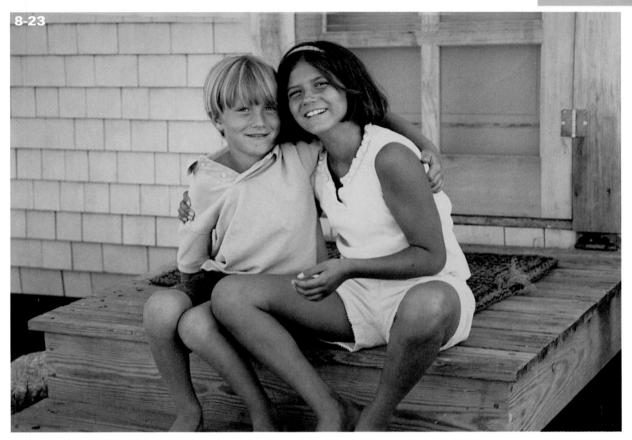

TEEN BOYS

Teen boys can be excruciating to photograph. They usually have two modes: smiley or tough, with no in-between. They usually have to be bribed by a parent to get their photograph taken in the first place so your job is to make it as painless as possible for them. It's helpful to fire off a few shots, even if you know they aren't exactly what you are looking for, and give him a few, "That's great, looking good" comments to put him at ease. If he feels successful early on, he'll relax

more quickly. The smiles come more easily and you get a natural expression as shown in 8-24. Get your camera ready and ask him who his girlfriend is!

TEEN GIRLS

While teen boys are reluctant to be photographed, most teen girls are ready to be the next supermodel. They love to change outfits, try different poses, and will do just about anything you suggest to get the shot. Show them some of the

ABOUT THIS PHOTO Very contemporary and graphic, making use of good strong window light, this portrait is strong, straightforward, and natural. 1/80 second, f/1.6 at ISO 200. ©Scarlett Photography

shots you are taking as you go along to show them what is working and what isn't. Complimenting her on how she looks and how she's doing will keep confidence high and the energy flowing, as in 8-25.

GROUPING FAMILIES

As you photograph children's relationships with parents and siblings, keep in mind that the opportunities to tell a story in your images are waiting for you at every turn. The story can be about connection, either with each other, their environment, or activities.

PARENT AND CHILD

When you photograph families, spend some time photographing individual relationships within the family — that is, siblings, father/son, mother/daughter, and so on. This is extremely rewarding because there is usually special bonding and tenderness that comes to the surface when you are sensitive and encouraging.

Sometimes an initial awkwardness disappears when you say something like, "Okay, guys, I want to see some serious snuggling!" The barriers come down, and you start to see some genuine connection going on before your eyes. It's almost as

"Family faces are magic mirrors. Looking at people who belong to us, we see the past, present, and future." ~Gail Lumet Buckley

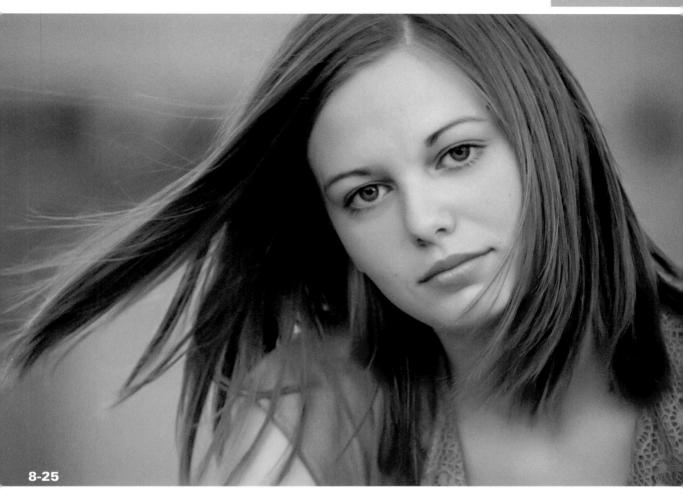

ABOUT THIS PHOTO A very sophisticated headshot of a young teen girl. You'd never know that she is only 13! 1/200 second, f/2.8 at ISO 400. ©Allison Tyler Jones / www.atjphoto.com

though they are waiting for your permission. That is when your heart beats fast and you are able to capture moments that will be treasured for generations.

When life gets frenetic and stressful, and the world news is depressing, fragile and profound moments, such as the one shown in 8-26, are very uplifting.

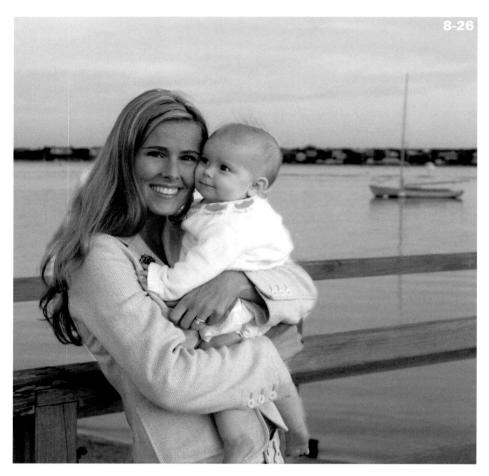

ABOUT THIS PHOTO Sarah and Virginia share a sunset on Nantucket Bay on a warm summer evening. The soft pinks of the clothing blend in with the skies; the composition creates a sense of place. 1/45 second, f/8 at ISO 100. ©Ginny Felch / www.silverliningimages.com

Don't rule out dads in terms of eliciting emotional connection. For example, in 8-27 the photographer turned some quiet music on in her studio while the mom was running after their two-year-old and dad sat by the window holding his newborn child. They shared the blissful feelings of this special moment. He was not afraid to show his feelings, and that was captured forever.

If you want to evoke a connection between people, you must relate to it yourself and let it mirror back...from your eyes, via your heart, and back out through the lens!

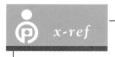

For tips on how to change the look of your photographs after they have been captured, turn to Chapter 10.

When photographing teenage boys with their dad, you can pretty much guarantee that there is not going to be much snuggling going on. Maybe some wrestling and punching in the arm here and there, but snuggling? No. So how do you get a decent shot of older boys and their dads? Well, tough is always in good recommendation when it comes to boys (and their fathers). The photographer told these boys in 8-28 to pose for their "CD cover" and they immediately assumed the pose.

Move in close for a tight shot of a mother and daughter, as in 8-29. The expressions here say it all.

ABOUT THIS PHOTO Nap time can be an opportune moment for some extra snuggles, as seen in this peaceful and tender image of a father and his young son. (Grain was added in post-production to lessen contrast and create a more peaceful look.) 1/125 second, f/4 at ISO 500. ©Ginny Felch / www.silverliningimages.com

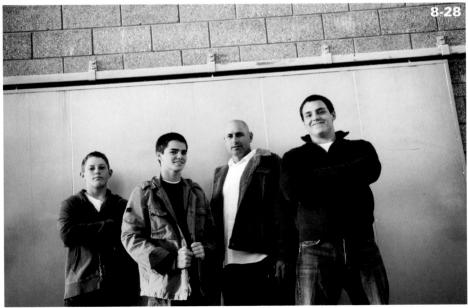

ABOUT THIS PHOTO A contemporary, graphic portrait of a father and his sons. Snuggly they aren't, but you can still feel the connection among them. 1/100 second, f/2.8 at ISO 100. @Allison Tyler Jones / www.atjphoto.com

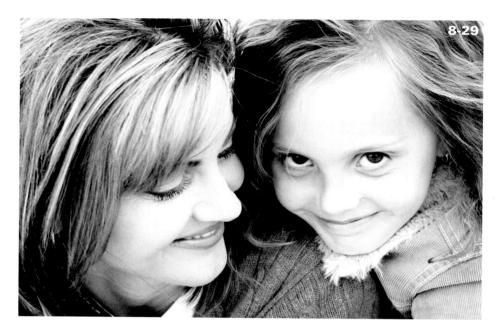

ABOUT THIS PHOTO The love and connection is obvious between this young girl and her mother. Moving in close puts the focus on the relationship. 1/125 second, f/2.8 at ISO 200. ©Allison Tyler Jones / www.atjphoto.com

SIBLINGS

If it is energy you are seeking when working with children, siblings generate it in abundance. It seems that their personalities bounce off of one another's, which can be fun to witness and capture.

Sibling relationships are primal and authentic, for better or worse. If there is tension, and there usually is, it shows. If you can be there to provide some incentive for fun, competition, or yes, even physical connection, your images shine.

Often the relationship reveals itself immediately without anything but your observation. It might not show through in conversation, but perhaps in body language, as in 8-30. Be on the lookout.

Don't enter into the session with preconceived notions and stereotypes such as boys will be boys or girls will be girls. Stay open to the possibility that your expectations can be blown right out of

ABOUT THIS PHOTO The adoration this little sister feels for her big brother is evident in her expression and body language. Do you think he knows how much she loves him? 1/250 second, f/2.8 at ISO 100. ©AllisonTyler Jones / www.atjphoto.com

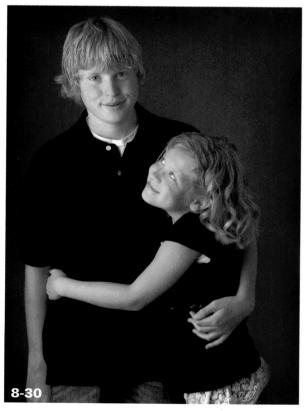

Service Servic

the water. Don't miss out on opportunities to surprise yourself and entertain the eye of the viewer.

Photographing siblings is a great opportunity to make a storytelling photograph, while the children are interacting with each other or the environment. Try to have them engaged in the same thing, however, so that there is a semblance of unity. In other words, they can be looking at you as in 8-31, looking at each other, or looking at something else as in 8-32, but try to have them looking in the same direction.

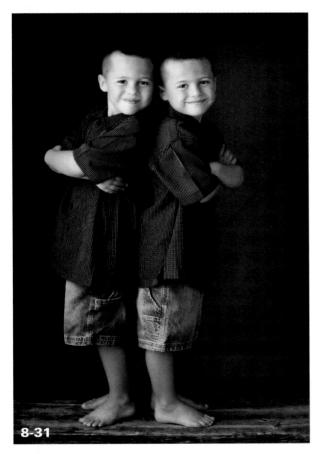

ABOUT THIS PHOTO There's mischief in those eyes! Standing the boys on a bench put the lens at their bodies' midpoint allowing them to look straight into the lens. 1/250 second, f/2.8 at ISO 100. ©Allison Tyler Jones / www.atjphoto.com

You can photograph siblings telling secrets, exploring nature as in 8-33, playing together as in 8-34, sharing pets, and so on. Always be prepared for spontaneous eruptions that can occur, no matter what you plan, some of which might work well for your photograph. A fit of laughter or surprise can tell a lot about siblings together and make a memorable photograph. Don't feel as though you must direct everything; let them discover some of these on their own.

Endless stories can be told in photographing siblings; you are limited only by your imagination!

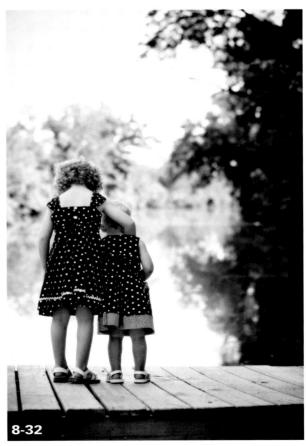

ABOUT THIS PHOTO There is lots of texture here with curly locks, polka dots, and foliage, yet this image of two little sisters is composed with elegance. The dark trees and dock frame the girls. 1/200 second, f/3.5 at ISO 50. ©Marianne Drenthe / www.marmaladephotography.com

ABOUT THESE PHOTOS This enchanting series of siblings reveals many facets of their personalities and relationship. The dappled light of the garden and the classic outfits create illustrative portraits. 1/125 second, f/5.6 at ISO 320. ©Patrisha McLean

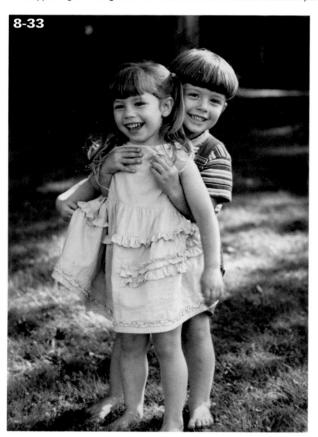

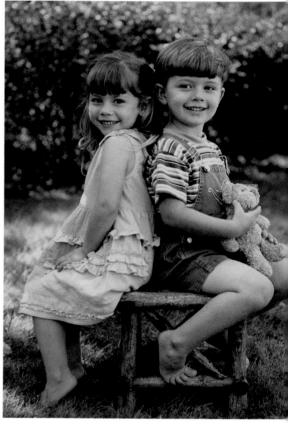

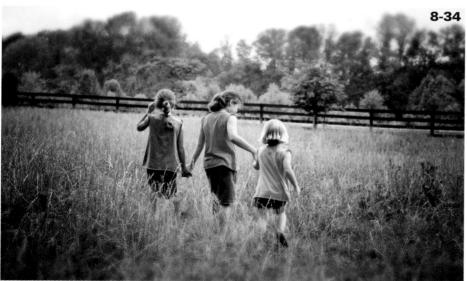

ABOUT THIS PHOTO These sisters take a walk across a meadow. Their body language and the camera angle all tell a story about their relationship. 1/50 second, f/6.3 at ISO 200. ©Lisa Russo / www.lisarussophotography.com

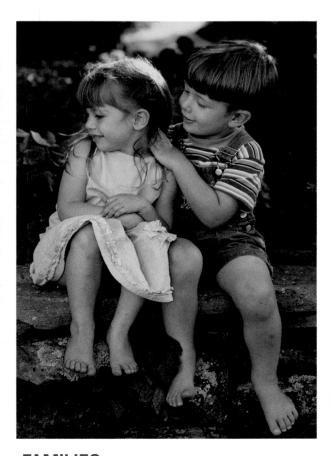

the beach, and so on, you can plan accordingly. Also, you can learn a little about the personalities, relationships, and so on.

It's a good idea to take different kinds of photographs during the session so that they have some

interests, such as fishing, picnicking, walking on

It's a good idea to take different kinds of photographs during the session so that they have some choices. If you are going to photograph them in a straightforward way (facing you, smiling, and so on), you might also encourage them to interact with one another.

Most families today prefer a family portrait that is more than just a visual representation of the family together. They want a family portrait that tells a story about their relationship with each other. For 8-35, a portrait of a mom and dad and their two daughters, the photographer encouraged them to walk along the tide line. She asked them to line up parallel to each other so that they would all be in focus. Then she told them to try to forget about her as they interacted with each other.

For more on using leading lines like tide lines in your photography, see Chapter 5.

FAMILIES

Photographing families can be as complicated and unique as each individual member. It takes a bit of patience and a lot of psychology, but if you try to make it fun, you have a better chance of success.

Depending on the number of family members, it can be difficult to find a location that accommodates them graciously. It is also difficult to avoid the cliché of just having them sit or stand and smile for the camera. The challenge becomes how to photograph a family creatively.

If you have the luxury of knowing the family or of spending some time with them before the portrait, you are at an advantage. If they have particular Once the family started walking, the photographer ran up the beach, and using a telephoto lens, followed them coming and going. The result is a photograph with a feeling of lightness and the elegance of a dance. These were not awkward, preadolescent girls, but if they had been it still would have worked very well.

Modern families are less likely to want their photographs to be serious or posed, but more natural and candid. That was the request of the family shown in 8-36 with three teenagers. Their interaction and trying to get the dogs to sit still was fun and hilarious, so it was easy to capture this natural, light-filled photograph.

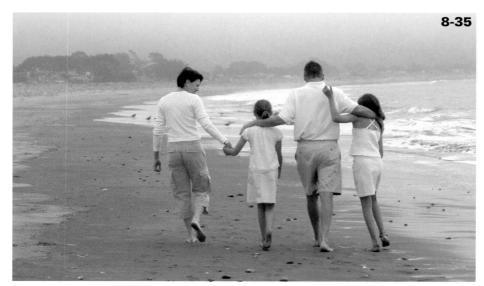

ABOUT THIS PHOTO

The color harmony between the setting and the clothing tie it all together, and the curved path of the shoreline lead you forward.

1/125 second, f/8 at ISO 400.

©Ginny Felch/

www.silverliningimages.com

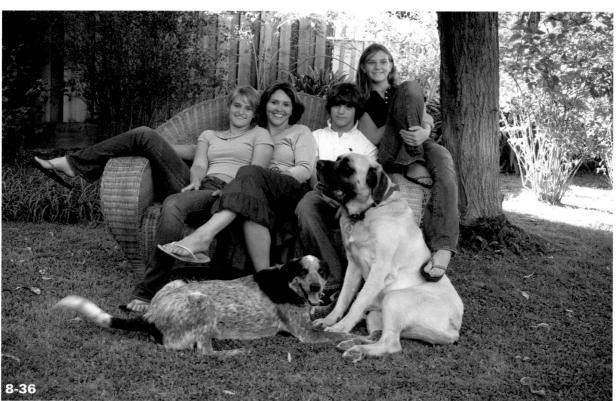

 $ABOUT\ THIS\ PHOTO\ The\ mood\ of\ this\ very\ casual\ and\ uplifting\ family\ portrait\ was\ elevated\ by\ the\ presence\ of\ dogs.\ 1/30\ second,\ f/8\ at\ ISO\ 800.\ @Ginny\ Felch\ /\ www.silverliningimages.com$

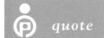

"Call it a clan, call it a network, call it a tribe, call it a family. Whatever you call it, whoever you are, you need one." ~Jane Howard

This kind of photograph forces you to move out of a comfort zone if you are used to posing families. However, if you roll with it and join in on the fun and energy, you can be successful.

As more and more photographers enter the hobby, clever ideas abound, such as using couches or beds in unlikely places like a field or a beach as in 8-37. Can you imagine trying to be too serious in that environment?

Photographing families outdoors or in their homes lends informality automatically when compared with a more-structured studio environment. It also enables you to be more creative as you find new places in which to work. An outdoor location also allows you more room to roam when photographing larger family groups, as in 8-38.

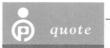

"The family is one of nature's masterpieces." ~George Santayana, The Life of Reason

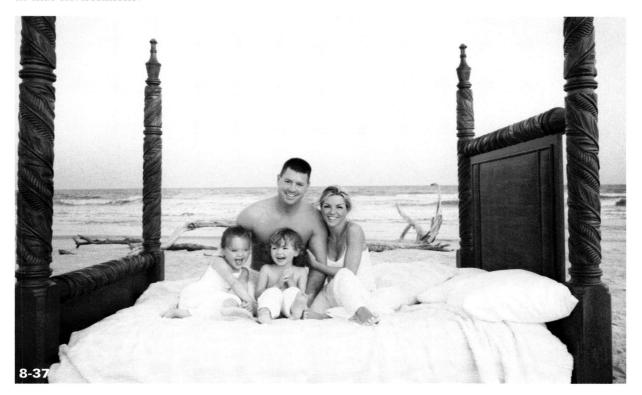

ABOUT THIS PHOTO A family portrait taken at the beach in a four-poster bed shows imagination and merrymaking. The frame of the bed adds solidity to the composition. 1/200 second, f/4.5 at ISO 500. ©Tina Wilson

 $ABOUT\ THIS\ PHOTO\ This\ high-energy\ family\ portrait\ captures\ their\ fun-loving,\ active\ nature.\ Shooting\ in\ a\ park\ near\ their\ home\ allowed\ lots\ of\ room\ for\ running\ and\ jumping.\ 1/800\ second,\ f/2.8\ at\ ISO\ 100.\ @Allison\ Tyler\ Jones\ /\ www.atjphoto.com$

Assignment

Families and Siblings

Take a photo of a family or siblings together. How are you grouping them to tell a story? Is the photo candid or posed? You can utilize some of the other elements you have learned — for example, composition and lighting — so that you have a stronger image. However, if you have to compromise, do it with light and composition. What is important here is to unite the subjects in one way or another, making a strong statement about the relationship.

In this photograph of a family the goal was to capture a feeling, something more than just their likenesses. The photo was taken near sunset, taking advantage of the sweet light, as discussed in Chapter 3. The great feeling in the photo was achieved by directing them to run through the strip of sunlight several times to get the shot. By the time they had run through twice, they were laughing and looking at each other as if to say, "Isn't this photographer crazy?" Taken at 1/125 second, f/2.8 at ISO 100.

©Allison Tyler Jones / www.atjphoto.com

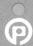

Remember to visit www.pwassignments.com after you complete this assignment and share your favorite photo! It's a community of enthusiastic photographers and a great place to view what other readers have created. You can also post comments, and read other encouraging suggestions and feedback.

Considering a Camera Upgrade Using Interchangeable Lenses LOOKING INSIDE YOUR CAMERA BAG

©Ginny Felch / www.silverliningimages.com

Although the emphasis throughout this book has been that equipment and technology are secondary to making your images of children it is helpful to have a starting point when purchasing expensive equipment. There are so many equipment options available; where do you start? The choices and preferences are personal and change a bit from photographer to photographer; making your own decisions depends on your needs, your level of experience, your budget, and even your brand preferences.

If you are entering into the field of photography right now, consider yourself fortunate in that you haven't had to ride the waves of early digital technology. It's been a very expensive ride, and you are now at a point where the learning curve has greatly diminished.

CONSIDERING A CAMERA UPGRADE

Consider that updates, upgrades, and new products hit the market on a daily basis. What is perfectly suited for you today could change on a moment's notice. If you are in the market for some new equipment or are just interested in learning what's out there, do your research first. Here are a few Web sites that might aid you in your camera and post-production research:

www.imaging-resource.com/tips/choose/choose.htm

www.cnet.com

www.dpreview.com

www.photo.net/equipment/digital/choosing2/www.tamron.com/lenses/fundamentals.asp

You save time and money by deciding ahead of time what you really need in the near future. The best advice is to start with what you have. Learn whatever camera you have inside out and backward and only upgrade when you know what you need to move forward. With the advent of digital photography, our cameras became computers with lenses on them and we all know it doesn't take long for a computer to be out of date. Technology moves very fast so don't leap before you know what you need or you'll find yourself with old technology that you still don't know how to use. Most beginners start with a simple pointand-shoot camera and use its automatic settings. If you need to advance to a camera that gives you more control over your settings (as covered in Chapter 2) ask yourself the following questions:

- Do you have the time and motivation to learn new things?
- What will you be comfortable using for the challenge of photographing children?

Chapter 2 covers more-advanced camera settings and photography concepts, such as aperture, ISO, and depth of field.

- Do you need a camera that enables you to choose your depth of field, either by modes such as Portrait, Landscape, and so on, or by Aperture Priority/AV mode? Does your existing camera offer that now?
- What size prints do you want to make? Are you ready to progress to a camera that produces higher-quality, larger-image files? This is going to be determined by the number of megapixels the camera offers. If you eventually

want to print a high-quality 8-×-10-inch print, you need to buy a camera with at least 5 megapixels. If you are making photographs for e-mail or the Web, you don't need to worry about having lots of megapixels. *Megapixel* is the measurement of resolution: the larger the number, the greater the resolution or quality of the photograph produced.

- Do you want to be burdened with lots of equipment when you are photographing children? Usually, you must make a trade-off here. Point-and-shoot cameras are light and lend themselves to spontaneous moments.
- Would you like to use interchangeable lenses? In that case, you need an SLR (single-lens reflex) camera. Are you intimidated by all the bells and whistles, or can you simplify your approach? Can your budget afford to invest in a selection of lenses?
- How much can you afford to spend? More expensive doesn't always mean the best. The best camera for you is the one that meets your needs without having more features than you'll use.

When you are ready to purchase equipment and have narrowed your search, here are a few items to consider:

- Does the camera fit your hands? When you hold the camera in your hands, does it fit your hands well? Can you find the basic settings without having to get out the manual?
- Check the reviews and get opinions from photographers whose work you admire. Find out what they are using. You may be surprised that it's not as flashy as you thought!

■ If you upgrade your camera, can your computer equipment handle the change too? With digital photography, the camera and lenses are only half of the equation. You may need to upgrade your computer and software as well, as discussed in Chapter 10.

USING INTERCHANGEABLE LENSES

When it comes to photography, nothing influences the look or quality of your image more than the lenses you use. Lenses are your most important investment. You would be smart to buy a less-expensive camera and put your money into good lenses that can grow with you. The price of lenses is directly related to their speed and quality. Today's manufacturers produce lenses of exceptional quality and sharpness.

LENS SPEED

In Chapter 2, the concept of aperture was introduced. Aperture, or the lens opening, can only open as wide as the maximum aperture for that particular lens. Lenses with very large maximum apertures (that is, f/1.2, f/1.4, f/2.8) are considered fast lenses because, at their widest settings, they let in two, three, even four times more light than a lens with a maximum aperture of f/3.5, f/4.0, or f/5.6, for example. These wider apertures let in so much more light than their slower counterparts that it takes less time for an image to record on your digital sensor, allowing you to work at faster shutter speeds. Many of the photographs in this book were taken with faster lenses. For example, if you look at the technical information under each photo, and you can see that many of the images were captured with apertures of f/2.8.

LENS FOCAL LENGTHS

You will notice that the focal lengths in Table 9-1 are listed individually. If you own a zoom lens, your lens length will likely encompass several of these focal length ranges (such as 12-24mm or 70-200mm). Breaking them out individually gives you more information as to which focal length is used for certain types of photography.

- Wide Angle. Less than 50mm (for example, 28mm, 14mm, also known as fish-eye). Great for interiors, landscapes, architecture, large groups. or for creative distortion.
- Standard. 50mm. What your eye sees, no distortion.
- Telephoto. Greater than 50mm (popular portrait lens lengths are 85mm, 105mm, and higher). These lenses compress an image, which is flattering for portraits; they also allow you to zoom in on the action from a distance. A lens can be both a telephoto and zoom for example, 75-300mm.

PRIME LENSES

Prime lenses are fixed focal length lenses. That means, instead of zooming from 12-24mm or 70-200mm, theses lenses are fixed at 50mm, 85mm, and so on. In the case of prime lenses, *you* are the zoom! Prime lenses are often overlooked by beginning photographers for several reasons, including the following:

- New photographers usually have a zoom lens that came with their camera when they bought it.
- No one has bothered to tell the newbie just how great and, in some cases, affordable prime lenses are.

Photographers who are purists use only prime lenses for their speed, quality, and sharpness.

The photograph in 9-1 was taken with a 50mm prime lens.

Another major benefit of prime lenses is that they are often significantly less expensive than zoom lenses. You can pick them up new or used online and in your local camera store or, better yet, try renting one from your local camera store for the weekend and see if it's a good fit for you.

Table 9-1

Lens Types

Common Focal Lengths	Type of Lens	Uses
12mm	Wide Angle	Good for large groups
14mm	Wide Angle	
18mm	Wide Angle	
24mm	Wide Angle	
35mm	Wide Angle	
50mm	Standard Lens	This is what the eye sees
85mm	Telephoto	
105mm	Telephoto	Often considered ideal for Portraiture
200mm	Telephoto	Good for blurring out backgrounds or for getting in close on the action
400		

ABOUT THIS PHOTO This photo was taken using a 50mm prime lens. Prime lenses are prized for their speed, sharpness, and quality. 1/250 second, f/2.8 at ISO 100. ©AllisonTyler Jones / www.atjphoto.com

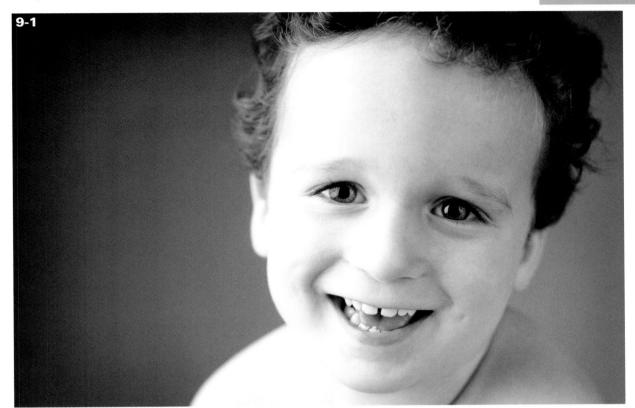

ZOOM LENSES

Zoom lenses provide several focal lengths in a single lens. This is the most common type of lens in use today. If you look at your zoom lens you will notice that there are two numbers denoting the focal length (such as 18-70mm or 35-135mm); this means that your lens will provide focal lengths from the smallest to the largest number. Zoom lenses are perfect for photographing children because they allow you to constantly change your focal length without actually switching out lenses. The only downside to zooms is that they can be pricey.

The images in 9-2 and 9-3 were taken with a zoom lens, illustrating the advantage of being able to capture images from a wide angle as well as a close-up without having to switch lenses.

The five photographs shown in 9-4 through 9-8 are of Obie, a toy you met in Chapter 7. These images were shot with the photographer standing in exactly the same place while using a zoom lens at different focal lengths. Use these as a guide to the effects that various focal lengths can create in image width and depth of field.

A 300mm lens as used for 9-1 is considered a telephoto lens, which magnifies objects that are very far away. These lenses can be quite expensive, especially if you buy one that is fast. You could pay around \$1,500 or more. A 300mm lens is great for taking shots of children at the beach or sporting events when they are far enough away that you want to hone in on them more closely.

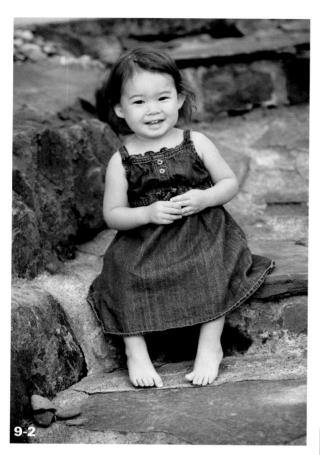

ABOUT THIS PHOTO This photo was taken using a 70-200mm zoom lens at approximately 85mm. 1/125 second, f/2.8 at ISO 100. @AllisonTyler Jones / www.atiphoto.com

A 200mm focal length is achieved using a 75-300mm telephoto lens for the photo in 9-2. The 200mm doesn't bring Obie as close as the 300mm, but it is a good choice for some portraits, if you're taking a picture of a child in the distance.

A 135mm focal length is also achieved using a 28-135mm telephoto lens as in 9-3. It still allows a longer focal length than a wide-angle lens, but has a narrower area that it will capture. I recommend it for portraits and great candid shots as long as your subject isn't too far away.

A 50mm focal length is achieved using the same 28-135mm zoom lens as in 9-4. This wider-angle perspective is great if you are taking family or sibling portraits because it allows you to get in closer and eliminates more of the background.

A 28mm lens as used for 9-5 is a standard wideangle lens. It was achieved here using the same 28-135mm lens as used earlier. This is a good focal length for group pictures, but not for closeup portraits because it can distort your image, making whatever is closer to the lens appear larger (like noses).

p tip

If you are unsure about a new equipment purchase, rent it first.

Many camera stores rent equipment for a few days or over a weekend so you can get some hands-on experience with the object of your desire. Some stores may apply the rental fee to the purchase of the new item.

HOW CAN YOU DETERMINE THE MAXIMUM APERTURE OF YOUR LENS?

Look on your lens (sometimes around the end of the lens barrel and sometimes on the front element of your lens) for a number that starts with "1:" (for example, 1:2.8). These numbers indicate the largest or maximum aperture for this lens is f/2.8. Your lens might have more than one number (for example, 1:3.5-5.6). A number like this can be found on a zoom lens. Having two numbers means your aperture gets smaller as you zoom your lens in. So, when you shoot photos and your lens is pulled back, your maximum aperture is f/3.5, but when you zoom all the way in to pull your subject in closer, your maximum aperture is f/5.6. There are also zoom lenses with apertures that remain constant as you zoom in and out.

ABOUT THIS PHOTO

This photo was taken using the same 70-200mm zoom Iens as in 9-2 but this time the Iens was zoomed in to approximately 200mm. 1/125 second, f/2.8 at ISO 100. ©Allison Tyler Jones / www.atjphoto.com

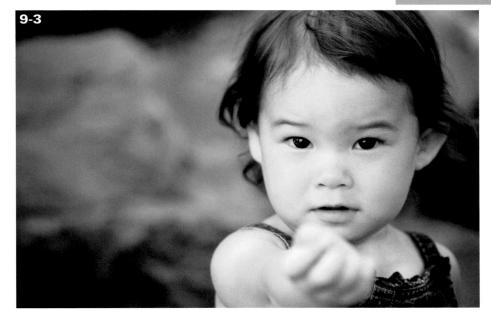

LOOKING INSIDEYOUR CAMERA BAG

Most professional photographers learn very quickly to streamline their equipment to the bare essentials so that they aren't hauling tons of equipment to every session. Being loaded down with too much stuff can affect your spontaneity.

Consolidate your equipment enough so that everything fits into one bag. The camera bag in 9-9 belongs to Ginny Felch. Take a peek into a working photographer's bag.

To be a successful children's photographer, you need some non-camera-specific equipment with you at all times. This equipment is entirely optional and depends on how much you want to carry and how you interact with your subjects. Here's a list of the items in Ginny's bag:

- Spray bottle of water (for bad hair days)
- Small comb and brush (for bad hair days)
- Small bottle of hair spray (for hair emergencies)

- Safety pins and duct tape (for clothing emergencies)
- Model releases (carry these if there is a chance you might put an image online or publish it), pen, business cards, and sticky notes
- Child's toy or comfort item such as a small, stuffed animal
- A few small noisemakers like a whistle and castanets (to distract restless subjects)
- Lens cloth

Your camera bag also should include the following pieces of camera equipment:

- Extra memory card extras, preferably 1 to 4 GB
- Your favorite lens (Ginny's is a 28-135mm)

You could also pack some optional items in your bag or in a separate bag that you keep in your car:

■ A backup camera (Ginny uses a Canon 20D as a backup to her Canon 5D)

- Additional lenses (Ginny uses an 85mm prime lens and her 100-300mm zoom lens)
- Two extra batteries, charged

Doublecheck before you leave the house or studio, every time you leave for a photo shoot, that you have packed those extra batteries and media cards. These are two items that, no matter how cool your camera is, you can't make an image without!

ABOUT THESE PHOTOS 9-4 was taken with a 300mm lens. 1/160 second, f/5.6 at ISO 400. 9-5 was taken with a 75-300mm lens set at 200mm. 1/200 second, f/5.6 at ISO 400. 9-6 was taken with a 28-135mm lens set at 135mm. 1/250 second, f/5.6 at ISO 400. 9-7 was also taken with a 28-135mm lens, this time set to 50mm. 1/250 second, f/5.6 at ISO 400. 9-8 was taken with a 28-135mm lens set to 28mm. 1/400 second, f/5.6 at ISO 400. ©Ginny Felch / www.silverliningimages.com

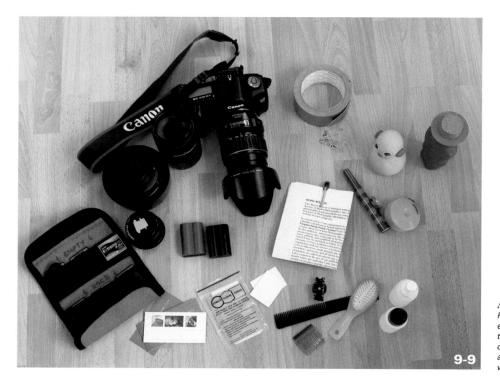

ABOUT THIS PHOTO Here is a photograph of the equipment and other goodies that Ginny always keeps in her carrying case. 1/30 second, f/8 at ISO 400. ©Ginny Felch / www.silverliningimages.com

Assignment

Exploring the Limits of Your Zoom Lens

Take the time to shoot some reference images using your zoom lens. Photograph the same subject from the widest to the longest focal length your lens will accommodate and notice how the appearance of each image changes. Print the images and keep them for future reference to help you visualize what your lens is capable of.

This image was taken by zooming all the way in at 200mm on a 70-200mm lens. This allowed the photographer to be on dry land and still capture the boy in the middle of a very large pool during his swimming lesson. You can see that the depth of field is very short (shallow) with just his goggles being in sharp focus that enhances the feeling as he breaks through the surface of the water. 1/1000 second, f/2.8 at ISO 200.

©Allison Tyler Jones / www.atjphoto.com

Remember to visit www.pwassignments.com after you complete this assignment and share your favorite photo! It's a community of enthusiastic photographers and a great place to view what other readers have created. You can also post comments, and read other encouraging suggestions and feedback.

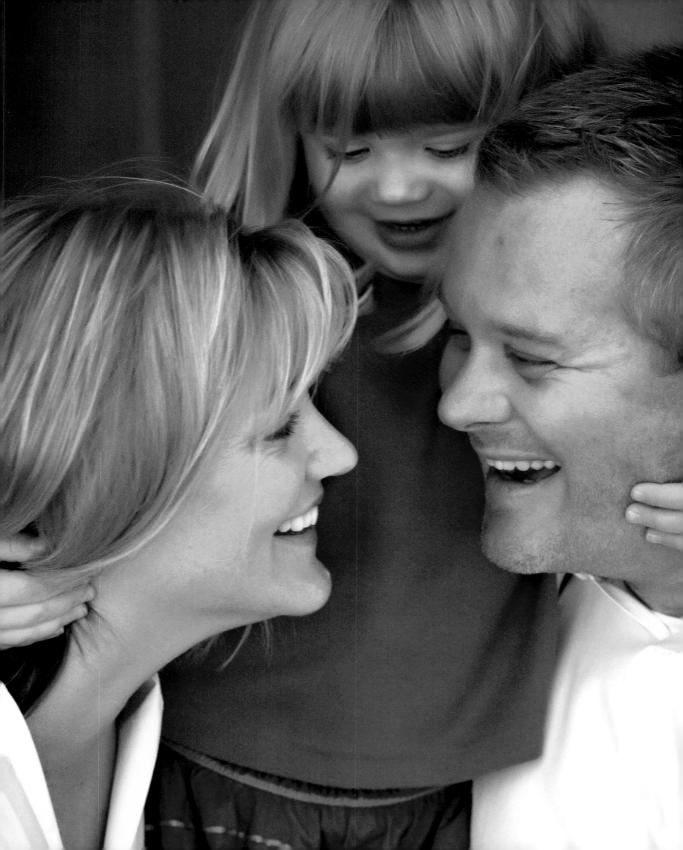

ESTABLISHING YOUR WORKFLOW
GETTING STARTED WITH IMAGE EDITING
IMAGE-EDITING WORKFLOW
BASIC RETOUCHING
CHANGING COLORS FOR IMPACT
CROPPING TIPS
PRESENTATION GALLERY

Capturing the image with your camera has always been just the first step in creating a final image. In the film days, the darkroom became the next step to apply your creativity to an image. Today, your darkroom is digital and there are more possibilities than ever before.

This chapter encourages you to experiment and play with your images. It's like doodling: The more you play, the more you see what you can do with your images, which enables you to find styles that appeal to you.

ESTABLISHING YOUR WORKFLOW

Post-production is the term photographers use to indicate everything that happens after the image is captured. That includes loading your images from your media card to your computer, playing around in an image-editing program, all the way to the final printed image hanging on your wall. There are a lot of steps to get you from here to there and each photographer has his or her own, unique way of working, which is called workflow. Workflow is defined by Wikipedia.com as a reliably repeatable pattern of activity.

A good, consistent workflow is critical for digital photographers. Everything is a digital file that can be easily deleted, corrupted, or just plain lost! So, establishing an easy-to-follow workflow for your images is critical because it allows you to:

- Consistently back up and archive your images
- Organize your images so you can find them quickly

- Preserve an untouched set of images so that you aren't working on your originals
- Virtually eliminate the chance of lost or deleted images

Even if you are "just a snapshooter" you have probably already accumulated a fair number of images on your computer. Can you find the image you need quickly? If not, set up a workflow that works for you. The following is a basic workflow that you can follow as you get started. Once you expand your skills and understand all the components of the workflow, you can begin to adjust it to fit your specific needs.

- 1. Upload your images. Upload your images from the media card as soon as possible after capturing the images to avoid any mix-ups with accidentally formatting or overwriting the card. Create a folder on your computer desktop using a name or numbering system that makes sense to you (the important thing is to keep the naming consistent).
- 2. Choose File ⇒ Save As. The Save As dialog box opens. Choose the location in which you want to save the file and type the new name in the File name field. Click OK.
- 3. Back up your files. After you rename the images, back up the folder by dragging it to an external hard drive (recommended but optional) or burn a disc with the renamed images, and label it ORIGINALS, and name it using your chosen naming/numbering system. Put this disc in a safe place (fireproof safe or safe deposit box are good options).

- 4. Retouch, crop, and enhance images as necessary in your chosen image-editing software. You now have at least one (hopefully two) backups on disc of your original, out-of-camera images. That disc with your original images on it is just like your negatives with a film camera and should be treated as carefully. All of the previous steps should be taken before you do any enhancements to any images. Now you can play all you want with the images in the folder on your computer desktop because you know that your originals are safe and untouched.
- 5. Backup your edited images. When you finish retouching and enhancing your images, back up those enhanced images to your external hard drive or burn another disc. This time you can label the disc FINAL PROOFS and reference your original number/naming system.
- 6. Output your finished images to a lab or printer. Output your final proofs to your favorite lab or your printer if you are printing your own images.

Ultimately, the key to a good workflow is consistency. If you unload, save, and file your images the same way every single time, you will have no trouble locating an image when you need it.

GETTING STARTED WITH IMAGE EDITING

Not long ago, when choosing imaging software, you would have been limited to Photoshop and

Photoshop Elements, but now many entry-level programs are available, and some are free! For example, Picasa for Windows (from Google) is available as a free download. If you work on a Mac, iPhoto is a very easy-to-use image manager.

Image-editing software enables you to manage your photographs in the following ways:

- Rename your files (for example, change from IMG_0932_2.jpg to grace_2007.jpg)
- Organize and rate
- Crop
- Brighten, darken, increase, or decrease contrast
- Color correct
- Sharpen or blur
- Add filters
- Rotate
- Correct red-eye
- Convert color to black and white or even sepia tone

If you are seriously entering the world of digital imaging, however, don't spend a lot of time on entry-level programs — Adobe's Photoshop Elements and Photoshop are industry standard for image-editing software. If you can take on the challenge, you might as well spend your valuable time learning Photoshop Elements. We recommend finding a good, entry-level book on Photoshop Elements such as *Photoshop Elements 5 For Dummies* (from Wiley).

Photoshop Elements has many great, high-end features and once you get comfortable with it, you should find it very easy to use and intuitive. It also lays the groundwork for eventually stepping up to the full version of Photoshop. The commands and working space are identical between the two, with Photoshop providing more options and control.

IMAGE-EDITING WORKFLOW

Many budding photographers start image editing with Photoshop Elements, but even if you use different image-editing software, you can still follow the basics presented here. Setting up a consistent order of working in image-editing software allows you to work more quickly and achieve more consistent results. The following order is a generally accepted workflow for enhancing your images. The basic idea is to work from large changes to small changes in a logical order.

For \$99 a year, you can join the National Association of Photoshop Professionals (NAPP) and receive its publications. This membership allows you to enter the Web site (www.photoshopuser.com) and learning centers to receive discounts and other perks. NAPP sponsors training workshops, which are relatively economical and extremely thorough.

1. Make tonal adjustments. It's best to make any exposure adjustments (a little bit lighter, little bit darker) as your first step. This includes any Levels or Curves adjustments that affect the overall lightness, darkness, or contrast of the image.

- 2. Make color corrections. Adjusting your white balance before you take the photo means much less work at this stage. Check Chapter 4 for White Balance details. However, you might have an image that has a strange color cast, such as too blue or too orange that needs adjusting. Do color corrections after tonal corrections.
- 3. Retouch as needed. Only after you have corrected the exposure and color should you begin other adjustments or enhancements to the image. This means that all the adjustments that affect the entire image have been made and now you are working refining the details.
- 4. Make any image enhancements. These include conversions to black and white or actions that give a different look to your image such as a super-saturated colors or high-contrast treatments.
- 5. Back up your files. After you finish fixing and retouching your image, back up the file that has been worked on save a copy for cropping and or sizing.
- 6. Crop and size your images. Working with a copy of your final file, crop to the size you want your final image to be. Because a digital file doesn't fit into the standard 8 × 10, 5 × 7 crops that we are used to seeing, you will need to size your image before uploading to a lab to ensure that the crop is how you want it to be. If you don't resize/crop your image, the lab may do it for you and your final print might be different than what you originally envisioned.

note

Photoshop Elements is a great tool but it's important to remember that

properly exposed images usually need very little done to them in post-production. Make it your goal to improve your technique on the front end or at the capture stage of photography rather than relying on an image-editing software fix later.

BASIC RETOUCHING

Portrait photographers most often use retouching techniques to eliminate blemishes and wrinkles in their subjects and eliminate distractions in the background. Fortunately, kids don't have wrinkles, so most retouching involved in children's portraits is limited to removing any marks on the face, such as scratches, disguising a runny nose, or removing blemishes on a teenager.

Here are the most commonly used techniques when retouching a portrait of a child:

- Removing a blemish such as a scratch, pimple, or mark on a face or body
- Whitening the teeth
- Enhancing the eyes
- Eliminating distractions in the background

USING LAYERS

If your chosen image-editing software has layers or something similar, you are in luck! One of the best things about Photoshop Elements is that it allows you to work in layers, which essentially is a quick copy of your image so you can manipulate it. If you mess it up, you can throw it away. If it's just right, you can save the image and you're

done. Before you try any of the following fixes, use the press Ctrl+J/\mathbb{H}+J to create a duplicate layer of your image (this preserves your original working image without changes). Then try the following fixes. When you have your top layer the way you like it, you can flatten the image (merge the layers), which allows you to save the image as a smaller file that it would be with several layers.

REMOVING BLEMISHES AND SMOOTHING SKIN

The easiest way to remove a minor blemish or to smooth out the texture in your subject's skin is to use the Clone tool set at 30 percent opacity so that it just smooths out the texture of the skin rather than drastically altering its appearance.

The Clone Tool allows you to clone copies of a portion of the image and apply that copy somewhere else in the image. This comes in handy when there are areas you would like to cover up or delete altogether.

Most children have beautiful skin but when you are photographing adolescents, this is a great trick for smoothing out the occasional blemish. Select from unblemished skin close by the area you want to fix and brush over the area that needs to be fixed and the blemish will slowly disappear. This is also a good fix for dark circles under the eyes as in the before and after photos in 10-1 and 10-2. The key to all retouching is to keep it subtle because you don't want your subjects to look like plastic dolls. A little image editing goes a long way.

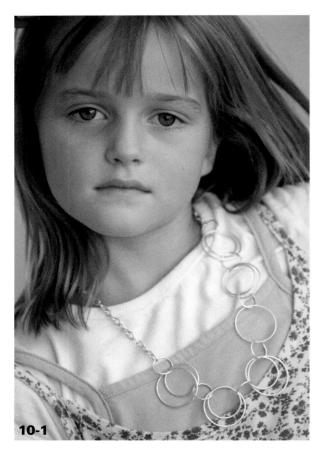

ABOUT THIS PHOTO Notice the dark circles under the girl's eyes. 1/250 second, f/2.8 at ISO 200. ©Allison Tyler Jones / www.ajtphoto.com

EYE AND TEETH ENHANCEMENTS

A quick fix for whitening the whites of the eyes and whitening the teeth is to set your Dodge tool at 20 percent opacity and carefully brush over the teeth and whites of the eyes until they are how you like them. Setting the tool at 20% allows you to lighten the teeth and the whites of the eyes without making them appear glowing. You can also use the Dodge tool to put a little sparkle into

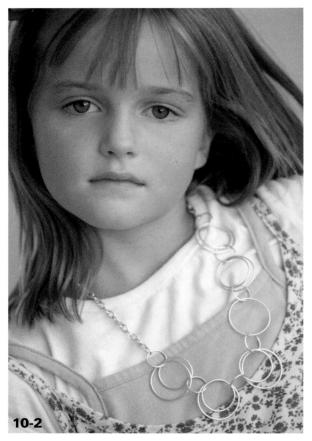

ABOUT THIS PHOTO After using the clone tool set at 30% opacity and selecting from the lighter skin on her cheeks, the dark circles have been eliminated. 1/250 second, f/2.8 at ISO 200. ©Allison Tyler Jones / www.ajtphoto.com

the irises of the eyes, but be careful that you don't overdo and make them look like an alien child! You can see the results of both the Clone tool and the Dodge tool on this before image of a toddler (10-3) and the after image (10-4). The little mark under the left side of his nose was removed using the above Cloning technique and the whites of his eyes were lightened to give his eyes more sparkle.

ABOUT THIS PHOTO A before photo of a toddler before using the Dodge tool to brighten his eyes and the Clone tool to remove the blemish on his face. 1/250 second, f/2.8 at ISO 100. ©Allison Tyler Jones / www.atjphoto.com

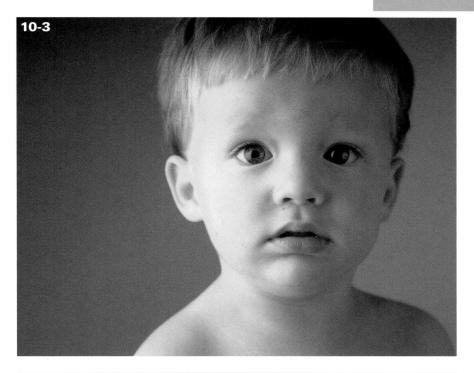

ABOUT THIS PHOTO
The results after using the
Dodge tool at 30% opacity to
lighten the whites of his eyes
and lighten his iris. Also used
was the Clone tool set at 30%
to fix the blemish under his
nose. 1/250 second, f/2.8 at ISO
100. @Allison Tyler Jones /
www.atjphoto.com

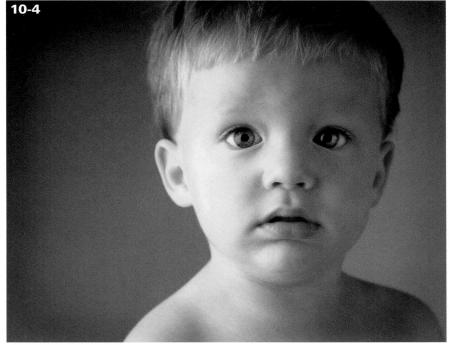

CLONING OUT DISTRACTIONS IN THE BACKGROUND

Sometimes, no matter how hard you try, a distracting element makes its way into the background of your image. In this case (10-5), it was the edge of the soft box on the studio light. Just go back to your Clone tool and change the opacity to 100 percent (10-6) and clone out the offending distraction as in 10-6.

CHANGING COLORS FOR IMPACT

Manipulation of photographic images has occurred in one form or another since the early days of photography. The majority of photographers have used their artistic license by altering their original captures to enhance or refine their story or style. With the advent of digital photography, the toolbox is much bigger and the possibilities are infinite.

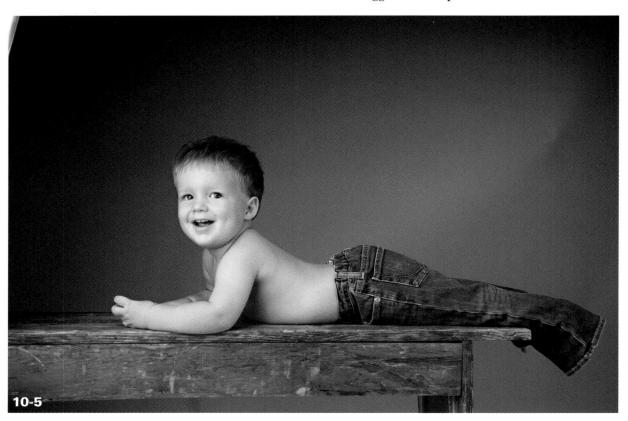

ABOUT THIS PHOTO The before photo with the light visible on the left side of the image. 1/250 second, f/2.8 at ISO 100. ©AllisonTyler Jones / www.atjphoto.com

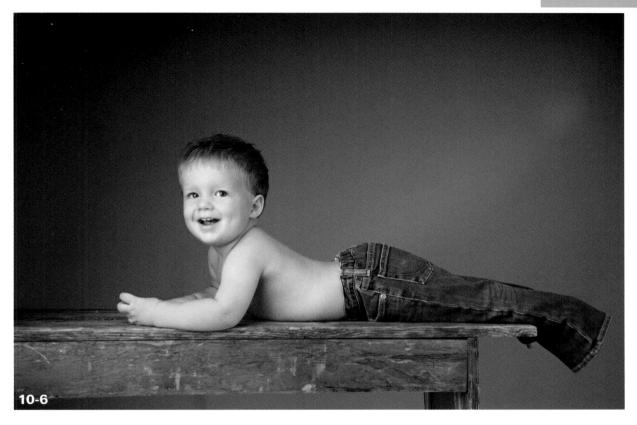

ABOUT THIS PHOTO After using the Clone tool at 100% and selecting the surrounding background to clone out the light.

@AllisonTyler Jones / www.atjphoto.com

BLACK AND WHITE CONVERSIONS

Converting an image from color to black and white is probably the most common form of color manipulation you can use, and even the most basic image-editing software can handle this job fairly well. If you are just starting out, you may want to purchase ready-made Photoshop Actions or Plug-ins for Photoshop Elements that automate these steps for you, allowing you to manipulate your images quickly and easily.

ACTIONS AND PLUG-INS

Plug-ins and Actions allow you to tone your color prints (10-7) in just about any direction you want once you convert them to black and white: for example, black and white (10-8), sepia (10-9), and brown tones. You can make your own Actions, but if you are just starting out, it is easiest to just download them from the Internet. There are many free Actions available on sites such as www.atncentral.com, or you can purchase Actions from manufacturers such as Nik Software and Kevin Kubota. If you are using Photoshop Elements, make sure the actions you download are compatible with the Elements software. Many of them are only available for Photoshop.

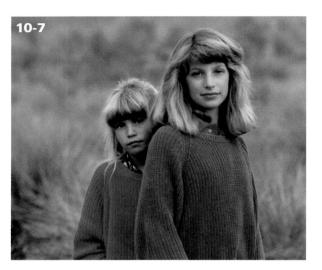

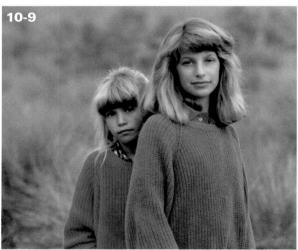

Please refer back to Chapter 5 if you need help with the finer points of composition. If you want to spend more time behind your camera and less time behind your computer fixing images, improve your technique in composition.

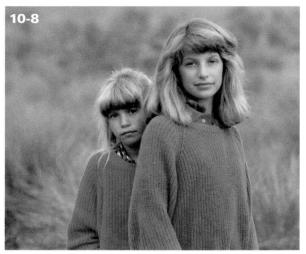

ABOUT THESE PHOTOS These two beautiful young sisters were photographed on an overcast day at the beach, creating a soft but colorful photograph (10-7). 1/250 second, f/4 at ISO 160. 10-8 shows the same photograph reworked in Photoshop Elements following the easy directions in one of the software's tutorials to remove color to create a sepia photo. 10-9 shows the same photograph reworked in Photoshop Elements following the easy directions in one of the software's tutorials to create a black-and-white image. 1/250 second, f/4 at ISO 160.

©Ginny Felch / www.silverliningimages.com

CROPPINGTIPS

If you are absolutely certain of your framing and composition, go for it and take the picture. Otherwise, it is advisable to leave a little room around the image as you have composed it before you click the shutter so that you can refine the cropping at a later date, especially if you are planning to print them at the standard photo sizes $(4 \times 6, 5 \times 7, \text{ and so on})$.

How you crop a photograph after you take it is as important as the original composition and final presentation of your image. After the photograph is made, you have a chance in post-production with imaging software to pay close and final attention to your cropping. Look at the example in 10-10. You can clearly see that cropping this image makes a huge difference in the impact it has.

When trying to decide on a crop after the photo has been taken, such as the one in 10-11, keep the following guidelines in mind:

Never crop off the hands or feet as in 10-12. This cropping error is often referred to as amputation. Either crop close to the head and shoulders or move out and crop below the hands as in 10-13, or back off completely and include the whole body.

ABOUT THIS PHOTO The cropped photograph is imposed on top of the entire original capture. You can see that cropping can change the story told by the image by either including or leaving out elements. 1/250 second, f/8 at ISO 400. ©Ginny Felch / www.silverliningimages.com

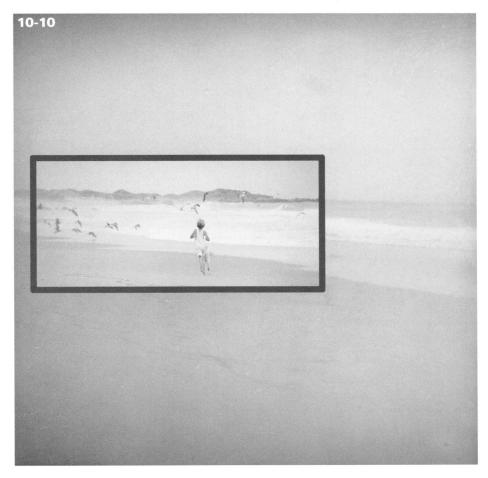

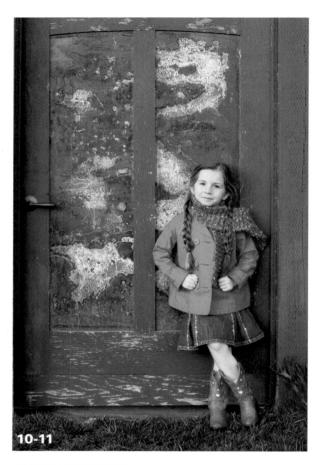

 $ABOUT\ THIS\ PHOTO\ \textit{This}\ is\ the\ full\ image\ taken\ of\ Daisy.\ 1/320\ second,\ f/4\ at\ ISO\ 1600.\ @Ginny\ Felch\ /\ www.silverliningimages.com$

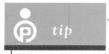

Imaging Factory Perspective (www. theimagingfactory.com) is very simple and friendly to use for straightening a skewed horizon.

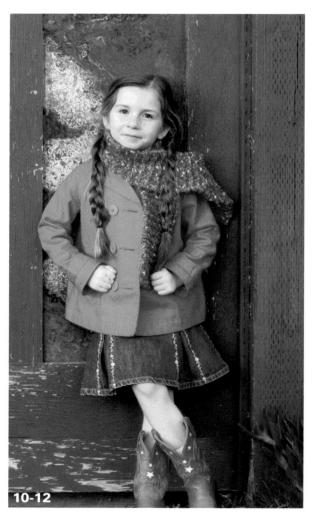

ABOUT THIS PHOTO Uh oh, no feet, no photo!

ABOUT THIS PHOTO

Successfully cropping an image to 3/4 length requires you to leave in the hands and to crop at mid thigh rather than chopping your subject off at joints, such as the knees, hips, etc.

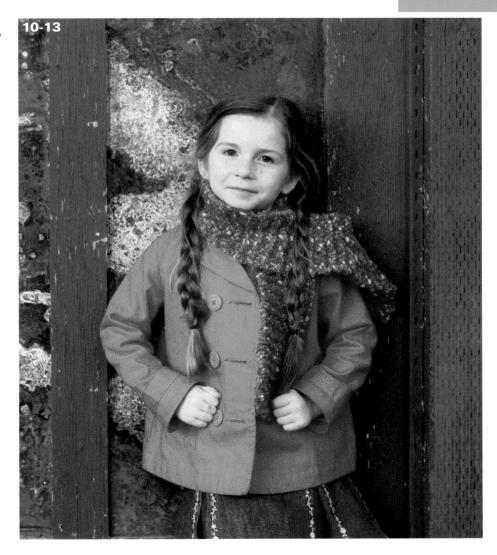

- Try to be creative so your subject is not in the very center of the photograph. Refer to general composition guidelines in Chapter 5, such as the Rule of Thirds.
- Leave plenty of growing room around the child, particularly above the head. It is comforting visually to create a sense of space. This also applies if the child is moving, leave space in the direction he is going or came from, which also helps to keep the subject off center.
- If a horizon line is visible, be sure it is straight. This can be done in a variety of ways in post-production if you didn't get it just right when taking the photo.
- If you weren't able to eliminate all background distractions when composing, try to remove them with careful cropping afterward.
- If the children are looking away from the camera presenting a profile, crop leaving more space in front of their line of vision. This gives the impression of space to look into, as in 10-14.

FAVORITE PLUG-INS You might not be ready to tackle some of these products now, but later on when your skills advance, these are some of Ginny's favorite Photoshop plug-ins. She uses them to enhance her images in a very natural way. This list steers away from filters and tools that distort things too drastically.

Nik Color Filters. Nik Color Filters includes a myriad of different artistic filters, including Classical Soft Focus, and Brilliance and Warmth. The use of these two filters together, modified to your taste, works really well to help make a digital image look more like a film image. Use them subtly, and you should find that they just take the edge off.

Nik Sharpener Pro. This is a filter used for sharpening images or parts of images as you see fit. There are varying degrees of sharpening available, and it is extremely user friendly.

Alien Skin Exposure. This is a wonderful and useful filter system for those who are used to film and want to replicate the qualities of certain films. The software also enables you to see your image in various tones (selenium and sepia) as well as with grain or softening. Both color and black-and-white options are available. After your photograph is shown on the screen, you can simply scroll through the choices and see the changes as you go.

Flaming Pear Melanch. Extra mood when you want to go a bit beyond the ordinary.

On the Edge Photographic Edges. Kitestrings Publishing sells a stunning set of edges that are simple to use and artful. For more information about this software, visit www.kitestringspublishing.com.

ABOUT THIS PHOTO The space left in the direction this little girl is looking gives a feeling of direction. If you don't compose an image like this when taken, you can crop it like this later. 1/60 second, f/4 at ISO 160. ©Ginny Felch / www.silverliningimages.com

PRESENTATION GALLERY

Capturing your image digitally gives you so many more options when it comes to printing your photos. Not only can you create different crops from the same image and change color to black and white for printing, you can also create online galleries at Web sites such as www.snapfish.com and www.shutterfly.com. Additionally, many of these Web sites have products you can purchase to place your images on to give as gifts, such as mouse pads, note cards, calendars, and so on.

STORYBOARDS

Once you learn your way around Photoshop Elements (or another chosen image-editing program), you know how to retouch, enhance, and crop your images. You can then create your own custom storyboards that will add a graphic element to your work. Storyboards use multiple images from a photo shoot to tell a larger story than a single image can. Start with a blank document in Photoshop Elements sizing the document to the desired size of your finished Storyboard. Next, open several different images that you would like to use for your Storyboard project. Using the Move tool just drag and drop each image onto your original blank document. Use the Ctrl+T/\#+T to transform each image and size it to the desired size on your document. Creating Storyboards can be addictive and you can use them in many different ways.

For example, the image in 10-15 could be used as a large wall print, the cover of a Christmas card, or for the cover of your very own coffee table book, as mentioned later in this chapter.

GALLERY-WRAPPED CANVAS PRINTS

A gallery-wrapped canvas print is an image that is printed on heavy artist's canvas and then stretched on stretcher bars with the image wrapping around the sides of the stretcher bars. Available through your local photo processor as well as many online outlets, gallery-wrapped canvases are a bold, contemporary statement and so fun to do with sweet baby faces as in 10-16. If you are planning to print a very large image, you will want to first check with your processor to make sure the image you have has a high enough resolution (size) to enlarge it to your specifications.

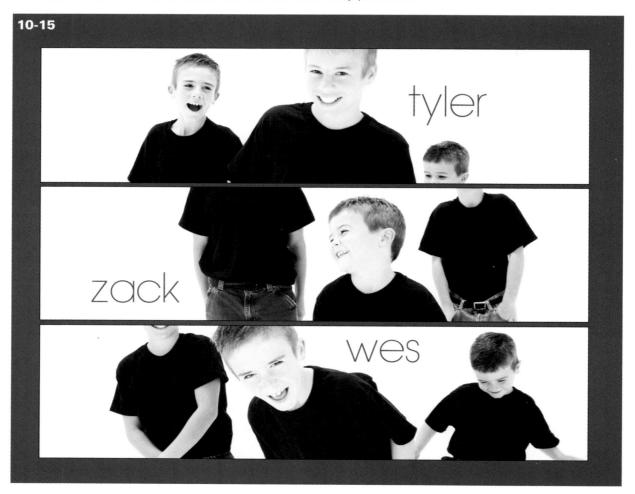

COFFEE TABLE DIGITAL BOOKS

It doesn't cost thousands of dollars anymore to have your very own coffee table book printed full of your own images as in 10-17. Check your local photo processor as well as online companies such as www.photoworks.com for hardcover books that

you can customize with their layout templates, fonts, and wording.

The options for outputting your digital images are endless and so fun they can be addictive. Pick a couple of your favorite images and have some fun with them.

ABOUT THIS PHOTO A beautiful baby is immortalized on a gallery-wrapped canvas. This image is actual size 20" \times 30". ©Allison Tyler Jones / www.atjphoto.com

ABOUT THIS PHOTO Make your own custom coffee table book by uploading your images to sites such as www.photoworks.com. Photos and book @AllisonTyler Jones / www.atjphoto.com

Assignment

Cropping for Impact

Create a photograph keeping in mind the cropping guidelines discussed in this chapter. Find an image that you like but could possibly be made better by creatively cropping it. Crop it three to four different ways and note how the impact of the image is changed for the better or worse.

The image chosen demonstrates two of the cropping tips. The photographer left the little girl small in the photograph relative to the environment, and there is extra space before her as she skips down the stairs. This cropping gives the perspective of a little girl in a bigger environment, and you can see some of the foreground toward which she moves. If it had been cropped differently, to eliminate the stairs, for example, the girl might look as though she were flying.

©Ginny Felch / www.silverliningimages.com

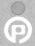

Remember to visit www.pwassignments.com after you complete this assignment and share your favorite photo! It's a community of enthusiastic photographers and a great place to view what other readers have created. You can also post comments, and read other encouraging suggestions and feedback.

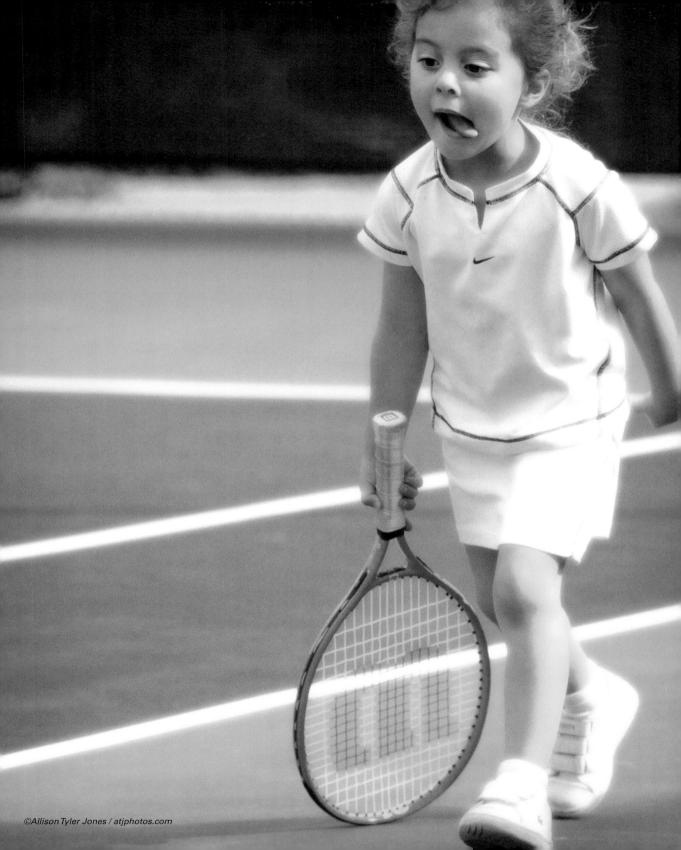

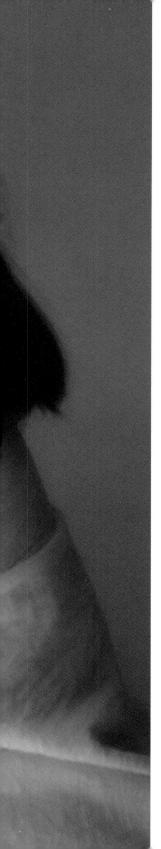

ambient light Refers to the available light in a given setting, whether by natural light or any other light sources in a room/setting. Ambient light does *not* refer to flash.

angle of view The area of a scene that a lens can capture, determined by the focal length of the lens. Lenses with a shorter focal length have a wider angle of view than lenses with a longer focal length.

aperture The size of the lens opening through which light passes. Aperture is referred to by f-stop numbers. See also *f-stop*.

Aperture Priority (Av) A setting on an automatic camera that enables you to choose the opening in the lens while the camera sets the shutter speed accordingly for the best picture.

backlight Refers to when a subject is primarily lit from behind.

bounce flash Pointing the flash away from the subject toward a wall, ceiling, or other hard surface, causing it to bounce off that surface before hitting the subject, thus softening the light illuminating the subject. Bouncing the light often eliminates shadows and provides a smoother light for portraits.

catch light The sparkly reflection captured in the eye of the subject. This catch light gives spark and life to the eyes.

color temperature The color of light in a given photograph. Different light sources have different color temperatures. For example, household lights have a very orange cast and fluorescent bulbs have a greenish cast.

contrast The difference between light and dark in a photo. A low-contrast image has a limited range of contrast in that there is no big difference between light and dark tones. A contrasty or high-contrast image has a big difference between light and dark tones.

depth of field The area in a photo that is in focus. In portraits, especially, a pleasing photo can be taken with a narrow depth of field, in which the person or people are in focus and everything else in the background is out of focus. See also *f-stop*.

diffuser Refers to anything that diffuses light in some way. It could be a sheet or curtain or a commercial diffuser made specifically for photographers.

digital noise Digital noise can be compared to grain in film. When an image is captured at a very high ISO (usually 800 or higher) noise is introduced into the image that makes it appear grainy and less sharp.

direct light Refers to light falling directly on the subject from its source. Direct light is light that has not been diffused or reflected off of something else.

environmental portraiture Portraits taken in the subject's environment — a yard, home, garden, workplace, and so on. See also *photojournalistic style*.

exposure Technically speaking, an exposure is a photographic image. An exposure is created when a certain amount of light (controlled by the aperture) hits the camera sensor for a certain amount of time (controlled by shutter speed).

fill flash Using a flash unit (on-camera or otherwise) to illuminate the subject in order to eliminate shadows. Using a flash for outdoor portraits often brightens up the subject in conditions where the camera meters light from a broader scene. See also *fill light*.

fill light Refers to any light that is not the primary illumination of a subject. See also main light.

filter Glass or other material that covers a lens to change the color or intensity of an image, soften an image, take away glare, or do any number of things to improve your photos. A filter also can be a post-production software tool that is used to create a variety of effects.

f-stop The f-stop or f-number is a measure of the size of the opening of the lens aperture. As the f-stop number increases in size (that is, f/8, f/9, f/22) the size of the aperture opening decreases. As the f-stop number decreases in size (f/5.6, f/4, f/2), the size of the aperture increases. The f-stop determines the depth of field or the area that is in and out of focus in the frame. See also aperture and depth of field.

golden hour The hour before sunset is prized by photographers because the sun is at a low angle in the sky and the light is soft and golden as a result of passing through the Earth's atmosphere at a low angle. See also *sweet light*.

Golden Rectangle Based on the Golden Ratio of 1:1.618, the Golden Rectangle is an area of an image considered to be most pleasing to the human eye. The Rule of Thirds is based on the Golden Rectangle divided into thirds to help guide the composition of a photograph. See also *Rule of Thirds*.

hard light Light quality that casts a harsh shadow and is often unflattering to most subjects. See also *direct light*.

high key Refers to an image that has predominately light tones and low contrast. The subject stands out because the skin tones appear darker than the clothing and background. The opposite of low-key photography. See also *low key*.

indirect light Refers to light that has been diffused through or reflected off of something else. Indirect light is not falling directly from the light source. See also *soft light*.

ISO setting ISO settings determine the sensitivity to light in your camera. In film cameras, the film has an ISO rating such as 100 speed, 200 speed, 400 speed, and so on. With digital cameras, you can set the ISO to make the camera more or less sensitive to light. The higher the ISO, the better the picture you get in darker conditions. However, you also get more grain or noise in your final image. See also *noise*.

JPEG An image format that compresses the image data from the camera to achieve a smaller file size. See also *lossy*.

leading lines Lines in the environment, such as roads, paths, edges, fences, and shadows can be used as a visual line to draw your eye to the subject in the photograph or through the photograph in a specific direction.

lossless A file compression type that discards no image data. TIFF is a lossless file format.

lossy A lossy file compresses image data, discarding it, often in the process of compressing image data to a smaller size. The higher the compression rate, the more data that is discarded, and the lower the image quality. JPEG is a lossy file format.

low key Refers to an image that has predominantly dark tones, with the subject usually standing out in light tones. The opposite of high-key photography. See also *high key*.

main light Refers to the light that provides the primary illumination of the subject being photographed. See also *fill light*.

megapixels This is equivalent to 1 million pixels. Digital cameras are rated by megapixels because the higher the pixel count, the bigger the potential print size. For example, 2-megapixel cameras can produce quality 4×6 prints, and 8-megapixel cameras can produce great prints up to 10×14 . See also *pixel*.

noise A grainy appearance in a digital photo that is usually the result of low-light conditions and long exposures, particularly when you've set your camera to a higher ISO rating than normal.

photojournalistic style Drawing on the candid, nonposed nature of true photojournalism, the photojournalistic style seeks to capture more candid moments rather than traditional posed portraits. See also *environmental portraiture*.

pixel Shortened from "Picture Elements," they are the units that make up a digital image. See also *megapixel*.

point and shoot A camera that does not have interchangeable lenses and typically is easier to use and more compact than an SLR camera. See also *SLR*.

red-eye An effect from flash photography caused by light bouncing from the retina of the eye. It is most noticeable in dimly lit situations (when the irises are wide open), and when the electronic flash is close to the lens and, therefore, prone to reflect the light directly back. It creates a red glow in human eyes.

reflector A device that can reflect light onto your subject. Reflectors can reflect flash/strobe lights or natural light.

Rembrandt lighting A lighting pattern that uses a single light source placed at a 45-degree angle to the subject resulting in an image with a three-dimensional appearance.

rim light The silhouette and halo effect around the hair of a subject achieved by placing a light in back of the subject.

Rule of Thirds Based on the Golden Rectangle, the Rule of Thirds states that you can divide the frame of your image into three sections vertically and three sections horizontally. The best spots to place your subject are where the lines intersect. This rule keeps you from placing everything in the center of the photograph; instead, the Rule of Thirds indicates that you should place the subject off center so that the composition of the photo becomes more interesting. See also *Golden Rectangle*.

sepia Photographs with a brownish tone — a great alternative to color or black and white. Sepia photographs look antique. The tone can be achieved either by a filter on the lens or in digital post-production.

shutter speed The amount of time that the lens shutter is open to let light in through to the film or sensor; measured in fractions such as 1/30, 1/60, 1/125, and 1/500 of a second. The combination of the shutter speed and the f-stop determine the exposure.

SLR Single-lens reflex refers to a camera that enables you to view the scene from the same lens that takes the photograph. In most point-and-shoot cameras with fixed lenses, you view the scene from a different lens than what takes the picture.

soft light Light quality that creates gentle shadows and is more flattering to most subjects. See also *indirect light*.

specular highlight The reflection of the light source (sky, sun, or flash) on the subject. Different examples include the catch light you see as a white dot in the eye in a photograph; the too bright spots on foliage that can be a terrible distraction in a portrait; and the soft line of light that you often see on a nose when light comes in from the side.

sweet light The secret of many photographers, this light is seen at dawn and dusk, when the sun is at a great angle. The effect it produces is soft and gentle and bathes the subject with modeling and often atmospheric light. See also *golden hour*.

TIFF A type of file storage format that has no compression, therefore, no loss of image detail. TIFF files can be very large image files. See also *lossless*.

white balance The colorcast to any given digital image that may need to be corrected using software or settings in the camera.

Y			

NUMBERS	Auto (A/P) mode
3D (Rembrandt) lighting, directional	exposure shortcomings, 19-20
light, 70–71	uses, 28
8,	Auto white balance, adjustment situations,
A	75–78
A mode	auxiliary flash, bouncing techniques, 69
defined, 224	Av mode
foggy days, 51	defined, 224
uses, 29	foggy days, 51
Actions, Photoshop Elements, 211–212	uses, 29
adolescents, 174–180	available light, 40–41
advertising shots, front (flat) lighting, 70	
Alien Skin Exposure, Photoshop Elements	В
plug-in, 216	babies
ambient light	six-to-twelve months, 167
available light, 67	three-to-six months, 166
defined, 224	backgrounds
angle of view, 224	classic style, 112
A/P mode	composition guidelines, 88–89, 94
exposure shortcomings, 19–20	contemporary style, 124–125
uses, 28	image corrections, 210
Aperture Priority (A/Av) mode	romantic style, 112
defined, 224	short versus long depth of field, 24–27
foggy days, 51	snapshot versus portrait composition,
uses, 29	86–87
apertures. See also f-stops	backlight
Aperture Priority (A/Av) mode, 28–29	defined, 224
defined, 224	halo effects, 67–68
depth of field, 24–27	backups, image files, 204, 205
exposure element, 23–24	beach shots
f-stop measurements, 23–24	classic/romantic style, 114
lens speed, 195	low tide reflections, 46
long depth of field, 26	parallel lines, 100
maximum opening determination, 198	subject involvement, 150, 152
Portrait mode, 28	benches, toddler perch, 170
portraiture, 29–30	black-and-white images
short depth of field, 26-27	conversions, 211
architectural shots, wide angle lens, 196	newborn photography, 163
architectural structures	blankets, newborn photography, 163
classic/romantic style, 114	blemishes, retouching images, 207–208
contemporary style, 123–125	blurs, shutter speeds, 23
image framing, 94–95	body language, mood/emotion indicators,
archways, subject framing, 94	153–154 hetanical gardens, classic/rementic style
arms, diagonal leading lines, 101	botanical gardens, classic/romantic style
artistic effects, reflections, 44–48	location, 114
assisted reality, photojournalistic style, 130–131	bounce flash, 224

bounce light, auxiliary flash units, 69	diagonal lines, 101–102
boys (teenage)	divine proportion, 98
father/son shots, 183	image framing, 92–95
photographic challenges, 179–180	negative space, 91–92
priotographic chancinges, 117 100	parallel lines, 99–100
C	parents as props, 95–96
	Rule of Thirds, 96–99
camera bags, 198–200	s-curves, 102–104
camera positioning, image framing, 93 camera shake	snapshots versus portraits, 86–87
	telling the story, 87–88
prevention techniques, 21–22	computers, camera upgrade, 195
shutter speeds, 21–22 cameras, upgrade considerations, 194–195	contemporary style
candid shots, family groups, 187–189	location shots, 123–125
catch lights. See also reflectors	studio shots, 119-123
defined, 224	contouring light, 53–55
eye enhancement, 58	contrast, 224
eye reflections, 144	converging lines, composition concepts, 102–103
c-curves, composition concepts, 102–104	creativity exercises, 11
childhood memories, 9	cropping
classic style	image framing, 93–94
clothing, 114–117	image workflow element, 205
location shots, 113–114	photojournalistic style, 131-132
mood capturing, 118–119	Photoshop Elements, 206, 212-216
studio shots, 112	cross-eyed babies, 163
Clone tool	cultural events, 11
eye/teeth enhancements, 208-209	curved lines, composition concepts, 102–104
image corrections, 210	
retouching images, 207	D
closed down shooting, long depth of field, 26	dawn
Close-up mode, 29	halo effects, 67–68
clothing	sweet light, 42–43
classic style, 114–117	daylight shots, white balance adjustments, 76
general guidelines, 121	Decisive Moment, 98
romantic style, 114–117	depth of field
coffee table digital books, 218–219	camera upgrade, 194
color corrections, Photoshop Elements, 206, 210–212	defined, 224
color temperature	shallow versus long, 24–27
defined, 224	diffuse lighting, flash units, 69
white balance adjustments, 75–78	diffusers
comfort, newborn photography, 162	defined, 224
compact digital cameras, enabling/disabling flash, 50	light modifiers, 75
composition	digital cameras, upgrade considerations, 194–195
backgrounds, 88–91	digital noise
breaking the rules, 104–107	defined, 224
c-curves, 102–104	high ISO setting, 24, 26
converging lines, 102–103	direct light
conveying the message, 87	defined, 224
described, 86	sunlight, 66–67

directional light	portrait focus point, 30
flat (front) lighting, 70	raccoon effect, 53
Rembrandt/3-D lighting, 70–71	red-eye, 71, 80
distortions, wide angle lens, 196	
distractions	F
composition guidelines, 90	facial shots
hot spots, 92	Rembrandt (3D) lighting, 70–71
image corrections, 210	soft window light, 56–58
divine proportion, subject placement, 98	family
Dodge tool, eye/teeth enhancements, 208–209	family group, 187–189
doorways, subject framing, 94	parent/child, 180–183
dSLR (digital single-lens-reflex) cameras, lensbabies, 200	siblings, 184–185
	feet, avoiding cropping, 93–94
E	fill flash, 224
e-mail, megapixel requirements, 195	fill light
emotions. See also moods	defined, 224
body language, 153–154	versus main light, 68–69
eyes as gateway to the soul, 143–148	film speeds, ISO ratings, 24
observing, 141–143	filter, 225
storytelling scenarios, 154–156	Flaming Pear Melanch, Photoshop Elements plug-in, 216
subject involvement, 148–153	flash
toddler photography, 167–170	bouncing, 69
environmental portraiture, 224	diffuse lighting, 69
environmental shots	foggy day, 51
classic style, 113–114	main versus fill light, 68–69
contouring light, 53–55	monolights, 80
family groups, 189–190	on-camera, 71
foggy days, 50–53	speedlights, 69
	white balance adjustments, 77
long depth of field, 26	flash meters, studio lighting, 80–81
low tide reflections, 46	
overcast sky, 50, 53	flat (front) lighting, directional light, 70
romantic style, 113–114	fluorescent lighting, 77
Rule of Thirds, 98	foamcore board, reflector uses, 74
subject framing, 94	focal lengths
subject involvement, 148–153	lens purchase issues, 196
environments, shooting style, 8	shutter speeds, 22
exposures	zoom lenses, 197–198
apertures, 23–24	focus, depth of field, 24–27
Auto mode shortcomings, 19–20	foggy days
defined, 224	classic/romantic style, 114
depth of field, 24–27	lighting condition, 50–53
ISO sensitivity, 24	foregrounds, short versus long depth of field, 24–27
shutter speeds, 20–23	framing
eyes	classic style, 112–113
catch light enhancements, 58	composition concepts, 92–95
catch lights, 144	romantic style, 112–113
gateway to the soul, 143–148	Rule of Thirds, 96–99
image enhancements, 208–209	

freeze frames, shutter speeds, 22–23 front (flat) lighting, directional light, 70 f-stops. <i>See also</i> apertures defined, 225	headshots, Rule of Thirds, 99 high key, 225 high-key photographs, foggy days, 52 high-key portraits lighting, 116
depth of field, 24–27	horizon lines, image framing, 94
exposure element, 23–24	hot spots, image framing distractions, 92
fractional measurement, 24	
lens speed, 195	
long depth of field, 26	idea files, image resources, 112
maximum opening determination, 198	image editors. See Photoshop Elements
portraiture, 29	image output, workflow element, 205
short depth of field, 26–27	image size, camera upgrade, 194–195
furniture	images
newborn photography, 163	backing up, 204, 205
toddler props, 170	black-and-white conversions, 211
	coffee table digital books, 218–219
G	color corrections, 206, 210–212
galleries, 11	cropping, 206, 212–216
gallery-wrapped canvas prints, 217	file backups, 206
games/activities, toddler photography, 169	framing guidelines, 92–95
gestures, body language, 153–154	gallery-wrapped canvas prints, 217
girls (teenage), 179–180	idea file resources, 112
goal setting, parent/photographer communications,	post-production workflow, 204–205
132–133	presentation gallery, 217–219
gobos, light modifiers, 75	retouching, 206, 207–210
Golden hour, 225	storyboards, 217
Golden Rectangle	tonal adjustments, 206
defined, 225	incandescent lighting, 78
divine proportion concepts, 98	indirect light
Google, Picasa for Windows, 205	defined, 225
group shots families, 187–189	open shade, 65–66
Landscape mode, 29	overhangs, 64
long depth of field, 26	porches, 64
parent/child, 180–183	interior shots, wide angle lens, 196
siblings, 184–185	Internet, inspirational resource, 11
wide angle lens, 196	iPhoto, image management software, 205
wide aligie ielis, 170	ISO (International Organization for Standardization), 24
H	ISO sensitivity
	digital noise, 24, 26
halo effects, rim/backlighting, 67–68	exposure element, 24 film speed ratings, 24
handheld shots	lighting/situation suggestions, 24
camera shake prevention, 21–22	ISO setting, 225
shutter speeds, 21–23	100 setting, 223
handling, camera upgrade, 195	I
hands, avoiding cropping, 93–94 hard light, 225	IDEC 225
naru ngiri, 229	JPEG, 225

K	direct light, 66–68
Kevin Kubota, Actions, 211	directional light, 70–71
reviii Rabota, 1 letions, 211	flash/no flash situations, 68–69
I	fluorescent, 77
L d d 20	foggy days, 50–53
Landscape mode, 29	gobos, 75
landscape shots, wide angle lens, 196	high-key photographs, 52
layers, retouching images, 207	incandescent, 78
lead-in lines, composition concepts, 101–102	indirect light, 64–66
leading lines, 225	ISO setting/situational suggestions, 24
legs, diagonal leading lines, 101	main versus fill, 68–69
lens speed, purchase issues, 195 lensbabies, dSLR accessory, 200	modifiers, 72–75
	mood keying, 116
lenses apertures/f-stops, 23–24	observation techniques, 36–39
	on-camera flash, 71
camera upgrade, 195 focal length, 196	overcast skies, 50, 53
interchangeable, 195–198	reflections, 44–48
lens speed, 195	reflectors, 72–74
lensbabies, 200	rim lights, 67–68
maximum opening determination, 198	shadows, 48–51
prime, 196	specular highlight, 54–55
shutter speeds, 22	speedlights, 69
standard, 196	studios, 78–82
telephoto, 196	sweet light situations, 42–43
wide angle, 196	tungsten, 78
zoom, 197–198	white balance, 75–78
life stages	windows, 56–58
adolescents, 174–180	lines
babies, 165–167	c-curves, 102–104
newborns, 161–165	converging, 102
preschoolers, 171–173	diagonal, 101–102
school age, 174	parallel, 99–100
toddlers, 167–170	s-curves, 102–104
lifestyles, shooting style, 8	location shots
lighting	classic style, 113–114
ambient light, 67	contemporary style, 123–125
available light, 40–41	owner permissions, 154
backlighting, 67–68	photojournalistic style, 128–130
catch lights, 58	romantic style, 113–114
classic/romantic style, 114	long depth of field
closer the source/softer the light, 82	Landscape mode, 28–29
color temperature, 75–78	uses, 24–27
	lossless, 225
compromising situations, 58–59	lossy, 225
contouring light, 53–55 diffuse lighting, 69	low key, 225
diffusers, 75	low-key portrait, lighting, 116
uniuscis, 19	

M	open shade, indirect light, 65–66 outdoor shots, Landscape mode, 29
Macro mode, uses, 29	overcast sky, lighting situations, 50, 53
magazines	overhangs, indirect light, 64
inspirational resource, 10–11	overnangs, municet fight, 04
photo file resource, 112	P
main light	
defined, 225	P/A mode. See Auto (A/P) mode
versus fill light, 68–69	parallel lines, composition concepts, 99–100
Manual (M) mode, 28	parenthood, aspiring photographers, 6
megapixels	parents
camera upgrade, 194–195	child groups, 180–183
defined, 225	expectation outlining, 132–133
mentors	newborn photography prop, 164–165
inspirational resource, 10	as props, 95–96
shooting style development, 7	session presence, 133–134
mid-key portraits, lighting, 116	toddler involvement, 168–169
mirrors, reflections, 47–48	parks
monolights, studio lighting, 80	classic/romantic style location, 114
moods. See also emotions	subject involvement, 150–152
body language, 153–154	pathways, diagonal leading lines, 101–102
eyes as gateway to the soul, 143–148	perches, toddler photography, 169–170
observing, 141–143	performing arts, inspirational resource, 11
story telling scenarios, 154–156	photo files, image resources, 112
subject involvement, 148–153	photojournalistic style
toddler photography, 167–170	assisted reality, 130–131
motion blurs, shutter speeds, 23	defined, 226
museums, 11	development methods, 6–9
B.I.	location shots, 128–130
N	Photoshop Elements
nature shots, subject involvement, 148–153	Actions, 211–212
negative space, composition concepts, 91–92	black-and-white conversions, 211
newborns	color corrections, 206, 210–212
black-and-white images, 163	file backups, 206
comfort, 162	image cropping, 206, 212–216
photographic challenges, 162-164	image enhancements, 206
photographic rewards, 164–165	image sizing, 206
Nik Color Filters, Photoshop Elements plug-in, 216	image-editing software, 205–206
Nik Sharpener Pro, Photoshop Elements plug-in, 216	layers, 207
Nik Software, Actions, 211	plug-ins, 211
noise, 226. See also digital noise	retouching images, 206, 207–210
non-directional lighting, soft window light, 56–58	storyboards, 217
nose, focus point, 26	tonal adjustments, 206
	Photoshop Elements 5 For Dummies, 205
0	Picasa for Windows, image-editing software, 205
On the Edge Photographic Edges, 216	pixel, 226
on-camera flash, pros/cons, 71	play activity, skill development element, 12–14
off Carriera Habit, probjectio, 11	plug-ins, Photoshop Elements, 211–212

point and shoot, 226	props
point-and-shoot cameras	family groups, 189
aspiring photographers, 5	newborn photography, 164–165
camera shake prevention, 21–22	parents as, 95–96
upgrading, 194–195	preschool photography, 173
porches, indirect light, 64	relation building, 156–157
Portrait mode, 28	toddler photography, 169–170
portrait shots	1 8 1 //
composition guidelines, 86–87	R
high-key lighting, 116	
low-key lighting, 116	raccoon eye effect, overcast skies, 53
mid-key lighting, 116	red-eye
portraiture	defined, 226
Aperture Priority (A/Av) mode, 29	on-camera flash, 71, 80
classic style, 112–119	reflections, dynamic design element, 44–48
family groups, 180–189	reflectors. See also catch lights
f-stops, 29	defined, 226
planning sessions, 135	light modifiers, 72–74
romantic style, 112–119	relationships, family group shots, 180–189
short depth of field, 26	Rembrandt (3D) lighting
style development, 8	defined, 226
poster board, reflector uses, 74	directional light, 70–71
post-production, workflow development, 204–205	resources, inspiration, 10–11
preschoolers, 171–173	retouching
presentation gallery	image workflow element, 205
coffee table digital books, 218–219	Photoshop Elements, 206, 207–210
gallery-wrapped canvas prints, 217	rim light
storyboards, 217	defined, 226
prime lens, fixed focal length, 196	halo effects, 67–68
print size, camera upgrade, 194–195	romantic style
printing, image output, 205	clothing, 114–117
prints, gallery-wrapped canvas, 217	location shots, 113-114
professional photographers	mood capturing, 118–119
	studio shots, 112
aspiration evaluation questions, 4–5	Rule of Thirds
style observation, 6–7	defined, 226
profile shots, cropping, 94	subject placement, 96–99
program modes	
Aperture Priority (A/Av), 29	S
Auto (A/P), 28	S mode, 30
Close-up, 29	school age children, 174
Landscape, 29	s-curves, composition concepts, 102–104
Macro, 29	sepia, 226
Manual (M), 28	shade shots, white balance adjustments, 78
Portrait, 28	shadows, image enhancement, 48–51
Shutter Priority (S/Tv), 30	
Sports, 29	shooting modes, camera upgrade, 194

short depth of field	development methods, 6–9
Macro mode, 28	high-key portrait, 116
Portrait mode, 28	low-key portrait, 116
uses, 24–27	mid-key portrait, 116
Shutter Priority (S/Tv) mode, 30	photojournalistic, 125–131
shutter speeds	romantic, 112–119
defined, 226	subjects
exposure element, 20–23	divine proportion, 98
fractional measurement, 20–21	image framing, 92–95
freeze frames, 22–23	nature involvement, 148–153
motion blurs, 23	Rule of Thirds, 96–99
movement versus camera shake, 21–22	sunlight
Portrait mode, 28	available light, 40–41
Shutter Priority (S/Tv) mode, 28, 30	direct light, 66–68
situational suggestions, 22	indirect light, 64–66
Sports mode, 28–29	soft window light, 56–58
siblings, family shots, 184–185	sweet light situations, 42–43
skills	sunrise
play activity, 12–14	halo effects, 67–68
shooting style development, 6–9 skin, smoothing, 207–218	sweet light, 42–43
	sunset
SLR (single-lens-reflex) cameras defined, 226	halo effects, 67–68
upgrading, 195	sweet light, 42–43
snapshots	supplies, 199–200
composition guidelines, 86–87	swaddling, newborn photography, 164 sweet light
shooting from behind, 135	
soft box, monolights, 80–81	classic/romantic style, 114
soft light, 226	dawn/twilight, 42–43 defined, 227
specular highlight	halo effects, 67–68
defined, 226	photojournalistic style, 131
subject placement, 54–55	photojournanstic style, 131
speedlights, bouncing techniques, 69	Т
Sports mode, 29	•
standard lens, use guidelines, 196	tables, toddler perch, 170
storyboards, presentation method, 217	teenagers, 174–180
strobe lights, halo effects, 67–68	teeth, image enhancements, 208–209
studio lighting	telephoto lens
flash meters, 80–81	photojournalistic style, 128
monolights, 80	use guidelines, 196
one-light setup, 80	temperatures, newborn photography, 162
studio shots	3D (Rembrandt) lighting, directional light, 70–71
classic style, 112	TIFF, 227
contemporary style, 119–123	toddlers, 167–170
romantic style, 112	tonal adjustments, Photoshop Elements, 206
styles	tracing vellum, diffusing light, 69
classic, 112–119	travel, inspirational resource, 11
contemporary, 119–125	tripods, camera shake prevention, 21
r,,	

tungsten lighting, white balance adjustments, 78	Imaging Factory Perspective, 214
Tv mode, 30	lensbabies, 200
tweens, 174–179	photo design, 86
twilight	photo file resource, 112
halo effects, 67–68	photoworks.com, 219
sweet light, 42–43	pwassignments.com, 32
	sunrise/sunset times, 42
U	Wikipedia.com, 204
upgrades, camera, 194–195	weddings, Aperture Priority (A/Av) mode, 29
urban locations, contemporary style, 123–124	white balance
, , , , , , , , , , , , , , , , , , , ,	color temperature adjustments, 75–78
V	defined, 227
	wide angle lens, use guidelines, 196
vertical parallel lines, composition solidity, 100	wide open shooting, short depth of field, 26-27
viewfinders, background checking before shooting, 91	window glass, reflections, 46-47
vignettes, image framing, 94–95	windows
visualization, capturing moods/emotions, 142–143	soft lighting, 56–58
AA7	subject framing, 94
W	workflow
walkways, diagonal leading lines, 101–102	color corrections, 206, 210-212
walls, diagonal leading lines, 101–102	image cropping, 206, 212–216
weather	image editing, 206–207
foggy days, 50–53	post-production development, 204–205
overcast sky, 50, 53	presentation gallery, 217–219
Web images, megapixel requirements, 195	retouching images, 206, 207-210
Web sites	workshops, inspirational resource, 10
Actions, 211	
camera research, 194	Z
coffee table digital books, 218	zoom lenses, use guidelines, 197–198
divine proportion theory, 98	200111 letises, use guidelilles, 197–190
home studios, 81	

Develop your talent.

Go behind the lens with Wiley's Photo Workshop series, and learn the basics of how to shoot great photos from the start! Each full-color book provides clear instructions, ample photography examples, and end-of-chapter assignments that you can upload to pwassignments.com for input from others.

978-0-470-11433-9

978-0-470-11876-4

978-0-470-11436-0

978-0-470-14785-6

978-0-470-11435-3

978-0-470-11955-6